OTTO PÄCHT

Venetian Painting
in the 15th Century

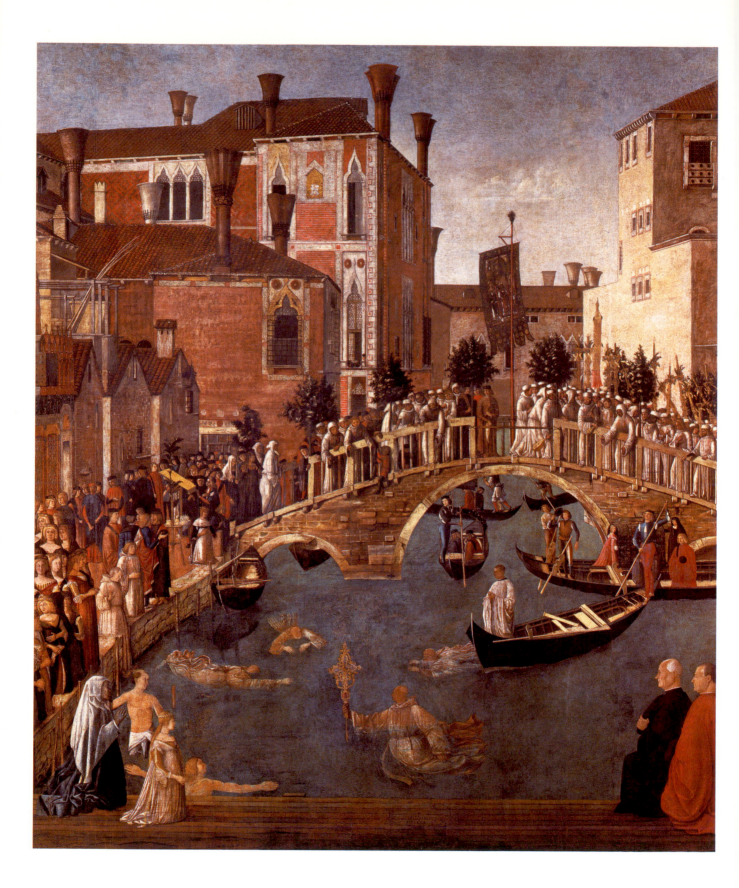

OTTO PÄCHT

Venetian Painting
in the 15th Century

Jacopo, Gentile and Giovanni Bellini
and Andrea Mantegna

Edited by
Margareta Vyoral-Tschapka
and
Michael Pächt

HARVEY MILLER PUBLISHERS

HARVEY MILLER PUBLISHERS

An Imprint of Brepols Publishers
London/Turnhout

Originally published in German by Prestel-Verlag, Munich 2002
as *Venezianische Malerei des 15. Jahrhunderts. Die Bellinis und Mantegna*
First English translation published by Harvey Miller Publishers,
London, 2003

Translated from the German by Fiona Elliott

Designed and produced by Michael Pächt

© 2003 Michael Pächt, Munich

British Library Cataloguing in Publication Data
A catalogue record for this book
is available from the British Library

ISBN 1-872501-54-0 *Hardback*
ISBN 1-872501-23-0 *Paperback*

Front Cover:
Giovanni Bellini, Madonna 'degli alberetti'
Venice, Gallerie dell'Accademia

Back Cover:
Jacopo Bellini, St Christopher
Paris, Louvre, Paris Sketchbook, fol. 79

Frontispiece:
Gentile Bellini, Miracle of the Cross
on San Lorenzo Bridge (Detail),
Venice, Gallerie dell'Accademia

Origination: Medienservice AG, Munich
Printing: Offizin Chr. Scheufele, Stuttgart
Binding: Schaumann, Darmstadt

Contents

In Memory of Otto Pächt

The publication of this book coincides with the centenary of the birth of Otto Pächt. On his return to Vienna to take up the Chair in Art History at Vienna University in 1963 after an extended period as an émigré in England, it took him barely nine years to establish himself as an extraordinarily inspirational teacher and scholar. His lectures and seminars had a decisive influence on his students in Vienna, many of whom came from abroad to participate in his courses.

Some of these lectures have since been published, also in various languages in addition to German *(The Practice of Art History, Book Illumination in the Middle Ages, Van Eyck, Early Netherlandish Painting, Rembrandt)*, giving readers a vivid impression of Otto Pächt the teacher. The lectures on Venetian painting in the 15th century conclude the series. In Pächt's lectures that ideal union of teaching and research – so often invoked and so rarely achieved – was always in evidence. The scripts of his lectures were virtually ready to go to press; as had been the case with the previous volumes in this series, the manuscript needed only minimal adjustments.

What distinguished Pächt as a teacher was his interest in fundamental issues, his immense knowledge, but above all the impassioned seriousness with which he pursued his profession, never ever willing to compromise. Behind his unerring pursuit of scholarly exactitude, there was the human integrity that so moved his students. Otto Pächt was an art historian out of a deep inner conviction.

His prime concern was always the work of art as such; it took precedence in every respect and was more important than any other source. A passage from a letter Pächt wrote to the American art historian Meyer Schapiro in 1934 is very telling. In this letter Pächt talks of his study of Netherlandish painting over the previous fourteen years and refers to the fact that his work was above all about developing "a more mature ability to see."

Otto Pächt, himself a friend and supporter of the well-known Austrian writer Robert Musil, was able to express this finely tuned ability to see in equally finely tuned language. And it was thus that he communicated his deep respect for the works under discussion to his students. Now, just as the scholar once taught his students to see for themselves, the texts of his lectures will do the same for his readers. Pächt's lectures take us down the path to optical maturity.

Despite his profound learning and his immense knowledge of iconography, Pächt's primary interest was in form, for in his eyes this was the real content of the work of art. He was unfailingly sceptical in the face of interpretations that were either too rigorous or too glib.

In the lectures published here, as always, it is more important to Pächt to find a way into Bellini's pictorial fantasy, to explain his pictorial inventions – which he does with such supreme skill particularly in his discussion of the mythological and allegorical compositions – than to come up with an interpretation at all costs.

The breadth and mastery of Pächt's account of this period is immediately evident in the way that he is able in just a few short opening pages to sum up the art-historical situation of Venice, making the distinction between Venetian painting and Netherlandish painting, and locating the Bellinis in the history of painting in Venice. And then there is the fascination of his deep insight into the making of specific works of art. His analysis of Mantegna's San Zeno Altarpiece – elucidating the various conditions to which Mantegna reacted with such skill – is a prime example of Pächt's capacity to identify and illuminate the problems that these 15th-century artists were grappling with, in short, always to approach the work of art from the point of view of the artist.

Artur Rosenauer

Introduction

These lectures on 15th-century Venetian painting, delivered by Otto Pächt in 1967/68 at Vienna University – still vividly and enthusiastically remembered by those fortunate enough to attend them, and published here for the first time – reveal a little known interest on the part of this great art historian. His name is associated above all with his ground-breaking studies on medieval book illumination and late Gothic painting north of the Alps. Aside from a few shorter investigations into Humanist book decoration, Pächt never published any studies on the Italian Renaissance, one of the 'classical' topics in art history.

Nevertheless, like all the other lectures from Pächt's later years in Vienna, these, too, are the result of studies that had come to fruition after decades of intense deliberation. In the case of the Bellini family, we know from unpublished texts and fragments among Otto Pächt's papers that these deliberations go right back to the time around 1930 when the young art historian was already making a crucial contribution to the 'New Viennese School of Art History'. At that time he was concerned with the consequences that the new perspectival illusionism, which opened up every angle of visibility to artists, in fact had for the purely artistic order of a picture – a question that Erwin Panofsky's 'Perspective as Symbolic Form' (1927) had left to one side. In his renowned essay 'Gestaltungsprinzipien der westlichen Malerei' (1933), Pächt analysed the different pictorial systems that were used in the Southern Netherlands, Holland and France to meet the constitutive demand of post-medieval painting that projective spatial representation should harmonise with the aesthetically coherent organisation of the picture plane.[1] That Pächt had set his own sights even wider than this is evident from the typescript of an unpublished lecture on 'Pictorial Illusion in 15th-century painting'[2] delivered in Freiburg in 1931, in which he not only anticipates the argument in his later essay, but also discusses compositional principles in Italian and German painting (he was to return to the latter in 1952 in 'Zur deutschen Bildauffassung der Spätgotik und der Renaissance'[3]). The Italian artists whom he cites are Giotto, Piero della Francesca – and Jacopo Bellini, specifically his drawing of *Christ before Pilate* in the Paris Sketchbook.

Jacopo's compositional strategies – a regular arrangement created by the triumphal arch depicted parallel to the picture plane, foreshortened perspectival lines 'slipping' into a surface pattern – are identified by Pächt as fundamental to the Italian principle which favours the autonomy of the composition over the relativity of the subjective perspective of the beholder. "But the function of the formal equivalence of existential form and visible form is to ennoble the visible forms. ... By thus being skilfully subordinated, visible form acquires something of the dignity of objectively regular, well-proportioned, that is to say, beautiful form. Thus the artist can awaken in us the illusion that the representation is more than mere semblance, that the pictorial world and its order do exist unconditionally." In his Fouquet essay (1940/41), written in English, Pächt comes to a similarly broad conclusion in his analysis of Jacopo Bellini's London drawing of the *Death of the Virgin*: "The Italian picture implies that the order and regularity contained in its composition is inherent also in the object represented."[4] Thirty years later, in his Bellini lectures, Pächt is no longer seeking to deduce – from a single example – a constant pictorial system for a whole painterly tradition. Now, starting afresh each time, in numerous

meticulous analyses of individual works, he gradually identifies Jacopo's unique artistic qualities. However, the precision of his discussion and his attention to fundamental structures show just how much he is still faithful to the high theoretical aspirations of his early texts.

It is not only in his analysis of the pictorial structure of Jacopo's drawings but also in his description of their specifically Venetian narrative mode that Pächt develops earlier arguments. "For the Venetians any event, any incident is inextricably linked with the environment in which it occurs, with the milieu in both a spatial and temporal sense." "The Venetian artist's pictorial fantasy starts with the idea of the pictorial space, always appearing with its own particular characteristics. The seed of the artistic invention is the vision of an individual topographical situation, the particular circumstances of which affect the shape of human activities." These sentences, which one could readily match with similar moments in the lectures, are taken from an early unpublished study from around 1930 entitled 'Venezianische Architekturlandschaft'.[5] Pächt is here elucidating the development that starts with Jacopo's discovery of man-made or natural "existential space" in which human activities become merely episodic, and which ultimately leads to the pure vedutas produced by artists in the 18th century (Canaletto, Guardi, but also Piranesi).

In these early studies Jacopo Bellini already emerges as a pioneer and innovator, a founder of the Venetian tradition. And Pächt changed nothing in this assessment in his lectures, devoting the whole first semester to the work of Jacopo Bellini. In the 1960s this was by no means the norm. Jacopo's art was widely regarded as derivative and backward-looking. This was due in part to the blinkered view of art historians whose researches into the paintings had largely ignored Bellini's astonishing drawings – constrained by genre in a way that was entirely alien to Otto Pächt – but above all it was due to the uncertainty concerning the dating of the so-called 'Sketchbooks' in London and Paris. Röthlisberger, for one, dated both to around 1455, taking the view that Jacopo was already under the influence of the young Mantegna. While Pächt does not go into these questions in detail (it seems he accepts the tradition of Golubew's opinion regarding the sequence of the volumes of drawings – London before Paris), but shows beyond any doubt that Jacopo's crucial shift from International Gothic to Early Renaissance must already have occurred in the 1440s. This insight into the modernity and originality of Jacopo Bellini's work has since been compellingly confirmed by Bernhard Degenhart and Annegrit Schmitt in the relevant volume of their *Corpus der italienischen Zeichnungen* (1990). In this they explain the course of Jacopo's development by reversing the chronology of the two volumes (first Paris ca. 1430–1455, then London ca. 1455–65), and while certain details are still debatable, overall their findings seem entirely plausible. Both authors refer expressly to Otto Pächt – they know and repeatedly cite from his lectures – because, as they point out, he had already demonstrated "Jacopo's ground-breaking significance in fundamental areas of Venetian painting".

Following the discussion of Jacopo Bellini, Pächt then turns to Jacopo's son-in-law Andrea Mantegna (in Padua), and finally to his two sons: Gentile and, most importantly of course, Giovanni Bellini. Pächt's intention was not to tell the story of an artistic 'family saga', for – very much in the Viennese tradition of scholars such as Alois Riegl and Max Dvořák – his interest was in the genesis of the supra-individual *Kunstwollen* (artistic purpose) that was to lead to the emergence in Venice of one of the "great manifestations in European art of the specifically pictorial qualities of painting". Pächt's insistence on the sovereignty of the aesthetic was without doubt in decided opposition to the iconological method that was taking hold in the 1960s – particularly with reference to Humanist art in Italy – and which Pächt was known to view with critical caution. Of course the model of

iconological interpretation, which was tested primarily in the context of Florentine art, was only later specifically applied to Venetian painting during the Italian Renaissance. In any case, all the great recent monographs on Giovanni Bellini – by Giles Robertson (1968), Norbert Huse (1972), Rona Goffen (1989), and Anchise Tempestini (1997) – have appeared since Otto Pächt's lectures. Nowadays, after over thirty years of intense research into Venetian art in the quattrocento, in its cultural and social context, the Bellini lectures maybe seem a little like a 'message in a bottle' from the past. Nevertheless, this message has a particular urgency for the current debate, for it embodies an approach in which the reflective contemplation and scholarly rigour of the 'New Viennese School' are still very much alive and which engages with unfailing sensitivity with the purely visual qualities of paintings.

Pächt's lectures thus provide an important corrective to a trend in research into Italian art which for too long has relied on connoisseurship fixated on attribution. Suffice it to mention in passing that his lectures convincingly cast new light on many detailed issues – such as Longhi's suggestion that Giovanni Bellini was influenced by Piero della Francesca. For Pächt's texts are relevant today above all in view of the current interest in visuality as an artistic category, which – following criticisms of a purely text-oriented iconology, and following the iconic turn that philosophy has taken – now unites image theory, media science and art history. With its concentration on the formal qualities – or more precisely, the aesthetic structure – of the works in question, Pächt's Bellini lectures demonstrate in an exemplary manner, that traditional art-historical practice, namely formal analysis, can achieve a great deal more than an enumeration of the stylistic features of a work, and that it can furthermore throw light on the essence of artistic imagination, on a particular world of imagery. Thus in his discussion of the work of Andrea Mantegna, Pächt took his audience from Mantegna's depiction of garments and folds – a conventional topic for stylistic critique – to a basic principle of form, namely the plasticity that was applied equally to living and dead matter alike, and from there to an understanding of the content of Mantegna's imaginary, utopian pictorial world, which is endowed "with the materiality of classical sculptures that were revered as a higher form of being." The same may be said of Pächt's course on 15th-century Venetian painting as Artur Rosenauer said in the introduction to his Van Eyck lectures: it was a "school of seeing".

The young lecturer on pictorial illusion was fascinated by the boldly experimental Jacopo Bellini. Yet in his later lectures in Vienna, Pächt displays an almost intimate affinity with the gentle art of Giovanni Bellini, who attained a wholly individual classicism in his sensitivity to the coloured hues and tones of the visible world. Pächt's analyses of Giovanni Bellini's Madonnas and landscapes, altarpieces and poetic allegories must be amongst the most pertinent one could hope to find. "Sharp outlines on individual objects blur in the spatial ground", "the insubstantiality of the medium of colour", "the dispersal of matter into atmosphere" – for Pächt these are the formal coordinates of an emotional undercurrent which he describes in terms of the "unheard of deepening of the underlying silence", "absorption", "the silence of unworldly contemplation". There is no doubt: in his maturity Otto Pächt ranked not only Vermeer and Cézanne alongside Jan van Eyck as the great painters of "purpose-less contemplation" – as he described it in his last course of lectures (1971)[6] – but also Giovanni Bellini, this "man of vision who paints the quietude of existential stasis and the deeds of soundless light".

The mastery of Pächt's analyses lies not least in his ability to see beyond local schools, in his synoptic, comparative perspective on the *ars nova* of the 15th century both in North-Western Europe and in the South (long before the relationship between the two was a topic of research in art history). In Pächt's view, Jan van Eyck and Giovanni Bellini effect the same fundamental change in the relationship between the artist and the

painted world: the mobile gaze, encircling the object and in a sense modelling it, is replaced by a steady, "stilled" seeing, which absorbs the optical appearance of things from a fixed distance. Early in his career, Pächt already regarded the "repose of the fixed gaze" – the concept comes from Wilhelm Pinder – as the main constituent of the "field of vision" in modern painting. In the unpublished, second, historical section of his 'Gestaltungsprinzipien' (accepted in Heidelberg in 1933 as part of his 'Habilitation'), Pächt gives examples from Netherlandish painting of the "stilling into immobility of the ambulant gaze", and the emergence of "a purely observant, suspended, mirror-like mode of seeing", which means that things are "now really objects, counterparts in the purest sense".[7]

However, this "pure seeing" was more to Otto Pächt than simply an art-historical principle. On a loose sheet of paper from around 1930, tentatively searching for the correct terms, Pächt noted down: "Art is about wishful thinking. Rose-tinted spectacles for wish-fulfilment – or painting things black for the sake of banishing fears – constitutional lying – stilling the eye – stilling one's desires. Wish-less vision."[8] There is still work to be done on the aesthetic and psychological associations of this and other early art-historical fragments – witness Friedrich Theodor Vischer, Sigmund Freud, even Aby Warburg's "mental space for contemplation" wrested from painful compulsion. At any rate, it is clear that the dialectic of magical identification and distanced contemplation, of illusive desire and disinterestedness were not deemed by Pächt to be bound up in the chronology of art history but were seen by him as anthropological constants, fundamental to human existence. And it soon becomes apparent that the seemingly descriptive notion of the "still eye" is charged, in Pächt's view, with the philosophical ideal of aesthetic contemplation. Another fragment specifically refers to Schopenhauer's "wish- and will-less beholder".[9] Even towards the end of his Van Eyck lectures, Pächt again cites from Schopenhauer's *Die Welt als Wille und Vorstellung* (*The World as Will and Representation*), referring to the "bliss of purpose-less contemplation."[10] And he found this bliss in the paintings of Giovanni Bellini, too.

Contemplation, an open mind, distance, pure seeing: it is hardly a coincidence that these same notions could be used to describe not only the art of great painters but also the scholarly approach of the art historian Otto Pächt. Pächt arrives at such empathetic analyses of the calm, "stilled" gaze of Van Eyck – or Giovanni Bellini – because there is an intrinsic affinity between his approach and theirs, each with that "external concentration" on the work of art, that Pächt memorably advocated in his essay 'Das Ende der Abbildtheorie' (1930/31),[11] building on and advancing Moritz Geiger's 'Phänomenologie des ästhetischen Genusses' (1913).

Pächt's Vienna lectures of 1968 came to a close with an interpretation of Giovanni Bellini's late portrait of a young woman, now in Vienna, with its subtly interrelated optical levels – frame, mirror image and window view – as an "apotheosis of seeing". As a scholar pursuing his researches, Otto Pächt always placed himself second to the work of art that he was seeking to understand. And yet, we would not be going too far if we were to take his description of still, open-minded, spontaneous seeing as a mirror image of his own art-historical work, as is so readily apparent in these lectures – published to celebrate the centenary of his birth – on Venetian painting in the Early Renaissance.

Hans H. Aurenhammer

[1] 'Gestaltungsprinzipien der westlichen Malerei des 15. Jahrhunderts', in: *Kunstwissenschaftliche Forschungen*, 2 (1933), pp. 75–100 (reprinted in: O. Pächt, *Methodisches zur kunsthistorischen Praxis. Ausgewählte Schriften*, ed. by J. Oberhaidacher, A. Rosenauer, G. Schikola, Vienna 1977, pp. 17–58).

[2] 'Die Bildillusion in der Malerei des 15. Jahrhunderts', lecture, Freiburg in Breisgau, 8.7.1931 Otto Pächt-Archiv, Institut für Kunstgeschichte der Universität Wien (two typescript versions with handwritten annotations in the margin by Hans Jantzen). – A short report on the lecture, by A. Kempf, was published in: *Oberrheinische Kunst*, 5 (1932), p. 258. – See also Pächt's' related discussion of the "special Italian response to the problem of illusion", in: 'Die historische Aufgabe Michael Pachers', in: *Kunstwissenschaftliche Forschungen*, 1 (1931), pp. 95–132 (*Methodisches zur kunsthistorischen Praxis*, pp. 59–106, here pp. 67–69).

[3] 'Zur deutschen Bildauffassung der Spätgotik und der Renaissance', in: *Alte und Neue Kunst*, 1 (1952), pp. 70–78 (*Methodisches zur kunsthistorischen Praxis*, pp. 107–120).

[4] 'Jean Fouquet: A Study of His Style', in: *Journal of the Warburg and Courtauld Institutes*, 4 (1940/41), pp. 85–102, here p. 92.

[5] 'Venezianische Architekturlandschaft', in the Pächt-Archiv (several versions, typed and hand-written, as well as a later reworking in English).
[Postscript: 'Die Venezianische Architekturlandschaft', was also the topic of the lecture that Pächt delivered on 17 December 1932 to the members of the Faculty of Philosophy at the University of Heidelberg, as part of his 'Habilitation', see: Universitätsarchiv Heidelberg, Philosophische Fakultät. Fakultätsakten 1932–33, vol. I (H-IV-102/157), no. 383/31–32.]

[6] *Van Eyck and the Founders of Early Netherlandish Painting*, ed. by M. Schmidt-Dengler, London 1999, p. 209.

[7] 'Gestaltungsprinzipien der westlichen Malerei des 15. Jahrhunderts', in the Pächt-Archiv (Typescript of the complete version; Part II: 'Vorbemerkung, Zur Genesis der neuen Kunst, Die wichtigsten Entwicklungsetappen der Malerei im 15. Jahrhundert').
[Postscript: Submitted by Pächt to the Faculty of Philosophy at the University of Heidelberg in July 1932, the text of the 'Gestaltungsprinzipien' was approved by August Grisebach and accepted on 26 November 1932 as Otto Pächt's 'Habilitation' thesis. Pächt then successfully delivered and defended the required lecture on 17 December 1932 (on 'The Architectural Landscape of Venice'); he was thus accepted for 'Habilitation' by the Ministry of Education in Karlsruhe on 30 January 1933. However, racist legislation introduced by the National Socialist regime prevented him from delivering his inaugural public lecture ('Die Struktur der gotischen Plastik Frankreichs'), despite its already having been announced. Thus the 'Habilitation' process was brought to an abrupt halt. See: Universitätsarchiv Heidelberg, Philosophische Fakultät. Fakultätsakten 1932–33, vol. I (H-IV-102/157), no. 383/31–32.]

[8] Pächt-Archiv (hand-written note). Cf. also the following fragment (in translation): "Form in the objects – beautiful objects – goal of wishful thinking (illusion: gradually slipping into the other world) / Other possibility: changing the world itself / 1. Deception, the world is in order (the West) / 2. Conjuring up a whole new world … ? At the same time: kitsch is like a non-critical drawing of the object of one's wishes (rose-tinted) / so there must be some kind of artistic truth which one may not transgress / controlled wishful image / artistic illusion = possible salvation??"

[9] "Schopenhauer's notion of the wish- and will-less beholder and of disinterested pleasure live on in Geiger's 'external concentration' ['Aussenkonzentration']. How can this be reconciled with the notion of art as an embodiment of wishful thinking? Evidently that denotes the attitude which is entirely [illegible word] to l'art pour l'art, but which also denotes that specific quality which negates its reciprocal effect on life, that is to say, releases art from that complex web." Pächt-Archiv (hand-written note).

[10] *Van Eyck and the Founders of Early Netherlandish Painting* (as note 6) p. 209.

[11] 'Das Ende der Abbildtheorie', in: *Kritische Berichte zur kunstgeschichtlichen Literatur*, 3–4 (1930/31), pp. 1–9 (*Methodisches zur kunsthistorischen Praxis*, pp. 121–128)

Preface

"In the eyes of the students, one of the most sought-after privileges was to attend Otto Pächt's lectures. Art History at Vienna University had never had such status and had never had such a magnetic appeal." (Otto Demus)

As one of those who attended and still enthuses about those lectures, it has been a joy to me to prepare for publication the surviving typescript of Otto Pächt's lectures on 'Venetian Painting in the 15th century'. The only additions made to the text are further explanations by the author himself, recorded in the notes taken by students attending his lectures in Vienna.

We have succeeded in illustrating in full all the works by Jacopo, Gentile and Giovanni Bellini as well as Andrea Mantegna, mentioned and discussed in the lectures. These are complemented by many of the additional works referred to in the lectures to draw comparisons or to explain a point more vividly. Bibliographic information on any of these additional works not illustrated here is included in the endnotes.

Wherever Otto Pächt discusses the opinions of other scholars, the relevant source is cited in the notes.

Numerous monographs and individual studies have been published in the thirty-five years since these lectures were held. The bibliography lists selected publications for further study. By definition, it was not possible to take into account in this volume the findings of more recent research. However, the attentive reader will notice that many of the questions debated in art circles today were already central to Otto Pächt's thinking. His message to the art historians of the present is at last available in print, and our deep gratitude goes to Michael Pächt for his tireless dedication, ensuring that his father's ground-breaking research on the nature of Venetian painting is now accessible to a wide readership in book form.

Margareta Vyoral-Tschapka

JACOPO BELLINI AND MANTEGNA

Brevity is a virtue in the titles of books and lectures alike. But brevity brings with it the risk of ambiguity, so that soon a disproportionately long explanation may be needed to clarify what one has in mind and what one's intentions are.

If – as in this case – we announce a discussion of the work of the Bellinis and Mantegna, then it might be that we are about to embark on the story of one of the great artistic dynasties in Venice, whose activities exemplify the evolution of Venetian art – in contrast to the more differentiated process in Florence. One need only call to mind the Vivarinis, the Palmas, the Tintorettos or the Tiepolos. And Mantegna, too, although a native of Padua, could be counted as a part of all this as the son-in-law of Jacopo Bellini, the *pater familias*, particularly in view of the fact that it would be impossible to imagine the art of the Bellinis without his inspired contribution; close stylistic links were matched by equally close personal ties.

Our focus will thus be on a period in the history of certain artists' lives, which – in the context of the corresponding historical time and the historical space – should also cast light on an important chapter in the development of art in general. But, in addition to this, the case of the Bellini family is a very particular one. For you might say that it was within the bosom of this artists' family that the fate of Venetian painting was decided. Or to put it more clearly: 'modern' Venetian painting – that is to say, what our culture today broadly understands by the term Venetian painting – began with the Bellinis. There had been painting in Venice before that, even painting that had emancipated itself from Byzantium, but – as Otto Demus has so aptly put it – that was only "the propylaeum to the Acropolis of real Venetian painting". In just the same way that, not much earlier, a whole new art of painting had been born in the Netherlands – rather than just a new style – in 15th-century Venice a new, special concept of painting emerged which had not existed before and which now reflected a world that was above all experienced in colour. Thus Venice became the stage for one of the four great manifestations of painting in European art; the others being Netherlandish painting, Spanish painting in the 17th century and French painting in the 19th and early 20th century.

The period that is of interest to us here is the time of the emergence and establishment of this great tradition of Venetian painting, which in fact retained its vitality longer than the artistic traditions of all the other great schools that we have just named – after all it was only towards 1800, when Tiepolo the Younger and Bellotto were active, that it finally came to an end, a hundred years after the demise of the Netherlandish tradition which had been born at the same time. It seems that artistic traditions most certainly do not grow out of nothing but only emerge when the ground from which they draw their strength is already well prepared; at the same time it also seems that often their establishment is not so much a gradual, stepwise evolution as a sudden eruption. There is a striking affinity in this respect between the emergence of the 'High Schools' of painting in the Netherlands and in Venice, despite the very considerable differences in their pre-histories. Flanders was comparatively virgin territory when the work of the Van Eyck brothers and the Master of Flémalle as it were made it 'overnight' into one of the most important regions in European art. Venice – albeit more as a cauldron for Byzantine ideas, forms and practices than in its own right – had, by contrast, long played a leading role

mediating and translating the art of Ancient Greece into the world of Latinate Christianity. Moreover, Venetian artists had always found a wealth of opportunity in their native city – in striking contrast to the situation in the Netherlands where the leading lights, before the Van Eycks, had tended to emigrate to French ducal courts in order to develop their talents to the full. But in both cases, at a stroke, there was something entirely new, which ever after would always be present as a recognisably constant factor in all the various guises of the style: in the case of Venice it was that specifically Venetian *Kunstwollen*, or however we choose to describe that collective phenomenon, the very continuity of which is such a remarkable historical fact.

For an illustration of this, let us turn to the succession of versions of the *Presentation of the Virgin*, painted by Venetian artists. If we start with the classic version by Titian in the Accademia in Venice,[1] we find that the line leads right back through Cima da Conegliano[2] and Vittore Carpaccio[3] to Jacopo Bellini, whom we know to have made not less than four versions. We cannot go back any further than Jacopo. But we should not simply blame this on the gaps among our extant pre-Bellini Venetian paintings. At most, the only possible forerunner paving the way for these later works might be a lost composition by Altichiero, a Veronese painter who did work in Padua not far from Venice, but who, as far as we know, never worked in Venice itself. We do not have a *Presentation of the Virgin* by Altichiero, nor do we know if he ever painted one, although certain aspects of the Bellini style are clearly rooted in his work. We do, however, have full-scale, architectural compositions by Altichiero, where the proportions of the architecture and the figures populating it are distinctly plausible, with the result that figures and architecture are fully integrated thus making the architecture serve as surroundings, as an environment.[4] Something similar had already been achieved during the trecento in Siena in paintings with a limited number of figures, by the Lorenzettis for instance,[5] but not in compositions with large crowds. Now in Altichiero's work, the architectural setting provides a stage for scenes with massed crowds, and thus prepares the way for the Bellinis.

Nevertheless, there are still some significant differences between Altichiero's architectural scenarios and those by Jacopo Bellini. Notably, Altichiero's architectural settings are still only reality at one remove, they are a stage set, with a mainly narrative function and secondary to the figure composition. By contrast, in some of Jacopo's versions of the *Presentation of the Virgin*, the figures are merely props in an architectural landscape, and the religious subject matter is almost a pretext for experimenting with the structuring and depiction of open spaces. This may in part be related to the particular character of the two large Sketchbooks that we mainly rely on in our investigations into the art of the elder

1

2, 47, 50, 51

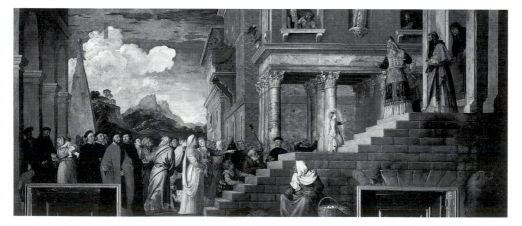

1
Titian,
Presentation of the Virgin
in the Temple.
Venice, Gallerie dell'Accademia

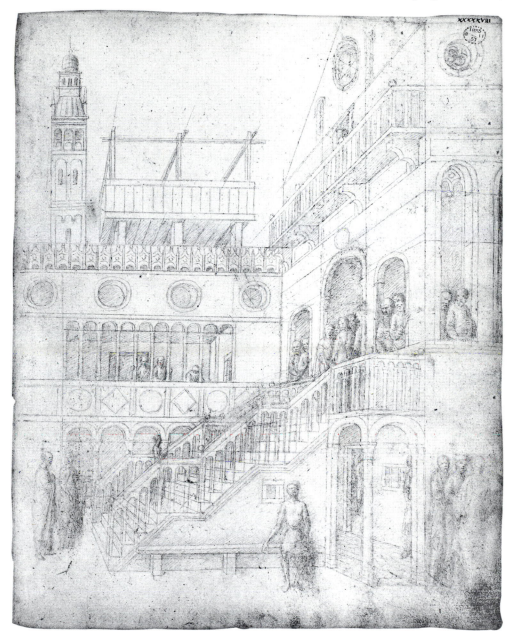

2
Jacopo Bellini,
Presentation of the Virgin
in the Temple.
London Sketchbook, fol. 58

Bellini and which seem, when we first hastily leaf through them, almost like a series of illustrations for a treatise on architecture and perspective. Indeed, it is not a long way from some of these sketches to the architectural vedutas of Guardi and Canaletto,[6] and the fact that another three hundred years were to pass before painted topographical vedutas came into their own – that great speciality of Venetian art – simply goes to show that most of the drawings by Bellini preserved in the two Sketchbooks are really an artist's private documents in the modern sense, in which the artist could express his innermost 'artistic purpose' more freely and uncompromisingly than in works that were destined for the public at large and that had to take account of the wishes and expectations of their clients and viewers, who were naturally very much of their own time.

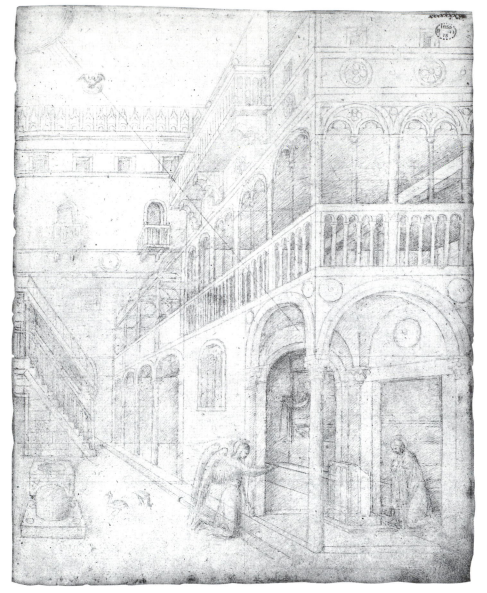

3
Jacopo Bellini,
Annunciation.
London Sketchbook, fol. 76

Just as the linear sub-structure of the perspectival construction is laid down before it takes shape as particular buildings and architectural forms – many of the construction lines in these 'sketches' are still visible – so, too, the architectural view anchored within the framework of the optical pyramid is also fully worked out before the addition of the figures, or rather the figurines, who are to play out this or that scene on the stage prepared for them. One might compare the process with that of a theatrical production that is *3* not having to rely on an ad hoc stage set, built to meet the specific needs and requirements of a particular play, but which is making use of a 'stage' that already exists somewhere in reality. For his *Presentation of the Virgin in the Temple* Jacopo thus had to find a *2* church with an extended flight of steps leading up to it. This one condition had to be fulfilled; as far as everything else was concerned, the scene obeys its own topographical laws of illusion, regardless of whether a detail or architectural motif might be significant in the legend or not, regardless of whether certain features are in keeping with the milieu required by the theme or at odds with it.

No one could fail to observe that the square with the campanile rising above the houses and with the *pozzo* (the well) outside the garden wall was a Venetian *campo* (square), so that the biblical events, by being transposed into a familiar milieu – into the 'hic et nunc' – were brought up to date, in just the same way that the Netherlandish painters of the day would depict the Nativity in Flanders or Brabant or use a bourgeois home in Flanders as the setting for the Annunciation. However, the distinction between the Venetian and the Netherlandish painters is not simply the different choice of setting, each drawing on their own local colouring. The way that the religious theme is treated in Venice is fundamentally different. Right from the outset the topographical interest was so dominant that the topic of the composition can almost get lost in the depiction of the setting and the action in question simply becomes an episode in the life of the populace who inhabit the city or the landscape shown in the veduta. So it is wholly symptomatic that in our example of a sketch for a *Presentation of the Virgin* the beggar sitting on a bench below the church steps immediately attracts our attention, whereas we have to search for Mary, the actual protagonist, whose form is cut across and partly concealed by the balustrade. (In Titian's rendition of the same subject there is an old woman sitting in this position who also attracts attention, not as strikingly as Bellini's beggar, but still very noticeably.) The priest, waiting to greet Mary at the top of the steps also barely stands out from the circle of onlookers, and is in effect no more than an architectural prop.

In Jacopo's finished works, for instance the no longer extant painting made for the Scuola di San Giovanni Evangelista, it is hardly likely that he would have permitted himself to present religious subjects in quite such an anonymous manner. Indeed, in the one surviving altarpiece by Jacopo, or one which can at least be ascribed to him, the *Annunciation* in Sant' Alessandro in Brescia, the scene is not at all presented like those in the Sketchbooks, but is set in a very remarkable interior with large figures that are certainly not props. So we should not assume that the large paintings were as progressive as the Sketchbooks: it is as though the drawings were hurrying on ahead, far in advance of their own time.

4

plate 1

4
Master of Flémalle,
Mérode Altarpiece.
New York, Metropolitan
Museum of Art, The Cloisters

5 Jacopo Bellini, Christ Among the Doctors. Paris Sketchbook, fol. 17 v, 18

6 Jacopo Bellini, Beheading of St John the Baptist. Paris Sketchbook, fol. 16v, 17

7
Jacopo Bellini,
Two Men standing on a Bridge.
London Sketchbook, fol. 13 v

There is documentary evidence that Jacopo also produced pure vedutas without any narrative thread: in 1493 his son Gentile confirmed that he would be prepared to retrace and strengthen the faded lines of a veduta of Venice by his father. It is clear that here the draughtsman Jacopo Bellini was already pre-empting the genre that three hundred years later was to be credited to Guardi and Canaletto and to bring them fame.[7] 7

But in order to properly describe the architectural scenery in Bellini-style composi-tions, we should – even here in these introductory remarks – also touch on some other distinguishing features, which set them apart both from Venetian vedutas in the 18th cen-tury and from the updated milieus of the Old Netherlandish Masters. Only a very small number of the architectural settings in Bellini's Sketchbooks are topographically realistic; most are fantasy views with a strong admixture of elements from Antiquity. However, it 5
is not possible to make a sharp division between the two types, and the explanation for 6
this may well be the fact that in Bellini's drawings the real city – Venice with its lagoons and all its characteristic features – that underpins the topographical depiction was more completely formed by human hand than any other city or place of human habitation one could think of: Venice and the ground it stands on were in a sense made out of nothing, with the result that the 'real' city in these drawings is in itself already the realisation of an ideal architectural landscape.

8
Jacopo Bellini,
Legnaro Madonna.
Venice, Gallerie
dell'Accademia

9
Gentile da Fabriano,
Madonna and Child.
Pisa, Museo Civico

Jacopo Bellini

Before we turn in detail to Jacopo's art, let us at least mention the most important biographical facts of his life. The earliest record that we have of Jacopo Bellini's existence is also the most significant in terms of the historical developments of the time: a certain Jacopo Veneto is mentioned in a Florentine document from 1423 as an assistant or journeyman in the workshop of Gentile da Fabriano, that is to say, working with the renowned itinerant artist who painted a battle at sea for the Doge's Palace in 1408 when he was staying in Venice, and who was also working on a large Epiphany Altarpiece for Florence.[8] The style of Jacopo Bellini's early paintings of the Madonna leaves us in no doubt that Jacopo Veneto and Jacopo Bellini are one and the same: the man who painted these Madonnas had learnt his trade with Gentile da Fabriano. Here, for once, written and visual documents speak the same language. Jacopo must already have been active as a painter in Venice in 1424. He himself refers to various commissions for Padua, Verona and Venice. In 1441 he went to Ferrara to the court of the Este family, and emerged victorious over his rival Pisanello with his portrait of Lionello d'Este. In 1453 his daughter married Andrea Mantegna. in 1465 he executed the largest commission for which we have documentary evidence: a sequence of scenes from the lives of the Virgin Mary and Christ for the Scuola di San Giovanni Evangelista. There is also evidence from the following year that he was working on paintings for the Scuola di San Marco. Jacopo most probably died in 1470, or at the latest in 1471.

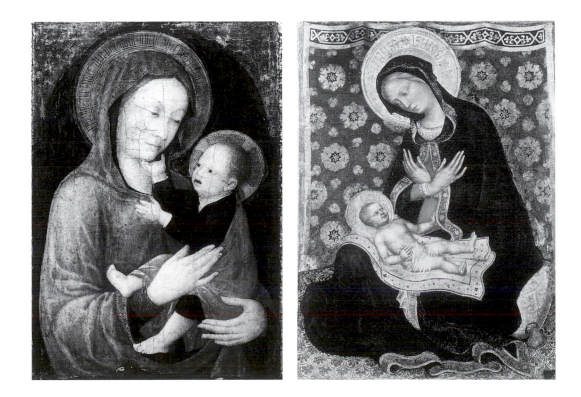

The Panel Paintings

The paintings by Jacopo Bellini that have survived – scarcely more than a dozen works or parts of works – provide no more than a very fragmentary insight into the nature of his art. Indeed, we should point straight away to the sad fact that the works that have come down to us are by no means enough to give us a real picture of his skills as a painter. As Hans Tietze[9] has rightly said, it is somewhat paradoxical that due to the chance survival of two unusually rich Sketchbooks, but not of representative paintings, the founder of one of the most important schools of painting in history will forever be present in our mind's eye as a draughtsman and not as a painter.

At most we can associate Jacopo with paintings of the Madonna. And it is significant in this connection that certain unsigned paintings, now known to be by Jacopo Bellini, were for a long time variously attributed to Gentile da Fabriano or to his Venetian pupil. That is to say: Jacopo follows directly in the footsteps of one of the leading masters of International Gothic, rather than in those of the older Venetian masters. Gentile, an Umbrian by birth, was so resolute an exponent of the cosmopolitanism of this style that he cannot be linked to any local school. At first his works were characterised by elements from Lombardy and Siena, later he drew inspiration from the most up-to-date Tuscan styles, specifically as seen in the work of Masolino. Jacopo Bellini's earliest paintings of the Madonna seem scarcely to be influenced by the new currents in Tuscany, which is somewhat surprising in view of the fact that Jacopo had worked in Gentile's workshop in Florence. Jacopo must have finished his training with Gentile before the master's sojourn in Florence. The works in which the young Venetian first comes into his own – which must have been painted around 1430 – are more old-fashioned than the compositions his

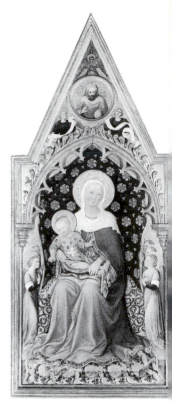

11
Gentile da Fabriano,
Madonna and Child
with Angels
(The Quaratesi Madonna).
London, National Gallery

10
Gentile da Fabriano,
Sacra Conversazione.
Staatliche Museen zu Berlin,
Preussischer Kulturbesitz,
Gemäldegalerie

12
Gentile da Fabriano,
Madonna with Angels making Music.
Perugia, Galleria Nazionale

master was producing at the same time. Jacopo adopted practically nothing from the Florence of the early 1420s. In his early paintings there are no hints of the work of Masaccio, Masolino, Uccello or Donatello, unlike the work of Gentile who created a polyptych in 1425, in which the emphasis on the horizontals and the block-like forms already points towards the Early Renaissance in Florence.[10]

8
10
12
 Jacopo's work adopts a type of Madonna that Gentile only used in his earliest paintings, as in the *Sacra Conversazione* in Berlin and the Madonna with angels making music in Perugia: works that were in all likelihood painted during the first decade of the century. In these paintings the Madonna's mantle, held together by a round clasp at the front, forms a hood, which – with numerous folds around the edge – creates an oval shape coming to a point below, that allows her face and neck to remain exposed. This colourful oval frame around the head and the neck of the Madonna, formed from gently undulating folds, lengthens the already somewhat oval shape of her head, and in effect plays down her bodily presence as it continues in the linear outline of the garments appearing to lie flat on the picture surface. Bellini's versions immediately seem much more Byzantine than those favoured by his master, partly because the maphorion – the veil – is slipped in between the fold of the hood and the Madonna's countenance, as in Byzantine depictions of the Madonna,[11] and partly because, as in Byzantium, although the shape of the garment does seem to derive from the bodily forms underneath it, these are only intermittently in evidence and, as fragmentary components, are secondary to the self-contained overall form of the garment. Here we can detect the Veneto-Byzantine substratum of Belliniesque art.

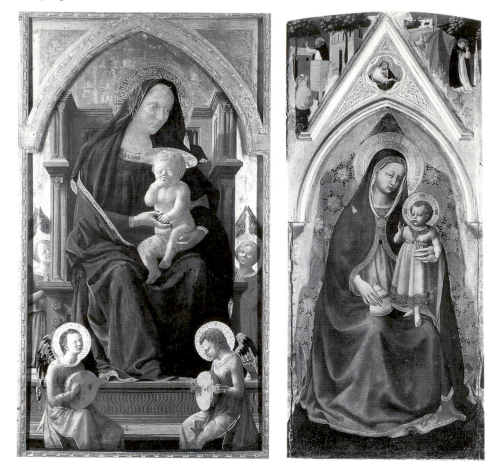

16
Masaccio,
Virgin and Child.
London, National Gallery

17
Fra Angelico,
Madonna,
Triptych of St Peter Martyr.
Florence, Museo San Marco

Italian tradition that led from Duccio and his successors in Siena to the Berlin *Madonna*
by Jacopo's teacher, Gentile da Fabriano. *10*

If one ignores the saints assisting the Madonna in Gentile's composition, this last pic- *plate 2*
ture is in fact identical in its iconography with Jacopo's. The Christ Child in Gentile's
composition is also positioned on Mary's right knee, bending downwards in blessing
towards the kneeling donor. The only major difference is that Bellini's figure of Mary
is not enthroned in the manner of Gentile's, but is a *Madonna dell'Umiltà*, seated on a
cushion that rests on the grass. This motif, depicted in a very similar manner, is also found
in the International Gothic Style, particularly in French painting. And this was no doubt
also the source of another motif in Jacopo's work: the Mother of God conceals the Child's
nakedness with a section of her veil, clasping it with her thumb and index finger in the
same delicate gesture used by the angels in Malouel's *Pietà* (now in the Louvre) to hold
Christ's loin cloth in front of Him.[15]

Seen in this light, Jacopo's *Madonna dell'Umiltà* could be described as a late flowering
of the International Gothic Style, even if it has little of the characteristically fluid lines of
the Soft Style, which have come to an impasse in the solid fullness of a new ideal of the
human form. This is most evident in the realisation of the Child's body, whose three-
dimensional roundness is very distinctly different from the relief-like plasticity of the
Madonna, almost as though He were stepping forwards out of the pictorial space into a
sphere of greater tangibility, that is to say, the sphere in which we ourselves exist. The
most telling symptom of the simultaneity of two categories of space – the pictorial space
and the tangible space 'detaching' itself from the former – is the contrasting treatment of

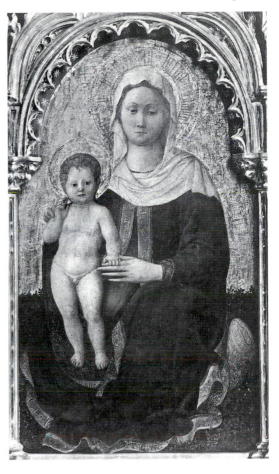

18
Jacopo Bellini,
Madonna of Humility.
Milan, Museo Poldi Pezzoli

the two halos. The Madonna's halo lies flat on the picture plane like an ornament, while the Child's is a material disc which conforms to the perspectival laws of the real world and appears foreshortened as we look at it from below. (Let us compare this for a moment with an image of the Madonna by Masaccio, in which we see a similar discrepancy in the halos, although not a similar difference in the physicality of the Madonna.) In this detail – the foreshortened halo of the Christ Child – we see the arrival of a fundamentally new principle of composition, that is to say, the perspectival order of the pictorial world, a phenomenon for which the most obvious explanation would be the fact that Jacopo has in the meantime become acquainted with the work of the Florentine artist Paolo Uccello, who was living and working in Venice around 1430. Concrete evidence of his work there is hard to come by, the most likely being a group of frescos in Asolo, not far from Venice, which are attributed to Uccello's workshop.[16]

As a composition, Jacopo's Louvre *Madonna* seems a little uneven. The manner in which the Christ Child, His hand raised in blessing, steps forwards out of the picture, loosens the lateral connection to the donor kneeling in prayer. The much greater size of the Madonna, compared to the donor, is hardly in keeping with the notion of humility that would normally by symbolised by her humble 'crouching down on the ground'. And then there is also the discrepancy in the two kinds of spatiality that apply within the group of three figures.

All these inconsistencies seem to have been removed in the *Madonna Humilitatis* now in the Museum Poldi Pezzoli in Milan. The Christ Child turns with resolute frontality to the faithful, whom we imagine standing or kneeling facing the picture. And now the

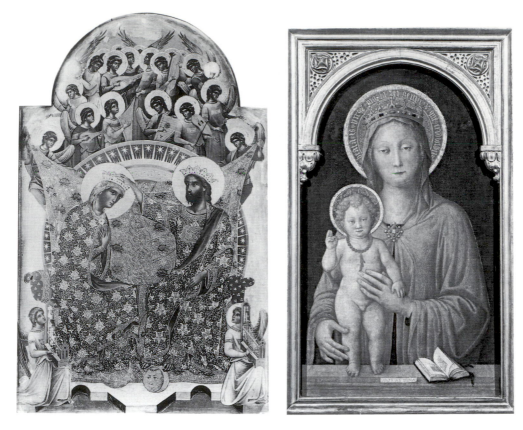

19
Paolo Veneziano
Coronation of the Virgin,
Central panel of a polyptych.
Venice, Gallerie dell'Accademi

2
Jacopo Bellin
Madonna and Chilc
Lovere, Accademi
Belle Arti Tadin
(colour plate 3

countenance of the Madonna, modelled in the same rounded relief, also faces directly forwards. Mother and Child may be in the Elysian fields, but there is no view of a distant landscape and the figures are silhouetted against an abstract gold background, into which both halos merge. The gold of the background becomes an extended halo, which reinforces the iconic aspect of the fully three-dimensional figures. This is the Venetian counterpart to the Madonnas of Fra Angelico. There is also a very remarkable half-length version of the same theme in the museum in Lovere: on the balustrade, on which the *20; plate 3*
Child is standing – again directly facing the viewer – there is also a still-life of a book.

With regard to the greater physicality of the figures, besides the Madonna in the Brera of 1448 that we have already discussed, the Paris Sketchbook contains a sketch for an image of the Madonna which goes very much further and is entitled *Mater Omnium*. The full-length Queen of Heaven, standing facing forwards, is flanked on either side by an angel making music and an amphora: five plastic entities are arranged on a platform with a central, polygonal apron. Had the composition been executed as a painting, the result would have been a depiction of a statue with elements on either side designed to act as a foil to the monumentality of the central figure. Two imaginative leaps in the format create this effect: the amphoras make the angels next to them appear tall and slender, while the small stature of the angels makes the figure of the Madonna seem almost gigantic. In this composition the Christ Child does not take the same dominant role as in the examples we have looked at so far; He is being carried in front of His mother's breast, held in His Mother's symmetrically crossed arms. The motif of the Child is contained entirely within the outline of the Madonna, and overall the standing figure is dominated by its breadth; with its uninterrupted contour and hierarchical rigour it has distant echoes of Byzantine steles, which on occasion similarly depict the Child in the form of a medallion inscribed into the form of the Madonna.[17]

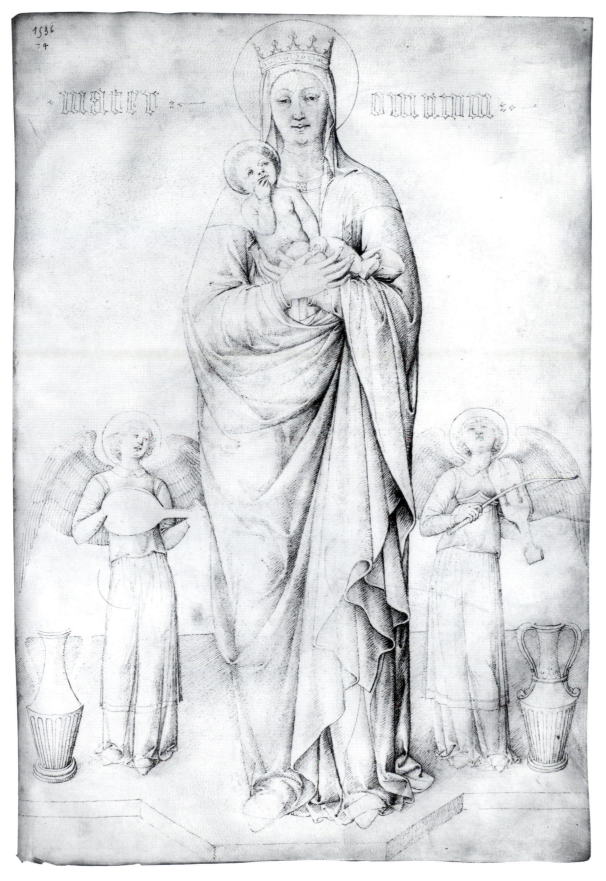

21 Jacopo Bellini, *Mater Omnium.* Paris Sketchbook, fol. 74

We have seen that up until 1440 Jacopo Bellini could not free himself from the spell of the unending melody of International Gothic and its love of harmony; so it will not come as a surprise to find that the coloration in his images of the Madonna is noticeably conservative at first. For a long time he continues to use colour primarily as an embellishment, although the decorative patterns that are still the ultimate goal of the overall effect of his compositions already display some of the painterly qualities for which Venetian painting was later to become famous. In the early works, light and shade are still predominantly used to model forms; there are no hints that the painter had already recognised the significance of the phenomenon of the unified illumination of the pictorial world from one specific source of light. In the Louvre *Madonna* the buildings on the left are lit from the right and vice versa; there is no evidence here of the new principle of a single light source. As a rule, forms tend to emerge out of darkness into the light, with individual figures or forms rising up out of a single, dark overall tone – a pseudo-painterly method that seems to be anticipating chiaroscuro and which is already seen in the earliest stages of International Gothic, in the works of Broederlam or of the Master of Wittingau.[18] It is however also still very effectively deployed by Gentile da Fabriano, for instance in the predella of the Florentine *Adoration*, where Gentile used extreme tension between light and dark in his depiction of the *Birth of Christ* as a night scene. The highlights in the treetops or along the edges of hills and mountains that Bellini uses are already known to us from the work of Gentile. Even the seemingly very modern lightening of the horizon behind the Louvre *Madonna* is only marginally more noticeable than in the case of the horizon in Gentile's *Flight into Egypt*.

One of the special qualities of Bellini's colour technique is his use of gold dust to heighten the modelling of the Madonna's mantle. A dark, almost black olive green gleams with gold on the top edges of the folds. For Jacopo, light can virtually be equated with a golden gleam. It is not hard to understand the significance of this phenomenon.

14; plate 2

22

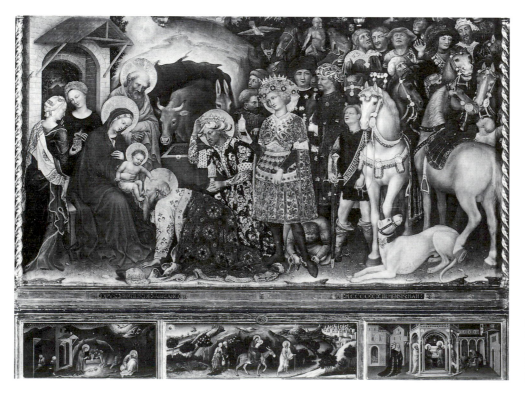

22
Gentile da Fabriano,
Adoration of the Magi
(detail).
Florence, Galleria degli Uffizi

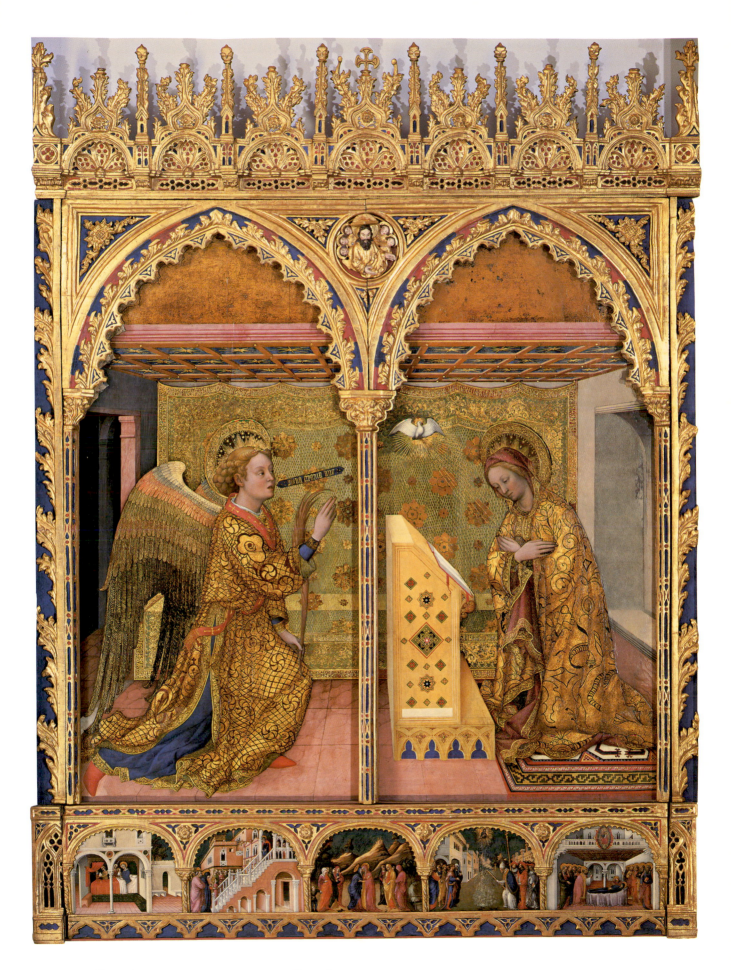

1 Jacopo Bellini, The Annunciation. Brescia, Sant' Alessandro

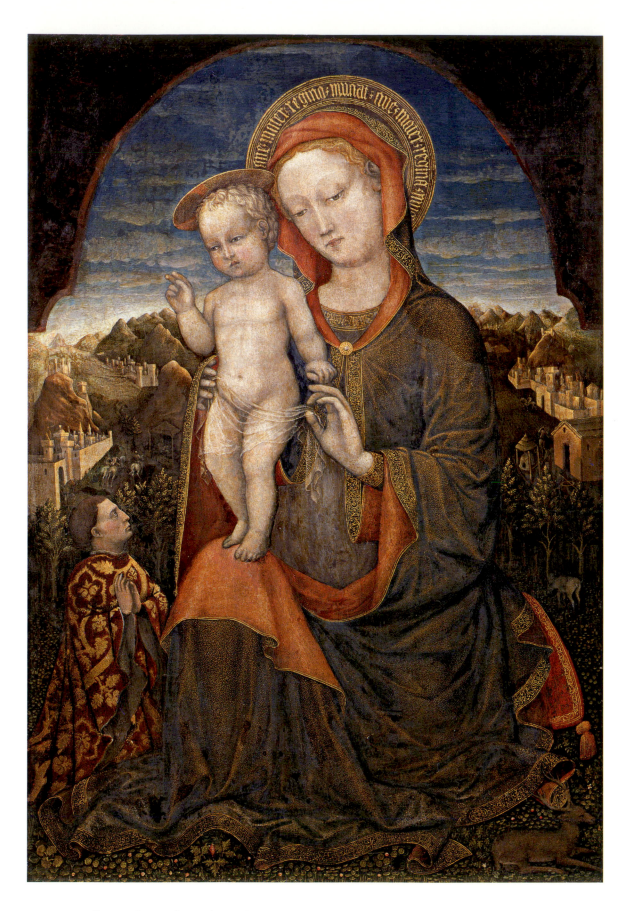

2 Jacopo Bellini, Madonna of Humility with Lionello d'Este. Paris, Museé du Louvre

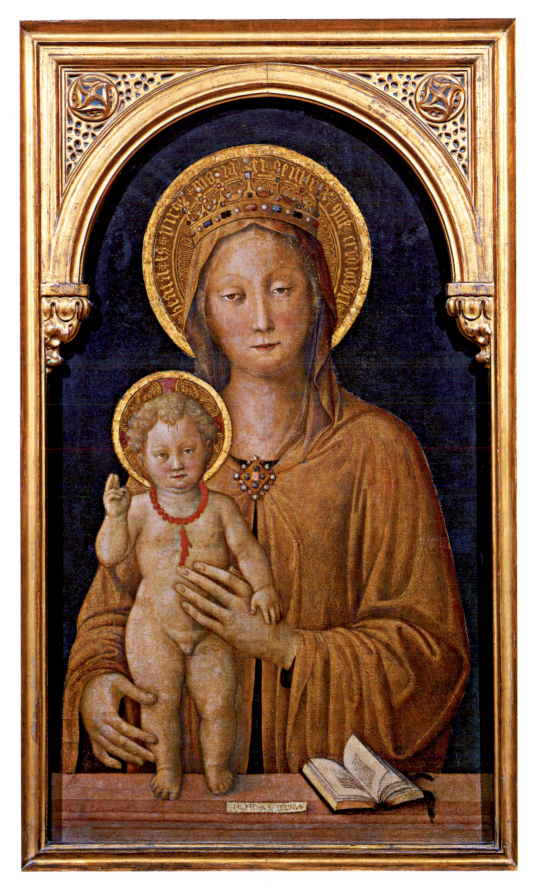

3 Jacopo Bellini, Madonna and Child. Lovere, Accademia Belle Arti Tadini

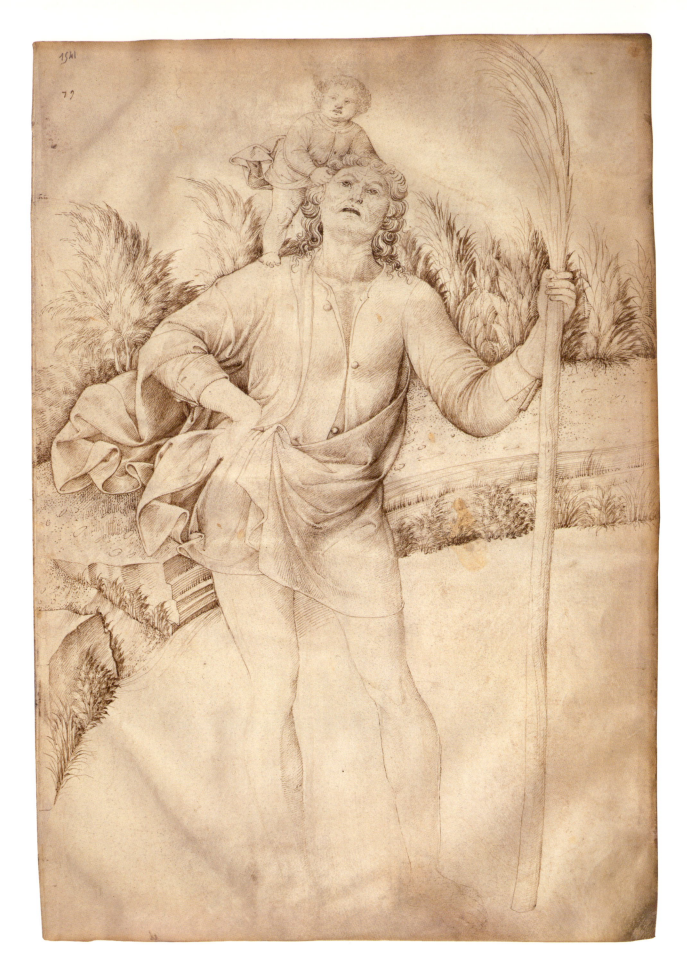

4 Jacopo Bellini, St Christopher. Paris, Museé du Louvre, Paris Sketchbook, fol. 79

19 In older, pre-Bellini Venetian painting, gold – used purely decoratively – played a dominant role, specifically as the ground for ornamental patterns on garments, patterns which – entirely non-spatial and non-representational – turn originally spatial trecento compositions into disembodied schemas.[19] Extended areas of the painted surface can only be recognised as part of a depiction of a figure if the overall context is taken into account. Taken in isolation one might most readily see them as a patterned pictorial surface rather than the depiction of a patterned object within a pictorial space. For the Venetians, the picture plane is primarily a surface for decoration. And in Venetian painting there were two different kinds of pattern: fabrics with large flowers or brocades and, for divine fig-
24 ures, Byzantine gold threads, which are in effect an abstract substitute for illusionistic highlights on three-dimensional figures, and which stand out against the dark background like a spider's web or could in a sense be made to do so. Bellini's sprinklings of gold dust in effect recreate the normal function of light, in 'natural-looking' gold patterns. After Bellini, Venetian painters never failed to have at least a shimmer of gold in their paintings. And after Jacopo Bellini, blatantly decorative gold embellishments gave way to the "secret rule of gold", as Theodor Hetzer called this fundamental feature of Venetian coloration in his study of Titian's use of colour.[20]

Jacopo's "*verde con punti d'oro*" is a very unusual colour for the Madonna, and to our knowledge does not exist anywhere else. His earliest Madonna is rather surprisingly dressed in red, not in the blue – the colour of the sky – which is traditionally associated with the Madonna. This latter anomaly is shared by the Netherlandish paintings of the time which also depict the Madonna clothed in red,[21] a colour whose symbolic significance is still unclear today. It would be worth investigating whether this might not be an indication of a premonition, anticipating the Passion of Jesus Christ. This may possibly be confirmed by the fact that a Mater Dolorosa by Rogier, who otherwise strictly abides by the traditional colours, is also clad in red. In the paintings of Jacopo Bellini we do not once find the blue traditionally associated with the Madonna.

plate 1 In one large altarpiece wing by Jacopo that has survived to this day, the *Annunciation* in Sant' Alessandro in Brescia, he openly declares his allegiance to ornamental decoration. Both the Virgin Mary and Gabriel are enrobed in precious brocade garments, with delicate linear patterns that give the bright gold foil a very loose, wide-meshed grain. The brocade garments in Old Netherlandish paintings[22] are much more painterly with their large patterns or wide stripes with reds, blues and brownish-blacks only occasionally interrupted by the gold ground of the pattern, whose glow is itself often obscured by deep shadows. In this work Bellini is clearly paying homage to the *genius loci* with its with his tendency to be purely decorative at the expense of representing illusion.[23] The painting by Lorenzo Veneziano, showing Christ on a throne, surrounded by Apostles and angels, perfectly demonstrates the ornamental patterning that is such a distinguishing feature of trecento painting in Venice. In a *Madonna and Child* by Paolo Veneziano the motif on the
24 Madonna's gown melts into the drapery behind it as one gold pattern. And in the Accademia in Venice there is a *Coronation of the Virgin* from the immediate circle around Gentile, which was most probably made during the period when Gentile da Fabriano was still absorbing the impact of the Venetian paintings he had seen on his visit to Venice.[24]

The idea of expressing the celebratory nature of the scene in the clothes of the participants may well have originated in Siena. It is in an *Annunciation* by Simone Martini that we first see an angel wearing a brocade robe in blue and gold. Northern artists had already been familiar with this idea in the third quarter of the 14th century. But the phe-
15, 23 nomenon of the interplay of the sheen of the brocade and the light source coming into the picture from outside was only discovered by Jan van Eyck, and Jacopo Bellini's composition is linked to this Netherlandish manifestation of the motif, just as his scenario is

23
Jan van Eyck
Paele Madonna (detail).
Bruges, Groeningemuseum

2.
Paolo Veneziano
Madonna and Child
Venice, Gallerie dell'Accademi

unusually close to the interiors of the northern Annunciations, although without deriv-ing directly from them.[25] (This can be aptly demonstrated by comparing Bellini's work with that of the bourgeois interior of the Mérode Altarpiece by the Master of Flémalle). The pictorial field closes somewhere above the ceiling of the room in which we see Mary – not under it as would have to be the case in a real interior. In effect the rear wall (hung with a tapestry) and the ceiling form a throne canopy, that is to say, not a real hollow space.

In his Sketchbooks, Jacopo does not present the *Annunciation* as an interior, but sets it in an open loggia with the angel kneeling outside it. So there is a connection, a simulta-neity, with an interior view and an exterior view in one, which in itself corresponds to an early stage in Netherlandish painting. But in the Annunciation in Brescia, by way of an exception, we see a different version of the relevant scenario.

In the overwhelming majority of comparable depictions of the Annunciation, the angel is the only figure to be clothed in brocade, with the Virgin Mary clad in her traditionally obligatory blue. Only once, in an Annunciation scene displaying a Netherlandish in-fluence, on the Aix Altarpiece, do we see the Virgin Mary, and not Gabriel, in the more splendid robe (Gabriel is wearing a red robe with a decorative edging). In Bellini's *Annunciation* both are clad in splendid fabrics. And even that is not the full extent of patterned surfaces in the painting. Behind the two figures in their magnificent garments there is another, not less precious Cloth of Honour: a darker pattern is used as a foil for lighter patterns, there is scarcely a contrast between figure and ground in the usual sense.[26]

The predellas of this sole-surviving altar painting by Bellini have been over-painted to such an extent that one can at best only guess at the composition. At the same time, com-parisons with documented versions of scenes from the life of the Virgin, as in the *Presen-tation of the Virgin*, confirm with absolute certainty that the whole altarpiece came from Bellini's workshop.

4

3

plate 1

25
Giovanni Bellini,
after Jacopo Bellini,
Crucifixion.
Venice, Museo Correr

The *Annunciation* in Brescia was certainly not typical of Jacopo Bellini's use of colour. One of the few things that we do know from the extant paintings by Jacopo, is that he generally tended towards matt, quieter – less sumptuous – coloration. With a certain degree of caution, and not without some reservations, one might cite as evidence of this a small, horizontal-format Crucifixion panel, now in the Museo Correr in Venice along with a similarly presented depiction of Christ's Descent into Hell, in Padua. One is immediately struck by the lack of colour of these Venetian panels – particularly if one bears in mind the strong local colours used in the quattrocento in Tuscany.[27] Blues take on a blackish darkness, reds are drained to a whitish paleness. This disdain of bright colours is more readily comprehensible if one takes into account the fact that these compositions are depicting crowd scenes, and strong localised colour accents would isolate individuals from the throng. The individual figures, even those of the protagonists are supposed to remain part of the crowd and are only to be differentiated from it in retrospect and episodically. The artist's main aim is to render the crowd of figures as an almost colourless whole, with just a few individual colour accents here and there, almost as an afterthought.

25
26

26
Giovanni Bellini,
after Jacopo Bellini,
Descent of Christ
into Limbo.
Padua, Museo Civico

The Sketchbooks

Let us remind ourselves yet again: we can only guess at what Jacopo Bellini the painter actually achieved. Unless we are very much mistaken, his palette was still a long way from what we associate with the concept 'Venetian painting'. But, thanks to the two voluminous Sketchbooks that have come down to us – one now in the British Museum and the other in the Louvre – we have today a rather concrete, precise notion of the role he played as an inventor of pictorial ideas, and of the way his pictorial imagination worked before his compositions were transferred into the medium of painting; we also know of his nature studies and what graphic composition using pencil and pen in fact meant to him. An *60, 78, 79* Italian scholar once called the two compendiums of Bellini's draughtsmanship the "bible of Venetian painting", which is perhaps best explained in the words of another Italian art historian who declared that the seeds of all the characteristics of later Venetian painting were already to be found here. That these two Sketchbooks, which we will shortly discuss in greater detail, constitute an immensely precious treasure was evidently already apparent to Jacopo's family and his contemporaries. One Sketchbook – now in Paris – was left by Jacopo's widow to her elder son Gentile, who then left it to his brother Giovanni. The other was taken by Gentile to Constantinople when he was sent as a portraitist to the Sultan's court from the Venetian Republic in 1479. In all likelihood he gave or sold it to the Sultan, and it was only in the 18th century or early 19th century that it found its way back to Europe and finally came to rest in the Louvre. The first record of the former, now in the British Museum, is a report in the 16th century by a great connoisseur who describes having seen and admired it in the Palazzo Vendramin in Venice.[28]

Experts in the field hold widely different opinions concerning the genesis of these two volumes of drawings. The first sheet of the London Sketchbook bears an inscription which probably dates back to the 15th century: "*De mano de ms iacopo bellino veneto 1430, In venetia*" (By the hand of the Venetian Jacopo Bellini, 1430 in Venice). It has long been clear that this is a fabrication, for in this volume there are drawings that allude to an equestrian monument associated with the Este family in Ferrara and hence must be connected with *77* a documented stay by Jacopo at the Court of the Este family in the early 1440s. Nevertheless, the view was generally taken that the two volumes in a sense constitute a whole, that is to say, that they were made within not too long a time-span, with the London Sketchbook, drawn in pencil, being regarded as the more old-fashioned of the two.

However, as later researchers started to examine the individual sheets with a sharper eye for style, these assumptions started to disintegrate. Now the view was that each volume was a retrospective collection of drawings from different periods of the artist's life, and that they even included drawings by Jacopo's sons. (Tietze, for instance, attempted to ascribe to Giovanni Bellini a design for an altarpiece with a Pietà drawn using both pen *27* and brush). More recently there was a move to completely reverse this position. Important technical reasons were cited that seemed to suggest that the drawings were made in already bound volumes, and furthermore that they were drawn almost according to plan in quick succession and in the order that we see them in today, which even has a thematic coherence in places. This in itself made it necessary to date the volumes rather late in Jacopo's career, around 1455 or even later: a rather confusing conclusion because now there was a need for a whole series of auxiliary hypotheses to explain what had hitherto been seen as stylistic differences, that is to say, evidence that sheets came from very different stylistic periods.

We will not be able to avoid taking a view on some of these suggestions during the course of our deliberations here; but for the moment we will have to be content with just

27
Jacopo Bellini,
Pietà.
Paris Sketchbook,
fol. 1 v

touching on a few of the questions that arise from the controversy I have just outlined. The really large question mark concerns not so much the chronological order of the sheets as the actual purpose of the drawings, the Why and the Wherefore of the volumes, which have of course only rather misleadingly been labelled 'Sketchbooks' in modern parlance. In the wills of the Bellini family they are referred to as '*libri de disegni*' or '*librum designorum*'. Scholars are relatively unanimous in agreeing that the majority of the drawings are neither sketches in the modern sense – that is to say, spontaneous records of impressions or ideas – nor designs for specific, planned paintings, such as the frescos of San Giovanni Evangelista for instance. But Bellini's two compendiums are also far removed from medieval pattern books. They are not collections of formulas that a painter and his workshop assistants could use as required. The particular, innovative quality of these drawings lies precisely in that their genesis was not determined by some practical purpose, but that they document an artist's struggle to find solutions to specific artistic problems, without having an immediate practical application. It was the Viennese art historian Lili Frölich-Bum, who first recognised this fifty years ago, identifying the true character of the drawings and establishing their art-historical significance as evidence of

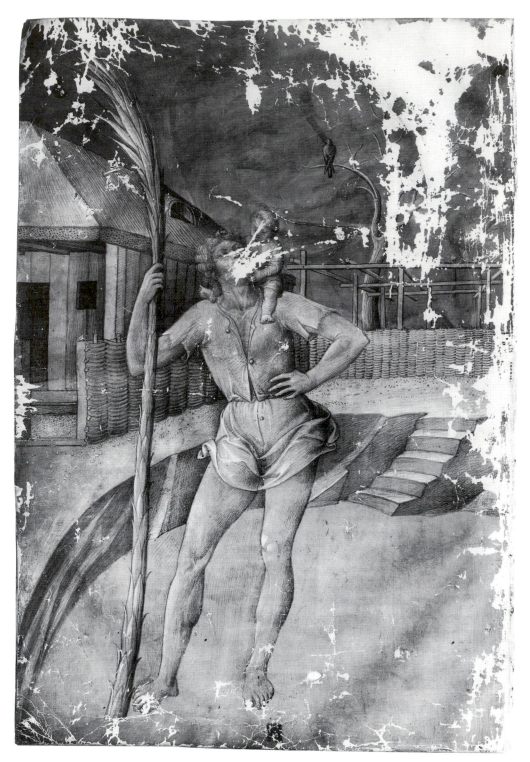

34 Jacopo Bellini, St Christopher. Paris Sketchbook, fol. 56 v

35 Jacopo Bellini, Young Man in Left Profile. Paris Sketchbook, fol. 23

36 Jacopo Bellini, Christ Crucified. Paris Sketchbook, fol. 41

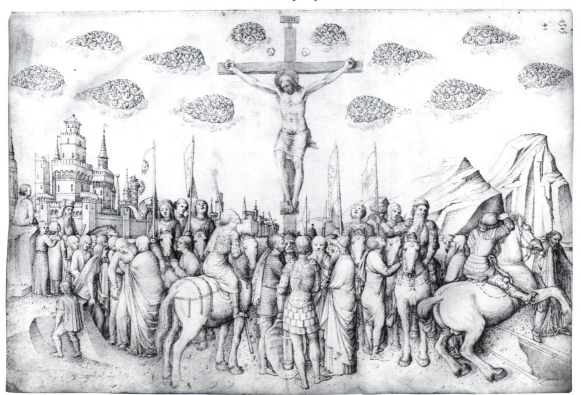

37 Jacopo Bellini, Antique Male Nude. Paris Sketchbook, fol. 85

a wealth of permutations there may be in the combinations of various techniques and chance states of preservation. So let us briefly highlight the complexity of this situation by looking at seven distinct examples.

38 *St Jerome in the Wilderness:* a pure silver-point drawing on blue-tinted parchment. Since the subtle modelling neither needs nor could take clarification or additions, this example stands as a self-contained, fully-fledged silver-point drawing.

39 *The Adoration of the Magi:* a contrasting example of a drawing executed entirely in pen with shapes modelled by means of a great multiplicity of lines and dots and a minimum of linear contours or schematic shading. Single forms, like eyes or heads etc., are often only indicated in a sketchlike manner, and not only in the case of objects in the far distance. There is scarcely any evidence of redrawing.

40 *Golgotha:* executed entirely in brush, almost as though in an extreme reaction to the preceding pen drawing. The features of the figures in the foreground are only hinted at by small spots. This led the Tietzes, in their history of Venetian drawing, to suggest that this composition was not by Jacopo but by his elder son, Gentile. There is one thing, however, of which we can be sure: this drawing does indeed pave the way for the style Gentile Bellini was to use in his authenticated drawings. But the attribution to Gentile mainly on the basis of the similarity of the techniques used here to those in works known to be by Gentile is most probably not correct.

41 *St Michael:* at first sight this looks like an unfinished pen drawing. But in fact it must have been based on a silver-point or pencil drawing which is no longer visible, or at least not with the naked eye. The quality of the reworking is patchy. While the dragon is drawn in pen with great flexibility, the figure of Michael, his armour and the wings are very schematic in their execution. It could in part have been realised by an assistant in the workshop.

42 *Christ with Four Saints:* this was in all probability originally executed in brush and silver point. In the case of the two figures on the right, a start has been made reinforcing the contours and the figures in pen; the style of drawing is the same as in authenticated drawings by Jacopo, although in many ways we have the impression that it has been retouched in a detached, entirely superficial manner.

37 *Man with a Loin Cloth:* a similar situation applies here. The original silver-point drawing is now only still visible on the head. Probably at the time when the landscape was reworked in pen, much more of the silver-point drawing of the male nude was still to be seen, and it is only since then that it has almost entirely disappeared.

27 *Altarpiece with the Lamentation:* the frame of the altarpiece is executed in pen, the picture itself is a brush drawing. Here we see the intentional combining of two techniques, each with its own clearly defined territory. The architectural motifs in the frame – pure Renaissance with no traces of the Gothic style – and the pictorial composition together suggest a relatively late date for this drawing, which prompted Tietze to take this sketch as the work of Jacopo's younger son, Giovanni.[36]

Whatever the case may be – even these few, yet typical, examples will have shown that only a strictly philological critique of the individual case can decide to what extent and in what sense the drawings from these two volumes can be regarded as documentary evidence of Jacopo's style, and moreover that we are no longer always in a position to have any very definite idea of the original version by Bellini. Often we can only be definite in our comments on the composition, the *invenzione*, not about its execution – as may be

43 seen from two comparable studies of lions. In the London drawing the mane and other

38 Jacopo Bellini, St Jerome in the Wilderness. Paris Sketchbook, fol. 19 v

39 Jacopo Bellini, Adoration of the Magi. Paris Sketchbook, fol. 32

40 Jacopo Bellini, Golgotha. Paris Sketchbook, fol. 63

41 Jacopo Bellini, St Michael Archangel and the Dragon. Paris Sketchbook, fol. 69

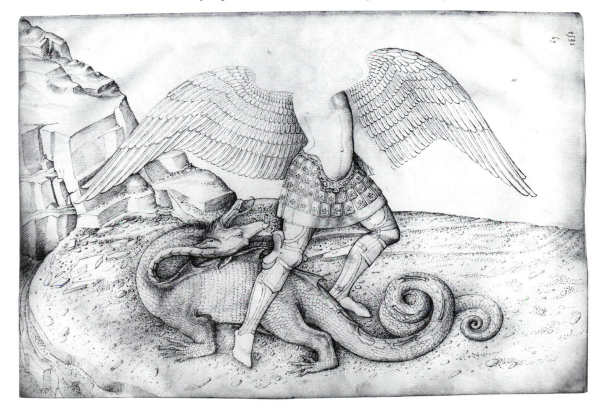

42
Jacopo Bellini,
Study for Altarpiece.
Paris Sketchbook, fol. 73

parts of the animals have been redrawn in pen, probably by Jacopo himself, if we are to
judge by other authenticated pen drawings. In the case of the Paris drawing, we are deal- *44*
ing with a pen drawing that was reworked at a later date. Even a fleeting glance is enough
to see that this is a very schematic, inferior reworking by another hand, as is particularly
obvious in the decorative design of the manes. The comparison of this pair of drawings
also shows that it is by no means true to say that the two volumes employ very different
techniques.

If one wants to grasp the essence of an *invenzione*, then one must naturally know
what the invention in fact consists of. And in the case of our drawings, that is not nearly
so obvious as might at first appear. Many of the compositions in the London Sketchbook
– and in the Paris Sketchbook, too – extend across two pages, covering the verso of one
sheet and the recto of the next; sometimes, however, two drawings facing each other have
nothing at all to do with one another, neither in terms of their content nor their compo-
sition. But there are also cases where it is not so easy to decide what belonged to the orig-
inal composition, as in the case of the *Resurrection* in the London Sketchbook. It often *45, 46*
seems that the right-hand sheet or 'half' could exist in its own right, with the left-hand
side being no more than an addition, an addendum, as in the depiction of *Christ Among
the Doctors* (BM 69 v, 70 r). This observation led one scholar, not very long ago, to come to
the – as I believe – rather too hasty conclusion that as a rule Bellini first drew his com-
position on the recto sheet and later added the left half in retrospective as an extension,
which at the same time entailed transposing the composition from a vertical format into
a horizontal format, in keeping with the general trend of his development. But as we will
soon see in individual examples, this astounding theory – founded on a wholly mecha-
nistic notion of the creative process – hardly holds water. The only truth in it is that often
the main content of a figure composition is on the right-hand sheet, while the left-hand
sheet serves to anchor the composition in space.

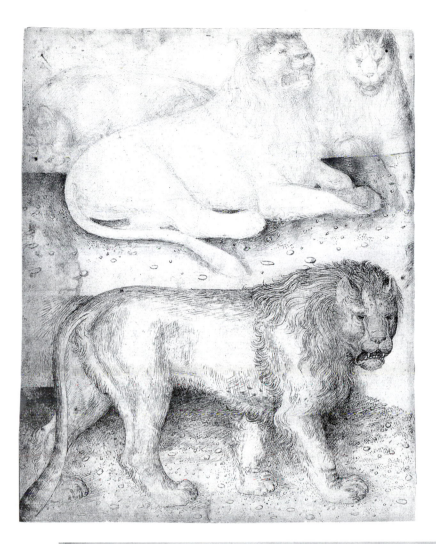

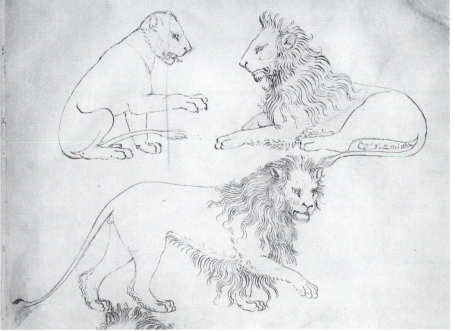

43
Jacopo Bellini,
Study of Lions.
London Sketchbook, fol. 2 v

44
Jacopo Bellini,
Study of Lions (detail).
Paris Sketchbook, fol. 77 v

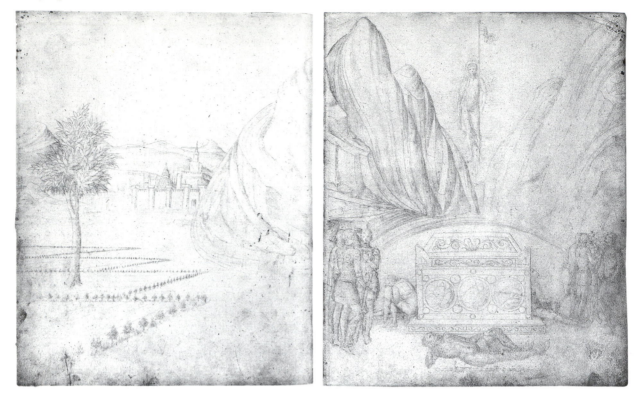

The Presentation of the Virgin in the Temple. We will start our foray into the world of Jacopo Bellini with a depiction of the Presentation of the Virgin in the Temple, the theme, which – as we have already seen – was to become a favourite for Venetian painters. In this case we are looking at a pencil drawing from the London Sketchbook, which appears very pale and rather worn and was already retouched in pencil at a very early stage. It is an undramatic and centralised composition with a view of the interior of the temple, in the style we know from the paintings of trecento Siena[37] – in contrast to the Florentine iconography which focused specifically on Mary's walk to the temple and her ascent of the steps leading up to it. In Bellini's sketch we view the scene through an arch, reminiscent of the way the Netherlandish masters – in their transitional phase of depicting true interiors – would set the nave within an architectural frame as though seen from the outside. Merely a cursory glance at other architectural settings by Jacopo Bellini tells us that even later on, when he had mastered perspective in a very different manner, he had not abandoned the concept of depicting an interior viewed through gaps from the exterior. While in the North, for instance in the Turin miniature of the Requiem Mass,[38] the architecture is confined to the edge of the picture plane in the shape of a fluted pillar – like a narrow frame – Bellini on the other hand favours wide, solid arches that extend across the whole area or confront us (parallel to the picture plane) as solid surfaces in their own right.

This convergence of the main aspect of the building and the picture plane means that there is no apparent difference in the projection between existential form and visual form, with the result that any inherent order – possibly geometrical – that is intrinsic to the object can transfer directly into the organisation of the picture plane. For the artist working in this way, the aesthetic qualities of the composition are determined by the objective qualities of the pictorial motif. Or, to put it bluntly, the picture appears harmonious and well proportioned because its original model, visible reality or maybe even the Antique –

45
Jacopo Bellini,
Landscape with City View.
London Sketchbook, fol. 21 v

46
Jacopo Bellini,
Resurrection.
London Sketchbook, fol. 22

31

32

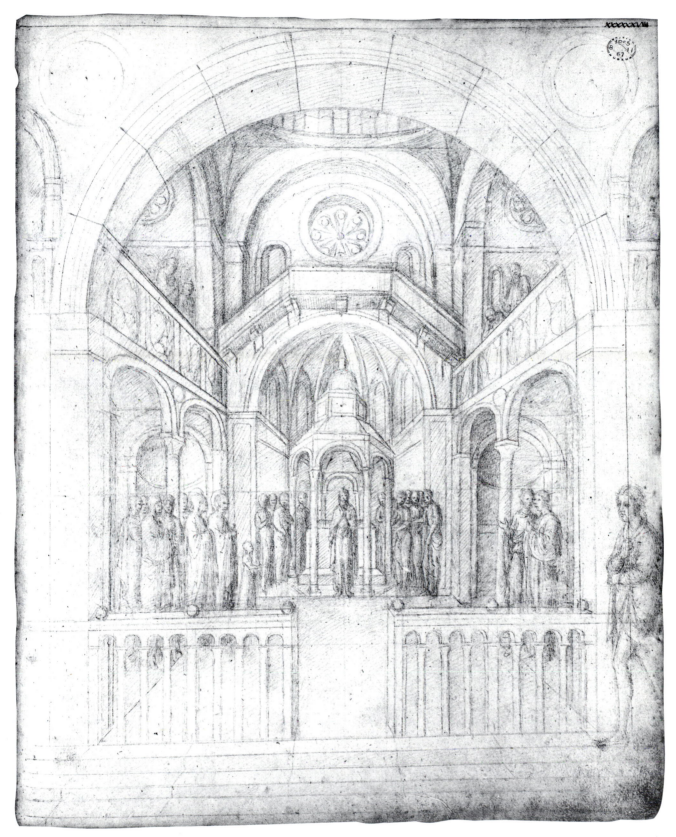

47 Jacopo Bellini, *Presentation of the Virgin in the Temple. London Sketchbook, fol.* 68

48
Jacopo Bellini,
Flagellation.
London Sketchbook,
fol. 81

refined, improved reality – has these qualities. This in itself explains why, for the Italians, the search for objective beauty – which is hidden within nature – was to take on such importance. But as the artist opens up the pictorial wall, the space behind it, that is its projection, appears on the picture plane. This is the danger zone, where the conflict between the illusion of spatial depth and the relationship of one plane to another has to be played out. In the case we are examining here, this raises a specific question: How can the changes, shifts and distortions induced by the foreshortening of forms still serve the compositional order or at least render the disturbing elements harmless? Jacopo Bellini initially avails himself of a very simple method. He creates an isocephalic figure composition and has the top edges of the figures' foreheads coincide with the horizon line of the picture, that is to say the line that is determined by the eye-level of the subject viewing the scene. *48, 49*
And this is completely in keeping with a passage in the treatise on painting by Alberti, the Florentine architect and theorist: "In temples ... we see people's heads almost all on the same level, the feet of those further away correspond more or less to the knees of those standing closer." But this concurrence does not in itself prove that Bellini knew of the treatise written by Alberti in 1435. In Jacopo's *Presentation of the Virgin* only one figure does not touch the horizon line, namely that of the child Mary, who is seen in the distance as smaller than the others, that is to say, objectively smaller and not just appearing to be so.

49 Jacopo Bellini, Christ before Pilate. Paris Sketchbook, fol. 39

With this horizon line, which Alberti generally called the central line, Jacopo also gains a main axis for his composition. It runs parallel to other horizontal lines that cut across the lower half of the picture, creating a solid foundation for the composition as a whole.

The upper half of the composition contains diagonal lines of perspective leading downwards, all apparently converging on the head of the high priest. And here we can see how Jacopo makes every effort to balance these diagonals with planes that consequently neutralise the sense of spatial depth. This is the function, for instance, of the diagonals of the open gallery of the choirwall, which is in effect parallel to the picture plane and which, together with other upwards-striving motifs, creates the impression of sharing the same plane as the arch of the facade in the foreground. And here we also see that typical feature of Bellini's depiction of spatial depth, which at first seems to be self-contradictory, a *contradictio in adjecto*. Lest there be any doubt that this was indeed Jacopo's intention, and moreover, if there be those who might want to suggest that we are merely projecting these linear structures into his composition – being such a fashionable thing to do nowadays – I should like to point to another drawing by Jacopo, depicting a sermon being delivered by St Bernard (BM 8v). Here we see a steep flight of steps against the rear wall, which is exactly continued by a diagonal line of perspective. If one ignores the representational function and the context of the whole, one could well imagine that these two diagonals – the real and the optical – were lying on the same plane. We read them as one. Thus the particular quality of Jacopo Bellini's depiction of space is that while he exaggerates the perspective, so that all the walls and architectural forms leading away from the picture plane are subject to maximum foreshortening, even to the extent of distortion, at the same time he also is clearly at pains to have the lines indicating spatial depths as it were return to the picture plane, which is certainly not conducive to creating the illusion of distance and space. The lines of perspective leading diagonally downwards on the right-hand side of the scene depicting the sermon are continued in the stairs parallel to the picture plane, as in the *Miracle of the Cross on San Lorenzo Bridge* by Gentile *plate 12*
Bellini where the line of the bank of the canal leads seamlessly into the curve of the bridge lying parallel to the picture plane. Were these pioneers of perspective – for whom the picture surface should only have been an optical plane – still clinging to the actual material surface?

The problem we have touched on here did not concern Jacopo alone. Indeed, as soon as the picture surface in effect ceased to be a material surface and turned into an optical plane, this problem took on an immediate urgency for artists both north and south of the Alps. In art history, the quattrocento is customarily regarded as the time when artists were struggling to conquer the third dimension. But this is to completely miss the nub of the problem, as though it were only a matter of the technical problem of projecting a third dimension onto a two-dimensional picture plane. In truth, the artists in the North and the South alike were grappling with an aesthetic problem, not a technical one – even if they were not entirely aware of this. And this aesthetic problem was about how to reconcile the new illusion of spatial depth – now seen as the yardstick of the veracity of the depiction – with the inner coherence of the picture plane, for the artistic value of the composition was ultimately dependent on the successful realisation of this inner coherence. Each of the artistic centres in Europe had its own approach to the problem, and each found its own solution; but in the early stages of this conflict between the desire to create the illusion of space yet nevertheless to do justice to the planar nature of the picture, the latter still had the upper hand throughout Europe, and at this stage the devices for creating spatial depth were forcibly transformed into, and deployed as, factors in the planar structure of the composition. In Jacopo's case this is seen in his tendency to flatten the depths by skilfully manoeuvring the ambiguity of the shapes. Pairs of diagonals harmonise like lines

rhyming in a verse of poetry, regardless of whether one is about 'being diagonal' and the other about 'looking diagonal'.

An instructive example of this is a second *Presentation of the Virgin* by Jacopo, whose idiosyncrasies are now readily understandable. This depiction conforms to the other iconographic type, which focuses on the Virgin's walk to the temple as opposed to her acceptance within the temple, a type for which the Florentine trecento had already found magnificent solutions – Giotto and Taddeo Gaddi immediately come to mind.[39] In Jacopo's composition, the steps leading up to the loggia-like entrance to the temple are not open as such, but have a balustrade on either side. The diagonals leading upwards, with several interruptions, lie parallel to the picture plane, yet they terminate at the entrance in the diagonal temple facade, that is to say, they merge almost seamlessly into the lines of perspective of the front of the building. A cursory glance at the balustrade of the balcony on the first floor might lead one to suppose that it occupies the same plane as the balustrade of the steps. And in order to allow the assonance of the diagonal view and the diagonal form to come fully into its own, up above the entrance to the temple there is a long balcony, with a sequence of uprights supporting the balustrade that invites comparison, by virtue of its matching form, with the series of supports in the balustrades on the flight of steps. The artist has created objects whose forms lend themselves to mediating between spatial depth and flat planes. There is much more in this vein that might be said of the artistic philosophy behind this flight of steps. It has both a narrative function and a specifically aesthetic function. From an aesthetic point of view, it acts like a kind of lightning conductor, deflecting the drive into the depths of the plunging orthogonals, which ultimately come to permanent rest in the elemental geometry of the structure of the picture plane.

In the Paris Sketchbook there are two more versions of the *Presentation of the Virgin*, which can be seen as a synthesis of the two works just discussed, which are also certainly much earlier works. In these later versions Jacopo returns to the centralised composition, but combines the view into the interior with the sight of the small figure of Mary walking up the steps. He was able to do this because for him the interior was to remain a 'pierced' exterior view for as long as he lived. However, in order to depict the walk to the temple he now had to relocate the facade of the temple in the background. He justifies the cut through the building by, as it were, placing a classical gable above a Gothic choir screen, with the arch of the gable resting on pillars. But what we see is a kind of atrium, fronted by a series of arcades with an opening in the centre. A semi-circular flight of steps leads up to the opening, with a trapezium-shaped projection extending to the front edge of the picture and, at the same time, continuing within the choir as a flight of polygonal steps leading perspectively towards the vanishing point. Therefore in this case the path to the high priest is a perspectival avenue, only Mary has not yet quite reached it. Mary, whose figure coincides with and covers up one of the supports in the balustrade, is still only approaching from the side. In the background the orthogonals are somehow drawn upwards by a ciborium with a steeple-like top. On the vertical axis there is a symmetrical correspondence between the central arch of the facade and the semi-circle of the flight of steps widening out below, which are in fact projecting forwards. We have repeatedly seen this assonance in Jacopo's work, this correspondence between the way that certain things 'are' and other things 'appear to be'. It occurs in most of his later drawings: a rising form, lying parallel to the picture plane and another widening form projecting downwards balance each other almost symmetrically. The arcades fronting the atrium provide the opportunity for creating two powerful horizontal accents. The lower of the two horizontals forms the main axis to which all the figures are orientated, both those in front of the balustrade ('below' it) and those behind it ('above' it). Since the principle of isocephaly is

50

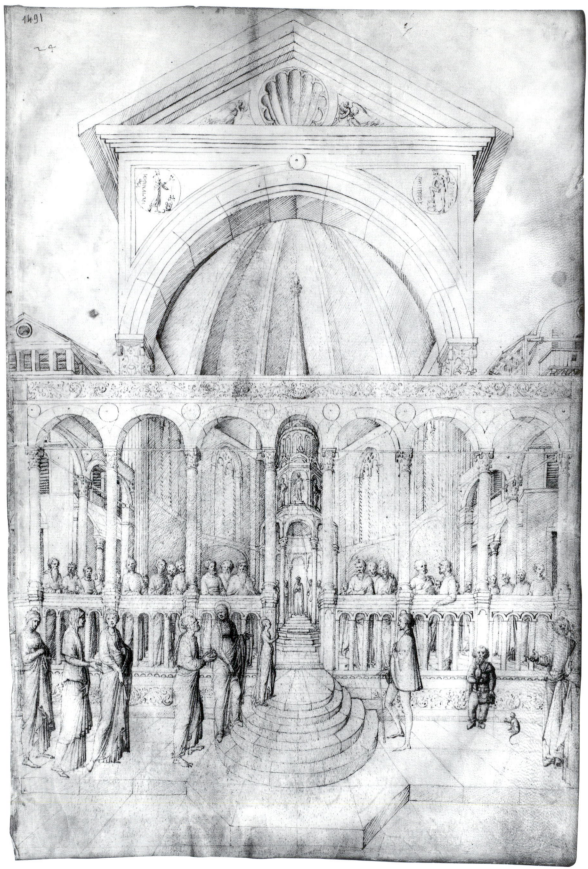

50 Jacopo Bellini, *Presentation of the Virgin in the Temple*. Paris Sketchbook, fol. 24

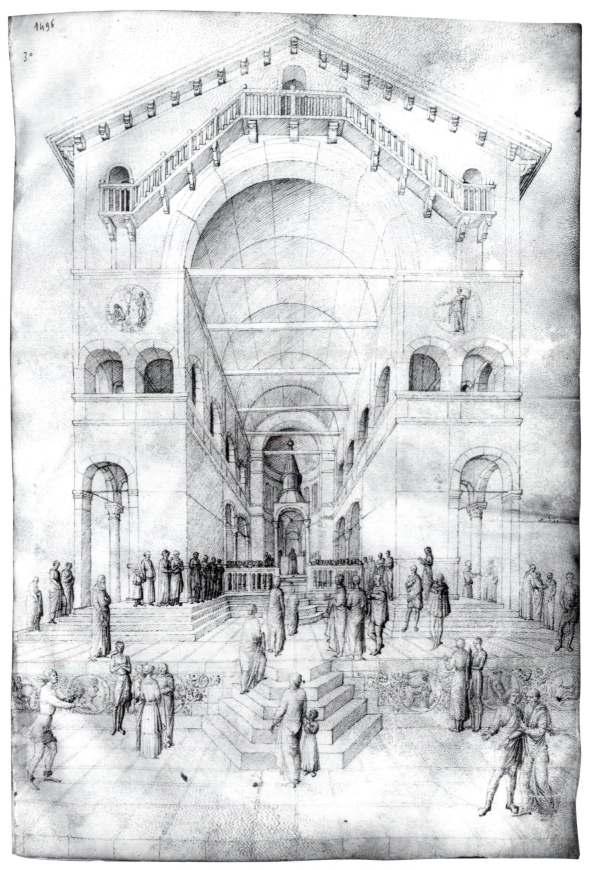

51 Jacopo Bellini, Presentation of the Virgin in the Temple. Paris Sketchbook, fol. 30

being applied here, the head of the small figure of the girl, just reaching the topmost step, is at the same height as those of the adults standing on the lower level. Only the figure of Anna, who has already started to ascend the steps, cuts somewhat across the line of the other figures, while the dwarf of course remains below it. The figures seen above the main horizontal axis look like busts placed along the balustrade.

The peculiarity of this scenario cannot simply be explained away with a reference to the concept of the 'mixed style', combining Gothic and Renaissance forms. It is truly a fantasy architecture, whose forms are dictated down to the last detail by the demands of the pictorial geometry, that is to say, they are its progeny. The guiding principle behind this architectural composition is the creation of a suitable setting for this particular moment, which the figures then populate as though they were temporarily playing walk-on parts. At the same time there is no question of a dramatic narrative account of the event itself.

A final development of all that we have seen so far of Jacopo's ideas regarding his depiction of the *Presentation of the Virgin* is found in a second drawing in the Paris Sketchbook. It constitutes a triumph of perspective, for the sake of which the scenario as a whole has undergone a huge process of amalgamation. The perspectival avenue that formerly marked out Mary's path to the altar, has now become part of a spatial 'tunnel' where all the lines lead to the same vanishing point. The facade of the building has receded yet further into the picture and the balustrade has been pushed back even deeper; it now forms the choir rail in front of the altar space. But it is still a horizontal line. To either side the arches of the galleries above keep step with Mary's progress towards the altar; a barrel vault ceiling, seen from a very steep angle, descends evenly towards the same goal. On the vertical axis we find the same symmetrical correspondence we have seen before between optical and actual forms, here in the rhythm of the bridge-shaped walkway above the arch and the apron of the front set of steps extending forwards – and in many other motifs mediating between the two. The path that the Virgin still has to follow – indeed the scene as a whole – has widened out significantly as a result of the changes we have already described. A greater number of figures is now needed to bring life to the scene and above all, to mark out the various stages of the Virgin's progress. A female figure, seen from behind and holding a child by the hand, stands at the foot of the nearest step; Mary is approaching the second set of steps leading up to the choir screen. In other drawings there were in principle no more than two groups of people, the procession approaching the entrance to the temple and those waiting to receive Mary in the temple, mostly passive onlookers. Now Mary's progress becomes just one detail in the life of the piazza outside the temple. The whole scene is set at a considerable distance, although distance and a view from below cannot properly be shown simultaneously within the same perspectival scheme. Even in its most highly developed form, Jacopo's perspective is never an end in itself, it is not permitted to adhere to its own logic willy-nilly, but has to play its part in revealing the imagined internal structure of the picture plane. And it is this skilful balance between two heterogeneous factors, this masterly game with the *quid pro quo* of semblance and appearance, that make this composition so powerful and so alluring.

So far we have rather one-sidedly devoted our attention to that sector of Bellini's art in which purely architectural settings provide the backdrop to the action. But Jacopo's pictorial imagination is just as intensely at work – with just the same love of experiment and zest for discovery – when he is devising open-air scenarios. And the new territories that he explored in the process were ultimately to become the most characteristic domain of Venetian painting.

51

The Baptism of Christ. We will start with a theme whose iconography has always been inextricably bound up with landscape imagery, namely the Baptism of Christ. In the depiction in the London Sketchbook the River Jordan winds upwards through the picture in a huge curve, flanked by rocky cliffs that reach to just below the upper edge of the drawing – not just rising upwards, but twisting heavenwards in keeping with the age-old convention of the corkscrew mountains that found their way from Byzantium via Italian trecento painting into the Western world.[40] It must be said that in trecento painting there are in fact no comparable depictions of the Baptism of Christ where the landscape occupies so much space, nor where the composition grows so organically out of the motif of the course of the River Jordan. In this respect Jacopo's work has an affinity with the northern late-14th-century landscape tapestries, particularly in the dynamic formation of the terrain. Symptomatic of his own style, however, is the way that he in effect turns the 'proper motion' of the landscape into a representational motif. A wide path winds steeply upwards towards the mountain peak on the left, following the course of the River Jordan. But the crucial advance on the International Gothic Style is embodied elsewhere. The mountains are no longer simply a backdrop rising up above the line of the river, but are sheer cliff-faces between which the Jordan cuts a path into the distance. For the first time in the history of the depiction of the Baptism of Christ on southern soil, the landscape scenario has a topographical individuality of its own. The scene is set in the valley of the River Jordan. Thus Jacopo Bellini's version can be seen as the Italian counterpart to the incomparably more modern-looking Baptism of Christ in the early Van Eyck style, where the river valley similarly takes centre stage.[41]

Jacopo's Jordan landscape is viewed with the wandering viewpoint of a pre-perspectival age and is strikingly dynamic. Contrasting strangely with this setting, there is a wholly static group of figures as it were projected into it. In a neatly symmetrical arrangement, John the Baptist kneels on one bank of the river with two angels holding Christ's robe on the other. Behind John the Baptist and behind the two kneeling angels, in each case there is a pair of standing angels, making music. They are positioned somewhat above where we could imagine the water level of the Jordan to be, their feet level with Christ's hips. It almost looks as though the artist had found himself obliged to place the figure of Christ somewhat lower down the picture in order to allow the kneeling figure of John the Baptist to pour water onto Christ's head. The accompanying angelic musicians have a double function: firstly they lead our gaze step by step to the head of Christ, secondly they help to set the mood of the scene. The stillness of the baptismal ceremony is underpinned with music. It had already been a favourite practice in International Gothic to include angelic musicians in order to glorify the figure of Mary, Queen of Heaven, in paradise gardens or at her Coronation and at other ceremonial occasions. This practice is seen at its most splendid in the Ghent Altarpiece.[42] In these depictions of elevated or supra-terrestrial life without a narrative as such, the musical accompaniment imbues the scene with poetry. But adding a musical accompaniment to the depiction of a real event from the earthly life of Christ, as Jacopo Bellini was to do in this Baptism scene, was wholly unheard of. The Baptism of Christ is one of the theophanies, one of the moments when the divine being of Christ became visible. This in itself allows the introduction of music as a sanctifying element. But the special quality of Jacopo's composition comes from the link between the musical element and the landscape, for in this conjunction of two atmospheric elements we already have a foretaste of some of the most poetic creations of later Venetian painting.

In the *Baptism of Christ* in the Paris Sketchbook the landscape setting is even more dominant than in the London drawing. In the latter a middle-sized group of figures was projected against a landscape backdrop. In the Paris version, the action of the figures

52 Jacopo Bellini, Baptism of Christ. London Sketchbook, fol. 16

53 Jacopo Bellini, Baptism of Christ. Paris Sketchbook, fol. 25

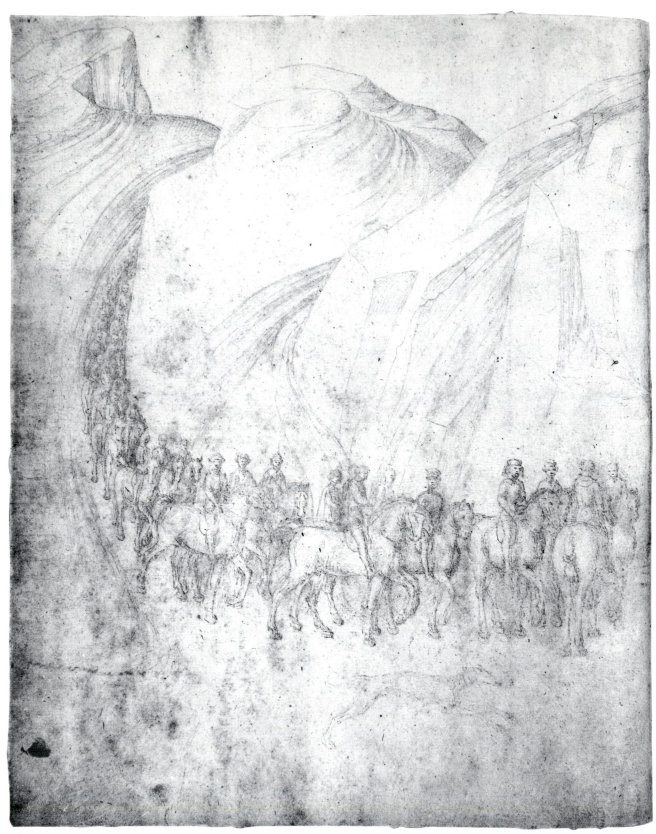

54, 55 Jacopo Bellini, Procession of the Magi, Adoration of the Magi. London Sketchbook, fol. 18v, 19

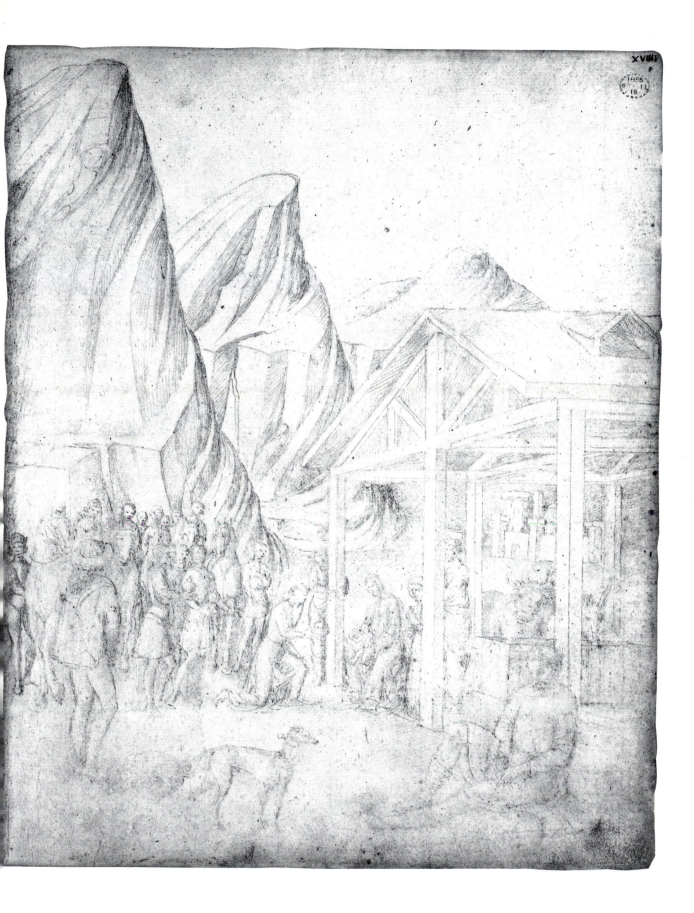

is integrated into the landscape scene. The proportional relationship between nature and humans has changed: the figures have been reduced to imply their distance from the viewer and have thus become no larger than staffage figures. At the same time the number of angelic musicians has increased, now forming a small orchestra and creating something of a crowd scene – a daring move when one bears in mind the fact that the relevant iconographic tradition does not prescribe more than three figures: John the Baptist, Christ and a ministering angel. Jacopo abandons the usual iconographic schema of Baptist and angel on opposite banks of the river; he brings all the figures together on one bank and closely integrates the person of Christ standing in the Jordan into the group of figures. The mass of figures, close up against the cliff face, almost becomes one with nature. In fact this is an early manifestation of a new principle of landscape composition: the human form merges into the terrain – a telling demonstration of the desire to be a more integral part of nature.

As in the London *Baptism*, the landscape still rises up, filling the pictorial field, and it still has a dynamic sweep. Indeed the various elements of the landscape are much more strongly united in this dynamic movement. River and rocks spiral steeply upwards in a unison corkscrew motion, the curve of the path runs parallel to the river. And it is true to say that to a large extent there is already an attempt here to depict the higher reaches of the picture as in fact rising up more steeply, to explain their 'elevated' status. As in Bellini's architectural compositions where staircases lead our gaze upwards, here rocky steps, mountain paths and sheer cliffs fulfil the same function. The terrain does not flow as it does in a landscape that one could really walk through, the substance of the scene has become significantly harder. It is a very stony landscape and the broken classical pillar in the foreground easily fits into it.

In this Paris *Baptism of Christ* we see the victory of open spaces over bodily forms; the notion of the landscape situation takes precedence, the figures almost seem to be staffage, as it were providing a pretext for portraying a motif that as yet has no real status of its own. Meanwhile the landscape type itself is distinctly archaic, a late phase and final exaggeration of International Gothic scenic depiction.

One glance at some of Jacopo's Epiphany compositions will suffice to confirm this, as we see for instance in the London Sketchbook, where it is clear that the iconography of the scene has evolved directly from International Gothic – specifically from the work of Bellini's teacher Gentile da Fabriano, whose Florentine *Epiphany* of 1423 ensured that the Courtly Gothic style would retain its influence until well into the Early Renaissance.

Images of St Christopher. If we want to understand the full extent of the developments in Jacopo's landscape paintings, we must also turn our attention to his depictions of St Christopher. There is an early version in the London Sketchbook. The river the giant is wading through forms an S-curve, exactly like the River Jordan in the *Baptism of Christ* landscapes. (In both compositions we see the river widening out into a delta.) The proportional relationship of figure to landscape looks distinctly old-fashioned, but we should bear in mind that the theme itself requires a larger-than-life figure. Other features that reveal the work's allegiance to tradition are the giant's bearded features, the motif of the wind catching his garments, and the lack of any sign of particular physical effort on the part of the Christian Atlas carrying – instead of the earthly globe – the Christ Child, who in fact represents the world, under the weight of which the giant is all but collapsing. The landscape and the figure alike are in the grip of an undulating movement.

The subsequent depictions of St Christopher in the Sketchbooks are a completely different iconographic type, which one could describe as 'statuary', in the sense that here the landscape is only an attribute to a monumental figure which, although it does not fill the

54, 55

22

56

56
Jacopo Bellini,
St Christopher.
London Sketchbook,
fol. 29

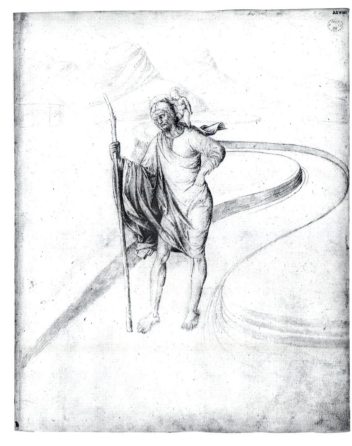

57
Jacopo Bellini,
St Christopher.
Paris Sketchbook,
fol. 22

majority of the picture field, does dominate it. This is the St Christopher we know from wall paintings and monumental sculptures,[43] who is in the first instance conceived as a single figure, not as part of a scene, and around whom the landscape generally looks like an additional extra, a kind of footbath for the colossus. In Jacopo's depiction we see an abbreviation of the earlier river landscape, a curved stretch of river as it were forms a niche in the landscape, in front of which the figure of the giant is firmly planted. In one composition in the Paris Sketchbook the monumentalism of the figure is particularly striking. The artist's full interest is now concentrated on depicting the physical action described in the legend, on making visible the wondrous fact that even the strength of a giant is not enough to carry the divine Child. The figure is weighted in such a way that we can almost feel the effort the giant is making. His right arm is braced against his side, the hip on the same side is extended outwards in order to balance the weight above it, his left hand is clinging for support to his staff. His engaged left leg is portrayed very differently from his right leg, his head is turned as in a classical contrapposto. This St Christopher has no beard, he is wearing a close-fitting tunic, he has no cloak: in short, suddenly we are faced with a classical figure.

plate 4

34

The general view is that the inspiration for this entirely new depiction of the theme is to be found in the representations of the legend of St Christopher in the Ovetari Chapel in the Chiesa degli Eremitani in Padua, which were most probably made between 1445 and 1450. In the St Christopher fresco, for instance, by Bono da Ferrara – who was taught by Pisanello – we find a very closely related iconographic type, although it lacks one very important and characteristic motif, namely the giant's 'upwards gaze' towards the Child, again with a contrapposto turn of the head. That particular motif can be very telling, with the giant visibly inquiring as to the cause of the near impossibility of carrying this burden. Bono's St Christopher simply stands there, muscle-bound and motionless. Yet we do find the 'upward gaze' in a drawing by Pisanello and even earlier, around 1430, it also occurs in a memorably dramatic form in Masolino's wall painting in San Clemente in Rome.[44] That it made its way to upper Italy via a classical current in Tuscan painting seems the most plausible explanation. Even Mantegna's *St Christopher* in the Ovetari Chapel in Padua is innocent of this contrapposto movement.

86c

The Paris Sketchbook contains one last version of the St Christopher theme. Surprisingly, we see in it a return to landscape, with the human figure firmly integrated into its open-air surroundings. But this is a wholly new type of landscape, which only has the meandering river in common with its predecessors. In fact it is the first flat landscape that also recedes into the distance since Ambrogio Lorenzetti's *Ager Senensis* – no landscape tapestry this, leading the gaze upwards over steeply rising terrain, climbing up to the topmost heights of the composition. The older vertical format – with its specifically Gothic dimension – has also been abandoned in favour of a horizontal format which more closely reflects the sense that the scene is set in this world rather than the next. Flat expansiveness is the specific quality of this landscape composition, expressing a sense of wide open spaces that no other artist had hitherto been able to convey.

57

58

Perspective was the means by which Jacopo Bellini solved the puzzle as to how one could indicate – without having to draw the viewer's gaze upwards by the material stratification of the pictorial motifs – that elements seen one above the other on the picture plane in fact lay one behind the other in the topographical space. The crucial fact was that he transferred the principles of perspective in buildings – in architectural scenarios – onto the natural landscape. And, as in the composition of the first flat landscapes in a pre-perspectival age, that is to say, in the calendar landscapes of the Limburg Brothers,[45] where it was not nature in the raw but a landscape already ordered by human hand that served as the basis of their work, so, too, Jacopo Bellini, probably inspired by Tuscan forerunners,

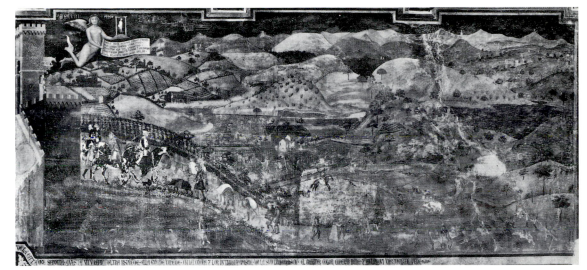

58
Ambrogio Lorenzetti,
Ager Senensis.
..ena, Palazzo Pubblico

replaced the ubiquitous rocky backdrop with a domesticated, cultivated landscape. We still know too little about the Tuscan prehistory of this decision. Take for instance the compositions by the artists in Uccello's circle or by the master himself.[46] Flat expanses of grass in the depiction of a fight with a dragon or perspectival furrows in a field (in the remnants of a fresco of the Birth of Christ) convey the impression of a flat landscape receding into the distance. Just as the figures in Tuscan painting were to influence Bellini's work, this also seems the most likely source of inspiration for his new flat landscape.

As the geometrically tiled floors are to architectural settings, so are ploughed furrows and hedgerows to the landscape: and while they provide the perspective orthogonals for the open country, trees and other upright objects – above all the human figure – loosely distributed across the picture plane, fulfil the function of architectural verticals parallel to the picture plane, decreasing in size the further back they are. In this landscape with St Christopher there are no rigorously laid out avenues of trees; instead slender tree trunks seem to be scattered at random across the area and, in this guise, supply the geometrical framework which unobtrusively organises the open expanse of the landscape. A tree stump at the right-hand edge of the picture, rising up like part of an internal frame out of a horizontal sill in the ground, is the first step, the tree with the eagle is the second step leading into the depths, the figure of St Christopher – its axis accentuated by the staff in his hand – forms the next step, and so on. This way of pacing out the march into the depth was to become the classic formula, and was subsequently adopted in Southern and Northern Europe alike, by artists ranging from Brueghel to Rubens and Poussin.

In Bellini's drawing the figure, standing on guard in the middle ground, conforms to the new type of large-format, statuesque St Christopher – except that over his tunic he does have a cloak fluttering in the wind. The combination of classical figure and a geometrically structured landscape may have been influenced by the masters of the Early Renaissance in Tuscany, Uccello in the first instance and perhaps also Pisanello and his school. At this point we should not fail to mention that in their history of Venetian drawing Hans and Erika Tietze decided that this landscape with St Christopher could not be by Jacopo and attributed it to his younger son Giovanni.[47] This would mean that it was the considerably younger artist who succeeded in establishing the modern Venetian landscape. From the point of view of the Tietzes, this was perfectly logical in the sense that they simply ascribed any drawings in these Sketchbooks that displayed the stylistic seeds of the younger Bellinis' work to those younger artists. However, I believe, that in this case

the Tietze suggestion is on shaky ground, for we know enough of the works that Giovanni was producing at the beginning of his career to see that the drawing in the Paris Sketchbook cannot be one of these. It is only much later in Giovanni's œuvre that we see similarities with the St Christopher landscape in the Paris Sketchbook.

plate 29

Images of St Jerome. Similar developments can of course also be seen in other landscape themes, for instance particularly interestingly in depictions of the penitent St Jerome in the wilderness, which was to play an important role in later landscape paintings in Venice and even more so in German art.[48] In the Paris sketchbook there are two examples of landscapes with the hermit. The first of these is a pen and ink drawing, where the space is depicted in the manner of the last phase of the old landscape tapestry style, and the staffage-like incorporation of the figure into the landscape calls to mind the style we know from the second *Baptism of Christ*, which in fact makes a double-page spread with this depiction of St Jerome. The second version of St Jerome in the Paris Sketchbook is a silverpoint drawing, which marks the transition from a vertical format to a horizontal format with a flat landscape. Characteristic of the new wide-angled view is the horizontal band of water which extends across the plain, leading the gaze across to the wall of mountains rising up parallel to the picture plane on the opposite shore, closing off the composition to the rear. The substance of the landscape – the terrain – no longer rises steadily upwards towards the horizon, as it still did in the pen drawing – there is no concrete peak marking the highpoint of the composition. The path into the depth has been shifted right over to the edge, and the moment where the water switches from the vertical to the horizontal is masked by a rocky rise. Exactly the same function is fulfilled by the rocky Mount of Olives in Giovanni Bellini's London painting, which in fact has many features in common with Jacopo's *St Jerome in the Wilderness*. Giovanni's composition, for instance, also has a horizontal strip in the centre ground although this time it is land instead of water, namely the road on which the conspirators are approaching with Judas.

plate 34

53, 59

38

plate 18

If one compares this with Mantegna's version of Christ on the Mount of Olives, which is now in London and known as *The Agony in the Garden*, then it becomes clear that Mantegna has not yet adopted the new expansive landscape and that the two Bellinis have a greater stylistic affinity than the contemporaries Andrea Mantegna and Giovanni Bellini. This is important with respect to the as yet unanswered question as to who can actually claim credit for breathing new life into the quattrocento landscape in upper Italy. We do know for a fact that Jacopo only arrived at the new landscape form at a late stage in his career, although we would normally expect a break with tradition of this kind to be made by a younger artist rather than by a man much later in life. And, as I see it, so far no very compelling reasons have been tabled for giving Mantegna precedence in this matter. But since it is absolutely necessary to have a thorough knowledge of the chronology of Mantegna's early career before we can form a sound critical opinion, we will have to postpone our discussion of this issue until we discuss the work of Mantegna.

plate 17

There is just one point we could make at this stage. It was not only with regard to landscape painting but in all areas of his creative output that it took Jacopo until late on in his career to break free from the International Gothic Style – in fact it was not until around 1450, as we know from dated representations of the Madonna which have been documented as Jacopo's work. It seems that on the whole he was a conservative who turned innovator rather late in the day. In the shadow of Gentile da Fabriano up until 1440, it was only in the fifth decade of the century that Jacopo made contact with the Early Renaissance in Florence and started to engage with the classical art of Antiquity.

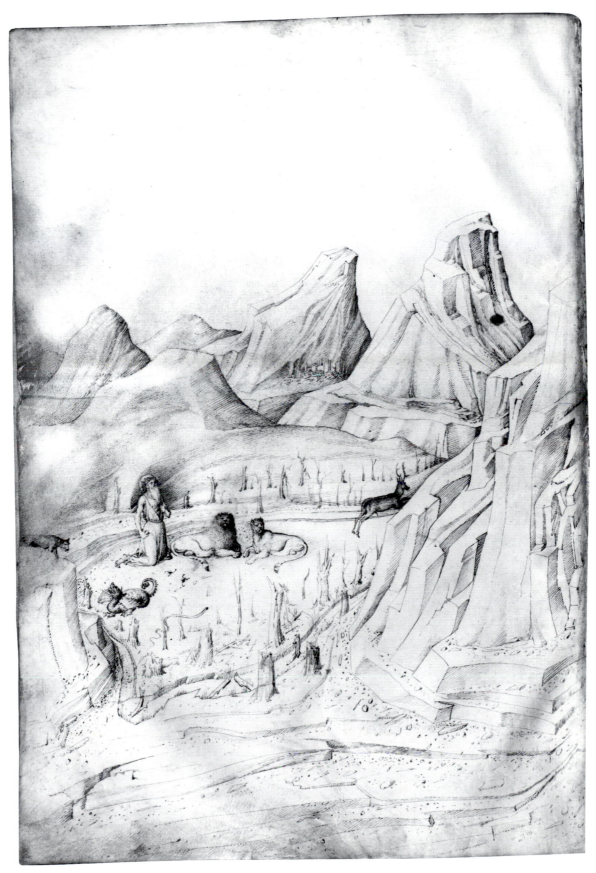

59 Jacopo Bellini, St Jerome in the Wilderness. Paris Sketchbook, fol. 23 v

60
Jacopo Bellini,
Iris (detail).
Paris Sketchbook,
fol. 62

Nature Studies. Of the various modern traits in Jacopo's art, the most notable must be his interest in nature studies. At the turn of the 15th century it seems that upper Italy, rather than Tuscany, was leading the way in nature studies, as we can see from the animal studies in the sketchbook of the Milanese artist Giovannino de' Grassi and from the plant studies in the Paduan Carrara Herbarium, both sources that laid the foundations for Pisanello's nature studies later on.[49] The stupendous study of an iris in Jacopo's Paris Sketchbook – which is so unformulaic, so unstylised, so very 'natural' that it would be virtually impossible to date if it were not in fact in this Sketchbook – is thus very much in the local tradition, and there is no need to assume that it is modelled on some other example, by Pisanello perhaps. *60*

In the Epiphany Altarpiece by Gentile da Fabriano there are more very natural-looking flower studies – clearly not executed for the sake of their decorative qualities but simply as flowers in their own right. However, it is possible that these may have been influenced by Venetian forerunners, for by that time there were already herbariums that went back a quarter of a century and were known in upper Italy, in addition to which, we know that Gentile stayed in Venice for some time during the early decades of the century.

Jacopo's magnificent studies of lions are a similar case, although we do have other reliable evidence that necessarily dates them to the year 1441 when Jacopo was at the Court of Borso d'Este in Ferrara. It was only in Borso's lion-pit that the artist could have found models for animal portraits of this kind. Moreover, we also know that Pisanello, the greatest master of early nature studies, was in Ferrara at just this time, and even that Jacopo pitted his own portrait of Lionello d'Este against that of Pisanello, and emerged victorious from the contest. And if Jacopo, as the reports go, beat Pisanello on his own territory, then this must no doubt also mean that he gleaned some useful hints from his rival. From Jacopo's Sketchbooks we know of just one study for a portrait – in silver point – the head of a youth in profile. It is precisely the same portrait type we see in Pisanello's painted and drawn portraits and in his portrait medallions, which were much influenced by the International Courtly Style. If we may draw any conclusions from this one authenticated *43, 44* *61* *62*

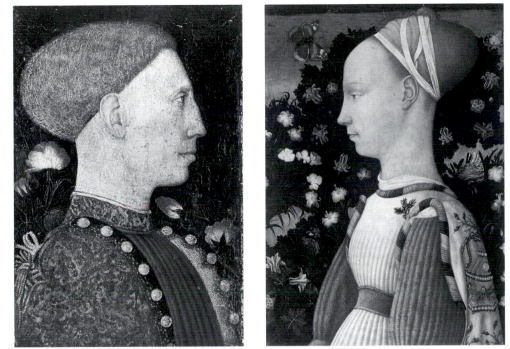

61
Pisanello,
Lionello d'Este.
Bergamo, Accademia Carrara
di Belle Arti

62
Pisanello,
Ginevra d'Este.
Paris, Museé du Louvre

63
Pisanello,
Sigismondo Malatesta, medal.
Florence, Museo Nazionale
del Bargello

example of Jacopo's work as a portraitist, then it would be that compared with Pisanello, Jacopo intensifies the sense of calm to the point where there is no tension left. There is a sense of repose in the outline, which seems to achieve its ends with a minimum of articulation. Characteristic of the more optical approach of the Venetian artist is the way he gives the head its plasticity, so that it stands out as a relief. There is almost no modelling within the outline of the head. Just two areas of soft shading define the form; the first is on the edge of the profile, on the parchment background behind the face, the silhouette of which is created as in a cut-out, that is, by cutting away sections. The second area of faint shading is on the cheek, on the nearest surface of the relief. Thus the shape of the head is created by the paler areas between two darker zones, by the painter's tonality.

Nature studies – and very competent ones at that – existed long before naturalistic representation emerged in religious painting and pictorial narratives *per se*. For this new mode of seeing and the existing representational style of pictorial invention proceeded side by side for a long time, in a personal union even, but as though their problems were entirely unconnected. Even Pisanello, as a narrative artist and in his compositional style, was still beholden to the Courtly Style,[50] to *tardo gotico*: elements taken from nature were only used as additional extras and distributed in a scatter pattern across a conventional landscape. Of course, we should not forget that the new mode of seeing was at first very patchy, and it is not by chance that what there is by way of life studies in Jacopo's Sketchbooks concentrate on the same three areas, which in fact provided the vast majority of the models used in early nature studies: examples of fauna and flora and the human countenance – living beings, albeit ones that could keep still. For the guiding principle in the choice of motif for early nature studies was that it should be an object that the artist's gaze could rest upon as he took in its form – something that could be studied at length, such as lions or other animals in a cage, for instance. In English, the painter's model is known as the 'sitter', underlining the fact that this is one who sits still. In Pisanello's huge repertoire of factual drawings there is an almost complete absence of motion studies. And such motion studies that do occur are copies of movement in classical monuments. While

it is true that there are two sheets with studies of hanged men, these, dangling from the gallows, were not able to move, and he seems not to have tired of drawing them from a whole variety of angles.[51]

The use that Jacopo made of his nature studies was in essence hardly different from Pisanello's practice. They provided the accoutrements for his compositions. Lions, deer, rabbits and eagles populate the wilderness into which St Jerome has withdrawn. 'Nature' *59* is seen here as a mosaic of nature studies: that synoptic, detached depiction of reality, which still prevailed in Dürer's portrait of the Madonna with its many animals.[52] The dilemma, that the naturalism of the modern era could never resolve, was immediately apparent even in the very earliest nature studies: living creatures had to be as much like still lifes as possible – *nature morte*, as they are so aptly called in French; they had to be lifeless or at least motionless in order to appear as lifelike as possible in the final pictorial composition.

One could counter the connection made here between nature studies and still-life by pointing out that in Jacopo's Sketchbooks there are several depictions of St George slaying the dragon, which show horses in the most powerful, dramatic movement. Are *64, 65* these compositions not based on studies of horses rearing up into the air? On the contrary, if we examine the older iconography of the legend of St George, grave doubt is cast on any such assumption. For the motif of the horse rearing up on its hind legs is seen elsewhere in an almost identical form in the early 15th century: in images of St George and the Dragon and in depictions of the journey on horseback of the Three Magi, as in the

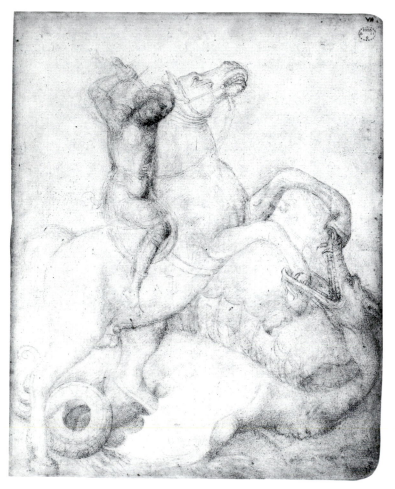

64
Jacopo Bellini,
St George and the Dragon.
London Sketchbook, fol. 7

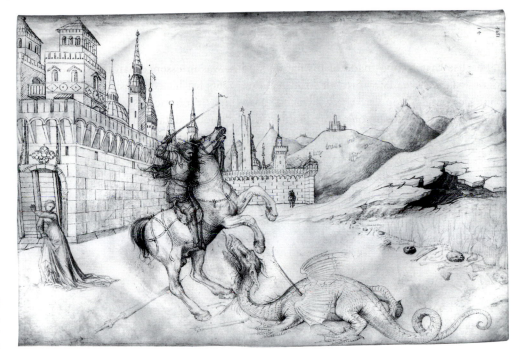

65
Jacopo Bellini,
St George and the Dragon.
Paris Sketchbook, fol. 14.

22 Epiphany Altarpiece by Gentile da Fabriano. The oldest incidence that I know of is in the Epiphany fresco in the Oratory of San Michele in Padua, which was painted in 1397 by Jacopo d'Avanzi.[53] In this example, a stable boy tries to calm the unruly, frightened animal. It is worth considering whether this motif might not have been taken from the Antique. Possible models could be either a Roman equestrian statue of a rearing horse or a sarcophagus relief.[54] Padua is near enough to Venice for us to assume that Jacopo is likely to have known the fresco by Avanzi. This would mean that Jacopo Bellini's composition was not based on a quick glance at real movement, but a look on one already captured by an artist in the past – which brings us to another important chapter in Jacopo's life.

Copies after the Antique. As early as the 13th and 14th centuries, great sculptors were already copying works from the Antique – one need only call to mind Giovanni Pisano's *Venus Pudica* made for the pulpit in Pisa Cathedral, or of the drawings in Villard d'Honnecourts *Book of the Tabernacle* from the early 13th century[55] – copied, that is, in so far as it was possible within the constraints of the very idiosyncratic optics that governed visual depiction at that time. And in the trecento, too – as we know from the report of Ambrogio Lorenzetti's copy of the Pisa *Venus* – artists did from time to time study classical works of art and seek to replicate them in drawings or paintings. But copying classical works only became commonplace in the third decade of the 15th century, specifically – if we may trust the most recent research in this field – with the visit to Rome of the great itinerant artist Gentile da Fabriano. There is, still extant, a group of drawings that are attributed to him and which possibly later came into Pisanello's possession from Fabriano's
72 estate. It contains numerous studies of classical subjects[56]: these are almost all drawings of individual figures, often extracted from a larger scene, more often than not selected from reliefs as opposed to free-standing sculptures. Sometimes these individual pieces, of which many could be taken from the same scene, are recombined in 'pseudo-groupings', but only for purely decorative reasons and not with the intention of making any connection in terms of their content.

66
Pisanello,
Copy after Roman statue of
the River God Tiber, drawing.
Staatliche Museen zu Berlin,
Preussischer Kulturbesitz,
Kupferstichkabinett, fol. 1359 v

For Pisanello – who took over the painting of the Lateran Basilica in Rome from Gentile and who was not only his material heir but, in a sense, also his spiritual heir – the study of the Antique had much the same function as it did for Gentile. They credited classical sculpture with the same degree of reality as nature. In the realms of the visible, the creations born of Greek and Roman imagination were on a par with the creatures made by God; one was as natural as the other. Copying works from Antiquity was the same as studying nature. Thus, as we read in the most recent research on the surviving groups of drawings, "within the same ensemble of drawings, there are concurrent studies from nature and copies of figures from Antiquity, which only differ in their poses and arrangements, not in artistic interpretation".[57] In both cases the artist is a passive observer, which in itself accounts for the exactness of the likeness. In the eyes of the new 'reality-fanatics', the world of classical sculpture provided a welcome and necessary complement to empirical nature. For the former allowed the artist to study the human body in the gesture of movement, and yet at rest, benefiting from the stillness that was vital to accurate observation. Indeed this seemed to offer a way out of a serious dilemma: now the artist was able to study a body in motion, that was not moving. Artists turned to the Antique for life-like images of motion, which in real life would escape the gaze of the painter trying to capture them. And just as in his studies of nature, so Pisanello also regarded his copies after the Antique as a means to an end, providing the same formal training that still prevailed in academies of art in the 19th century. Notably, there are few instances where the contents or identity of the classical figure kindled the imagination of the artist, as in his drawing of a nude female figure, now in the Albertina, which must be based on a classical figure of a goddess. In a semi-medieval way, she has been transformed into an allegorical figure, perhaps Luxuria; a spell has been cast over her, obscuring the classical origins.

In Jacopo Bellini's hands, the study of works from Antiquity enters a new phase. In fact the position changes on two counts. Drawings of single classical figures are now the exception, and where they do occur, they are scarcely distinguishable from a figure drawn from life. Now the copies are predominantly of classical monuments with purely ornamental or figurative decorations as well as drawings of coins, as we see on two sheets in the Paris Sketchbook. In all cases, any inscriptions are meticulously replicated. A new, antiquarian interest in the ancient forms seems to have awakened: form and contents are now of equal importance, whereas for Pisanello the role of classical imagery was still just

66, 68

67

69

70

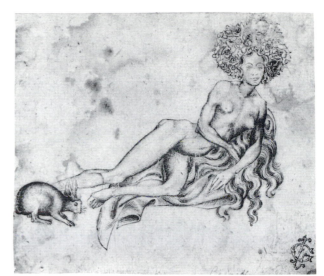

67
Pisanello,
Luxuria, pen and ink drawing.
Vienna, Albertina,
Inv. 24018 r

a treasure trove of formal motifs that one could plunder like a real quarry from which one could take the stones to build one's own house.

Now, in Jacopo's work, we see the artist starting to leave his own world and trying to transport himself into that of his country's great past, to understand how it was. He does not simply copy monuments, for he also adds to them, completing them as he thinks fit: instead of just copying existing fragments, he produces reconstructions of what was once there. Of course we hardly need say that Jacopo was without sufficient archaeological knowledge to make a scientifically correct reconstruction, but who is there even today with such a wealth of knowledge! In fact, one wonders whether he would even really have wanted an archaeologically correct reconstruction. As in the halls adorned with

68
Pisanello,
One of the Dioscuri,
Pen and brown ink drawing.
Milan, Ambrosiana,
F. 214 inf. 10 v

69
Jacopo Bellini,
Study after Antique Nude.
Paris Sketchbook,
fol. 82, Detail

statues in many of his religious compositions, clearly he was concerned – even in what looked like a copy of a classical work – to give visible form to his vision of Antiquity. In this sense Jacopo's copies after the Antique bear witness to a wholly new mentality – even compared to Pisanello – for they bear witness to a new Humanism, the highest aim of which was to witness the rebirth of Antiquity: in a word, these stand as documents of genuine Renaissance art.

New Creations 'all'antica'. The same may be said, even more emphatically, of a number of drawings of exclusively classical types and motifs, which are nevertheless not copies, not even partial copies, for they are genuinely new creations *all'antica*. What we have here – *71* even bearing the Florentine artists in mind – are the earliest examples of free inventions of classical material in antique guise, not copied from anywhere. The surviving drawings in fact portray just two mythological themes, each in a number of versions. The first concerns the myth of Pegasus, the second the mythology of Dionysus. In both cases the *74, 73* literary sources are as obscure as any compositional models. Scholars generally solve the problem by referring to them as 'Renaissance phantasmas'.

In the case of the Pegasus drawings, the theme seems always to involve an abduction: in one a Pan figure appears to be abducting a human being, in the other Amor appears to be abducting a young satyr. In the former the horse Pegasus – as is fitting – has huge wings, in the latter he has small fin-like wings on his legs. So far no one has been able to offer a convincing interpretation of these scenes. And the same may be said of Bellini's depictions of bacchanalian rites. It is true that there are countless classical representations of bacchanalia, and it would not be hard to find forerunners – in sarcophagus reliefs – of the drunken Silenus loaded onto an ass. But Jacopo has depicted a true triumph of Bacchus, as Titian was later to do, drawing on the writings of Ovid; the only difference is that in Bellini's composition there is no sight of Ariadne, who is a key figure in Ovid's account. Bacchus stands on a small cart drawn by a horse, with a retinue of satyrs and Pan figures, *75* but without maenads. It would be worth exploring whether the composition in part owed its existence to the notion of the triumphal processions of Antiquity which had been popularised by Petrarch's *Trionfi*, and whether its visual form might not also have been influenced by tales of Dionysus in India and his processions there. In fact according to the writings of at least one classical Humanist, Dionysus was to be credited with having invented triumphal processions in the first place.

The scene makes a very strange impression. Individually the figures and their postures may seem credible, but as a whole it is without any visual logic. The horse gallops across the picture at top speed, but the action of the figures in front of it, on it and behind it would only be possible if the horse were more or less rooted to the spot. A satyr, walking at only a steady pace, leads the wild horse by the halter. The satyr riding the horse is not prevented by its galloping from sharing a skin of wine with a comrade standing nearby. Under the horse a young Pan is sleeping off his intoxication. Another satyr finds time to take some fruits from the dish held aloft by Bacchus rolling past him on the cart. The composition is patched together in an almost comic manner, and cannot have existed as such in Antiquity.

At the same time, however, Jacopo composes very different works, in which he makes it clear that the motif is taken from life, as in the Entrance of Christ into Jerusalem. Here *76* the composition leads right back into the depths of the picture, and is no longer simply placed parallel to the picture plane. The triumph of Bacchus is a relief frieze without spatial depth – as are the depictions of Pegasus. There is no doubt that Jacopo regarded keeping to the single plane of a frieze-like relief as a stylistic law of classical art; and if we take classical to mean Greek, then he was not so far from the truth. Moreover the figures are

70 Jacopo Bellini, Studies of Three Classical Monuments. Paris Sketchbook, fol. 49

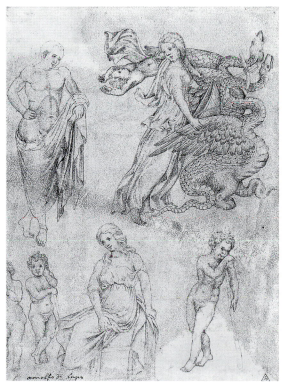

71 Jacopo Bellini,
 Monument and reclining figure
 drawn *all'antica*.
 London Sketchbook, fol. 3 v

72 Gentile da Fabriano or Pisanello, Jason, Medea
 and Creusa. Copy of a Roman Medea sarco-
 phagus, metal-point and pen drawing. Rotterdam,
 Museum Boymans-van Beuningen, fol. I. 523 r

73
Jacopo Bellini,
Triumphal Procession
of Dionysus.
London Sketchbook, fol. 4

connected as one whole only in terms of their planar relationships. As soon as we call to mind the compositional principle of the Greek relief, which moves in the rhythm of a continuously surging wave, we can readily understand the syntax of Bellini's Bacchus scene.[58] Each movement towards the right is answered by another towards the left, interrupting the progress of the procession. Seen in this light, the interludes that are so detrimental to the logic of the action – the satyr reaching out for the fruit held aloft by Bacchus and the intoxicated Satyr lying on his back – now prove to be necessary formal components within the composition. In essence we have here a rhythmic sequence of five main figures, with one pair face to face balanced by another pair who are back to back. Bellini's bacchanalian procession is indeed composed in the *more antico*, displaying an astonishingly deep understanding of the spirit of classical art three hundred years before Winckelmann was to alert his contemporaries to the past. Jacopo Bellini would have been ideally qualified if he had ever wanted to forge works from the ancient world. Now we see the copies of fragments of classical art produced by Gentile da Fabriano and Pisanello being replaced by a creative archaism, the first real instance of an artist invoking the Ancient world and its art, which in Venice – unlike Padua – was only to be taken up many

74 Jacopo Bellini, Pegasus with Cupid and Satyr. Paris Sketchbook, fol. 43

75 Jacopo Bellini, Bacchus and Satyrs. Paris Sketchbook, fol. 40

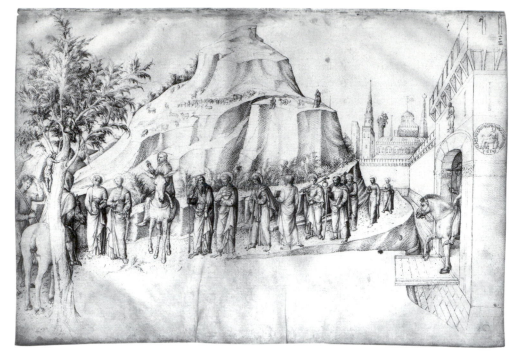

76
Jacopo Bellini,
Entry of Christ into Jerusalem.
Paris Sketchbook, fol. 21

decades later by Jacopo's son Giovanni in some of his mature works, by Giorgione and finally by Titian.

Before we draw our discussion of Jacopo Bellini's work to a close, we should turn our attention to a rather different aspect of his art, a different side of its fundamentally Humanistic outlook.

Funerary Monuments. On one of the sheets with copies of funerary monuments from Antiquity we see an equestrian figure that is well known to the traveller in Italy today, 70 easily recognisable – despite being seen from behind – as Donatello's *Gattamelata*. In fact Jacopo has used a contemporary work to realise his vision of a classical memorial. The idea of monuments in general and equestrian statues in particular had started to fascinate him quite some time earlier.

The catalyst for his intensive preoccupation with this theme seems to have been his visit to the Court of the Este family in Ferrara in 1440/41 when he came into contact with Humanists – including patrons and artists – and which certainly marked a turning point in his intellectual and artistic development. In the two Sketchbooks there is a whole series of drawings that are either designs for memorials for members of the Este family or which reflect real projects of the time. In 1451 the Este family commissioned a memorial for Borso d'Este. Let us look at one of these memorial designs, which vary above all in 77 the form of the plinth. The memorial is constructed like a tower, with its various stages narrowing towards the top and an equestrian figure at its peak. This very one-sided emphasis on the vertical is still beholden to a Gothic sense of proportion and balance, rather than to the classical ideal. Yet the idea of the memorial is classical, as are the individual figures and decorative motifs.

Opposite this drawing in the London Sketchbook there is a depiction of John the Baptist preaching, a theme that appears in a whole variety of guises in the Sketchbooks. In 78 terms of their content, the memorial design and St John cannot have anything to do with each other, but regardless of whether the juxtaposition was intended or merely came

about by chance, no thoughtful viewer could help but be struck by it as evidence of a fun-
damentally identical artistic striving in each work, which goes beyond the contents as
such. The preacher is standing on a circular plinth supported by a larger, solid, drum-like
structure. Together with the figure crowning the structure, the whole looks so strikingly
like a memorial – indeed looks so unlike a preacher at a pulpit or on a daïs – that it is hard
to decide whether the drawing is of a sermon being preached or of a memorial to a
preacher. The crowd listening to his words form a circle, like a protective, concentric
outer ring around the tall centre-piece. Since the horizon line coincides exactly with the
surface the Baptist is standing on, the listeners and the daïs alike are seen in perfect
isocephaly. If the positioning of the listeners were not just as strictly geometrical as the
stance of the preacher, if they, too, did not have such an air of permanence, then one
might well be prompted to wonder if this were really a crowd listening to a sermon or a
circle admiring a statue.

79 The other versions of *John the Baptist preaching* in the Sketchbooks are very similar. In
one case the preaching ascetic is positioned on a square plinth in the middle of a street
scene, creating a very decorative effect, particularly since a sculptured portal arch provides
a ceremonial frame for the whole. The rather appealing suggestion has been made that
Jacopo Bellini was inspired by ancient coins to depict John the Baptist preaching on a

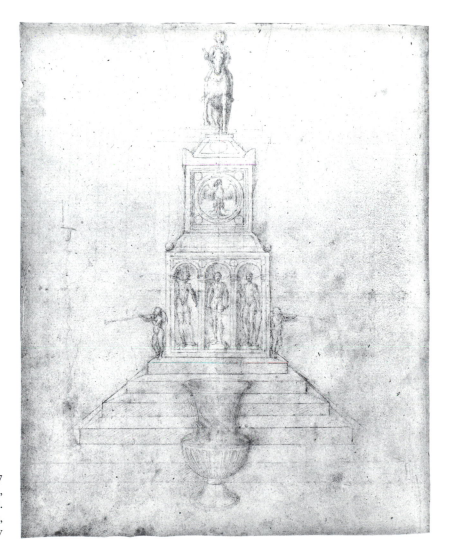

77
Jacopo Bellini,
Equestrian Monument.
London Sketchbook,
fol. 79 v

78
Jacopo Bellini,
St John the Baptist preaching.
London Sketchbook, fol. 80

pedestal, that is to say by coins showing an *allocutio*, a general addressing his troops.[59] This may indeed be the case, although in Jacopo's work, the circular form for a plinth – not documented in Antiquity – precedes the squared block or cube. Furthermore, the classical *allocutio* is always shown from the side, whereas Jacopo's preacher always occupies the vertical centre of the composition. In other words: by his stance, Jacopo's Baptist looks much more like a memorial to himself than does the general at a Roman *allocutio*.

From a statue-like image it is only a small step to the image of a statue. In another pen drawing by Jacopo, we see John the Baptist in a round-arched niche that is positioned on a plinth which, with its narrative scenes, looks rather like a predella. In mid-15th century Padua and Venice there had already been sculptural compositions with a statue as the main figure and a relief predella. Donatello's high-altar in Sant'Antonio (the Santo) in Padua is one such, although it has more than just one figure; the apse in the Ovetari Chapel in the Eremitani Church,[60] also in Padua – with frescoes by Mantegna – is another. Some have even taken the view that Jacopo's drawing was intended as a suggestion for the placing of Donatello's statue of John the Baptist in the Frari Church in Venice. But we will get closer to the truth, if we simply view the drawing on its own merits as a pictorial invention, not intended for any particular situation. In the case of the predella, it is hard to decide whether the decoration was to be painted or executed as a relief. And precisely this quality is typical of the special nature of illusion in Jacopo Bellini's work,

80

82

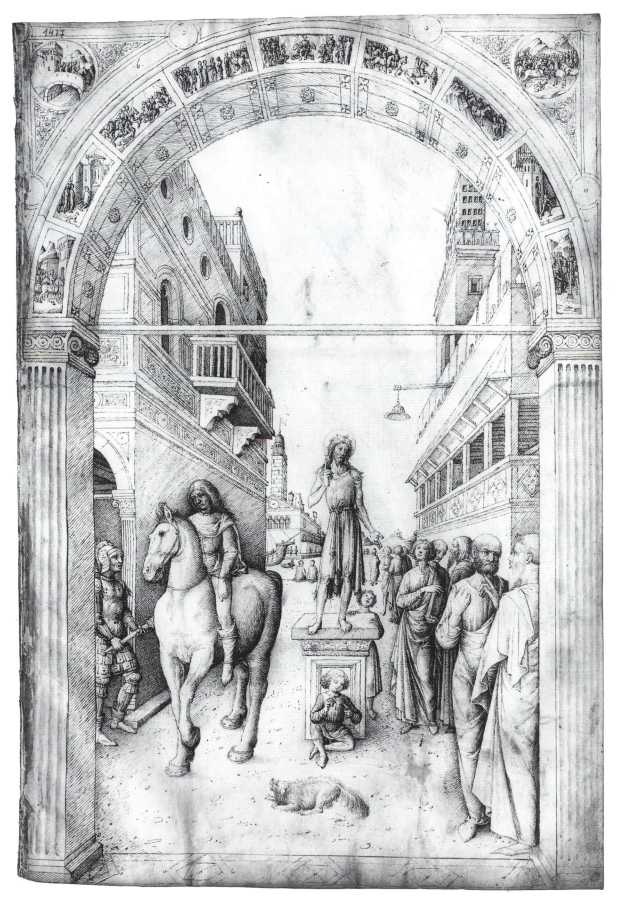

79 Jacopo Bellini, St John the Baptist preaching. Paris Sketchbook, fol. 6

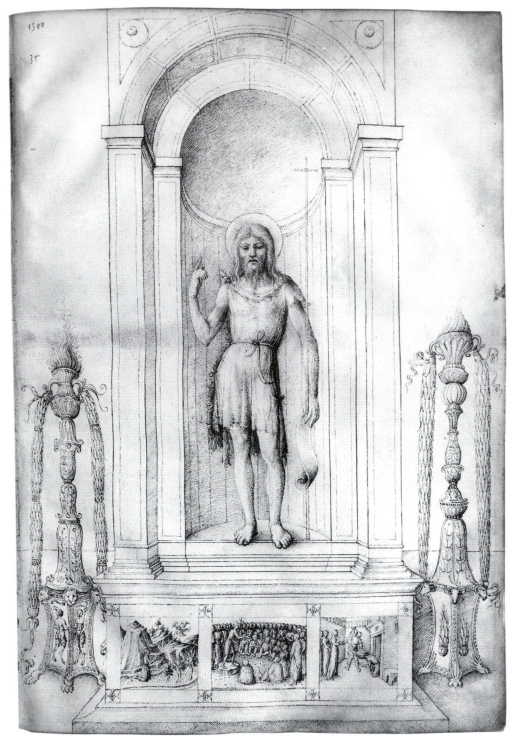

80 Jacopo Bellini, St John the Baptist preaching. Paris Sketchbook, fol. 35

namely the interchangeability of different media which arises from the sculptural solidity at the heart of his figurative compositions. Another example of this kind of ambiguity may be seen in the depiction of the Risen Christ holding the cross, flanked by the Virgin Mary, John the Evangelist and two saints. Are we supposed to read this as an illusory *42*

81 Jacopo Bellini, Circular Temple. Paris Sketchbook, fol. 53

world of living creatures, with a positively sculptural plasticity, or as a picture of a plastic work of art, depicting statues in wall niches? We are in a half-way world, between painting and sculpture – which under no circumstances should be confused with the three-dimensional illusionism of grisaille painting.

85 a, b

Mantegna painted; he then went on to say that it was always possible to recognise the hand of a master, particularly when that master was as great as Mantegna. This is the earliest record we have of this kind of attempt at identification.

Since Pizzolo and Mantegna were Paduans, the similarity in their styles might not seem that surprising on a superficial level, but, on the contrary, it is all the more surprising since Pizzolo never attended Squarcione's 'school'. Pizzolo was ten years older than Mantegna, and may have been an assistant to Filippo Lippi from Florence, when the latter was a guest in Padua in the 1430s. In the 1440s, he helped Donatello with his work on the high altar in the Santo. And that is all we know of the genealogy of Mantegna's early style. We can credit Niccolò Pizzolo with initially having introduced Mantegna to the Tuscan Early Renaissance, and we will come in due course to the second and third main influences in his work.

Astonishing numbers of contemporary documents concerning the Ovetari Chapel have survived to this day, and these understandably enough deal mainly with the distribution of labour. As a result they are extremely useful for distinguishing the different hands of the artists, but they reveal nothing as to the author of the overall plan. No decorative scheme of such dimensions and with so many different parts could possibly have been undertaken without a plan. The fact that the end-result was relatively homogeneous is no doubt a consequence of the fact that – whatever the original plan may have been – the death of Antonio Vivarini in 1450, and the subsequent complete withdrawal of the Venetian painters, meant that the necessary decisions regarding the final design of the frescoes in the Ovetari Chapel were then entirely in the hands of the Paduans, and – after Pizzolo's death in 1453 – in the end only up to Mantegna.

84 – 86

85
Andrea Mantegna,
Legend of St James.
Padua, Ovetari Chapel

a The Calling of James and John
b The Preaching of St James
c The Baptism of Hermogenes
d The Trial of St James
e St James on the way to Execution
f The Execution of St James

85 c

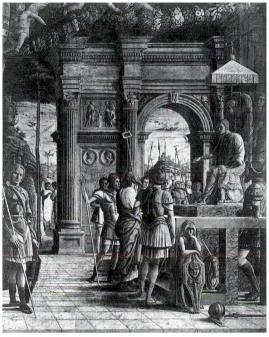

85 d

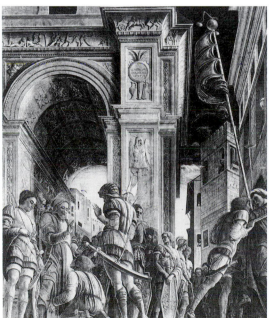

85 e

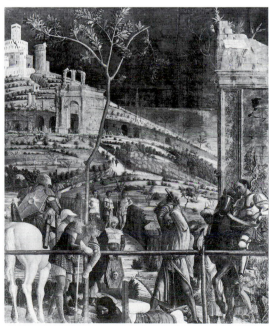

85 f

86a, b

The decorative scheme of course had to take the architectural situation into account, that is to say, the space available for painting and even the picture formats were to a certain extent determined by the architectural structure, which owed its appearance to the stylistic conventions of a past age, namely the Gothic era. Whatever the painters' ideals and intentions, they had to a greater or lesser extent to work with the situation as they found it and to make compromises where necessary. Put rather bluntly, the problem was as follows: The architectural structure prescribed the vertical organisation of the decorations on the wall, while the new ideal of pictorial illusion demanded that these should not be without the vital dimension of spatial depth, so that the viewer would be able to 'see through' the wall, would register the 'per-spective' and with that the negation of the wall as a planar surface. The task was to find a common denominator that would reconcile the tall, planar spaces of the actual architecture with a multiplicity of imaginary spaces receding into the distance.

The iconographic programme was rather simple. The chapel itself had, according to the will of the donor, been dedicated to St James Major and St Christopher, so their lives were to be told in six scenes each on the side walls. In the middle field of the polygonal apse, the vertical axis was allowed to come fully into its own by means of a factual reason for its rise upwards: the vertical rectangle of the wall was to be used for a depiction of the Virgin Mary's ascent into Heaven, the Assumption, with God the Father enthroned in the spandrel; in the side spandrels we see the standing figures of the Saints Peter, Paul and Christopher, and on either side of the round window that interrupts the line between the Assumption and God the Father, there are medallions with the four Church

85, 86

87, 88

89

90

86
Andrea Mantegna,
Bono da Ferrara
and Ansuino da Forlì,
Legend of St Christopher.
Padua, Ovetari Chapel

a St Christopher before the King
b Encounter with the Devil
c St Christopher carries Christ across the River
d Ansuino da Forlì, St Christopher and
 the Soldiers of the King of Samos
e Mantegna, The Martyrdom of St Christopher
f Mantegna, The Removal of the Corpse of St Christopher

86 c

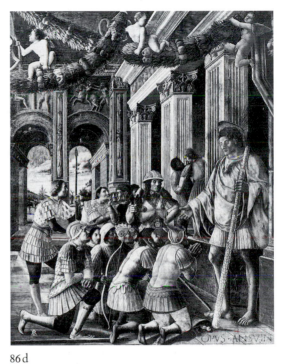

86 d

86 e

86 f

87
Andrea Mantegna,
Assumption of the Virgin.
Padua, Ovetari Chapel

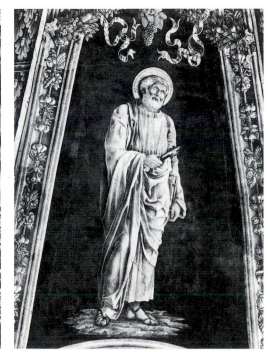

88
Niccolò Pizzolo,
God the Father.
Padua, Ovetari Chapel

89
Andrea Mantegna,
St Peter.
Padua, Ovetari Chapel

90
Niccolò Pizzolo,
St Luke.
Padua, Ovetari Chapel

91
Niccolò Pizzolo,
Church Fathers.
Padua, Ovetari Chapel

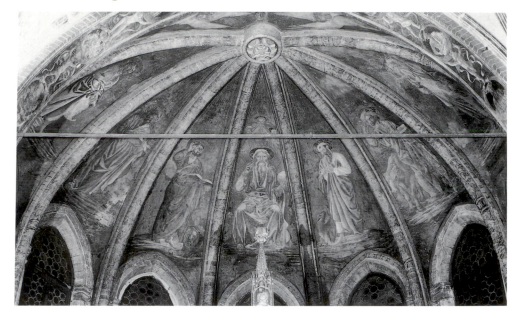

92
Andrea del Castagno
God the Father with Saints.
Venice, San Zaccaria,
San Tarasio Chapel

Fathers; lastly, high up in the nave of the chapel there are medallions with the four Evangelists.

As convention dictates – and as is only appropriate – the work started high up in the vaults, so that the decorations were painted from the top downwards. The Paduans started in the apse, and the Venetians in the chapel vaults. And the chapel vaults are in fact the only place that is at odds with the rest of the decorations, in the sense that the foliage painted along the ribs appears completely flat, not creating the illusion of plasticity. The four-winged *putti* in the spandrels are related to these, and are hybrids in terms of both their iconography and their style – imports from Venice only in the sense that they resemble the form and motifs of the *putti* painted by Castagno in San Zaccaria. What could still be seen in the Evangelists' medallions before the Church was destroyed in 1944 seems neither to fit properly into our picture of Venetian painting in the mid-15th century nor into new Paduan painting. The illusionistic details of the scholar's accoutrements at the front edge of the composition sit uneasily with the abstract background of the half-figures, and we cannot help but wonder whether the Evangelists' medallions are not in fact based on the Church Fathers' medallions in the apse, that is to say, are predicated on the new illusionism in Paduan painting. Whatever the case, they are not significant in terms of the development of art at the time.

When we come to the paintings in the apse, however, we find ourselves on more solid ground. Thanks to the clear language of the relevant documents and the confirmation of their contents in the style of the decorations, the central figure of God the Father in the mandorla can be attributed to Niccolò Pizzolo, and those of the standing figures on either side are the work of the young Mantegna, completed in 1449. All the figures are powerfully three-dimensional and enclosed within a frame that creates the impression of being concave-convex. The manner in which the figures are placed between the ribs of the vaults is very reminiscent of the decorations in the vaults of the small chapel in San Zaccaria in Venice, painted by the Florentine Andrea Castagno assisted by one Francesco da Faenza.[64] Clearly Castagno is also one of the originators of the new Paduan style. The deep fold below the knees of Pizzolo's God the Father emulates the high relief in the garments worn by Castagno's God the Father. In fact, this is not the earliest success in Padua

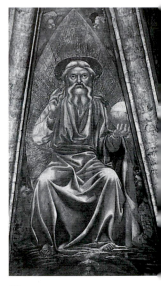

93
Venice, San Zaccaria
God the Father
(detail from fig. 92)

9.
Giotto
Noli me tangere, fresco
Padua, Arena Chapel

9
Giusto de' Menabuo:
Crucifixion
Padua, Sant' Antonic
Baptister

of the Florentine ideal of compact figuration, with its solid narrative figures almost like chess pieces. These very manly ideal figures – either block-like or cylindrical, where physical form and garments are as one and yet nevertheless still capable of dramatic movement – were first seen in Giotto's frescoes in the Arena Chapel. Later on, towards the end of the trecento, they were reintroduced to the Paduans in the bloatedly solid figures of Giusto de' Menabuoi, a native of Florence. Filippo Lippi, Uccello and Castagno came to Padua and Venice as apostles of the renewed Tuscan interest in the ideal human figure, which had been started by Masaccio: these artists were now striving for a fully perspectival human form which was then to be incorporated into a space that obeyed the same laws of optics. This trend, which gained new momentum after 1443 with Donatello's arrival in Padua, had already attracted the painter and sculptor Niccolò Pizzolo when he was still a highly impressionable young man, and he then in turn evidently pointed the way forwards for his younger compatriot Andrea Mantegna.

At first glance Mantegna's apse figures seem to belong to the same typological world and canon as Niccolò Pizzolo's art, but on closer examination we soon discover a very personal note, indeed they already manifest a very different approach to figures and forms. Unfortunately we do not have sufficient material available to us to judge whether Pizzolo's standing figures were equally well balanced and as consistently logical in their perspective. The real difference between Pizzolo and Mantegna is not merely a matter of degree, but much more deep-rooted. The Florentines had succeeded in creating the fiction of human forms, which – although they were in fact 'blocks' of garments, seemed to move like bodily organisms. The body-garment-amalgam produced a more powerful, monumental figure than could be achieved by means of a bodily organism alone. However, in Mantegna's case the garment does not add volume to the form, and does not have the capacity to generate a plastic form independent of the body. Indeed, it often seems to cling to the body, only the ridges of individual folds are able to detach themselves from the body and to reveal some of the main lines of tension between the core of the body and its clothing. Although the garment does not really seem to be able to mould itself to the shape of the body, it is nevertheless quite transparent. In short, in essence this is about a new version of the treatment of garments as we know it from classical Greece,

94

95

96

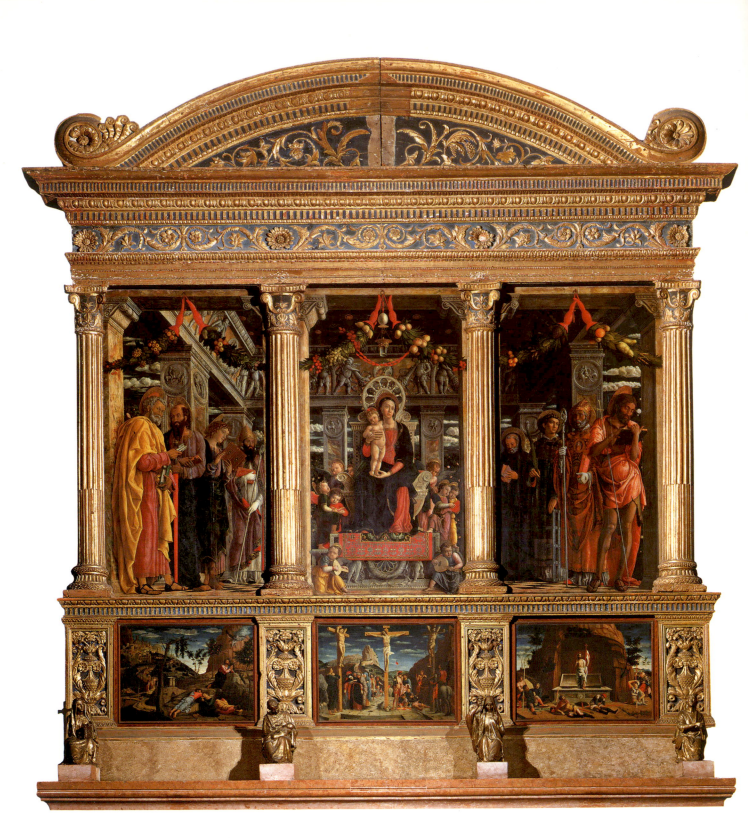

6 Andrea Mantegna, San Zeno Altarpiece. Verona, San Zeno

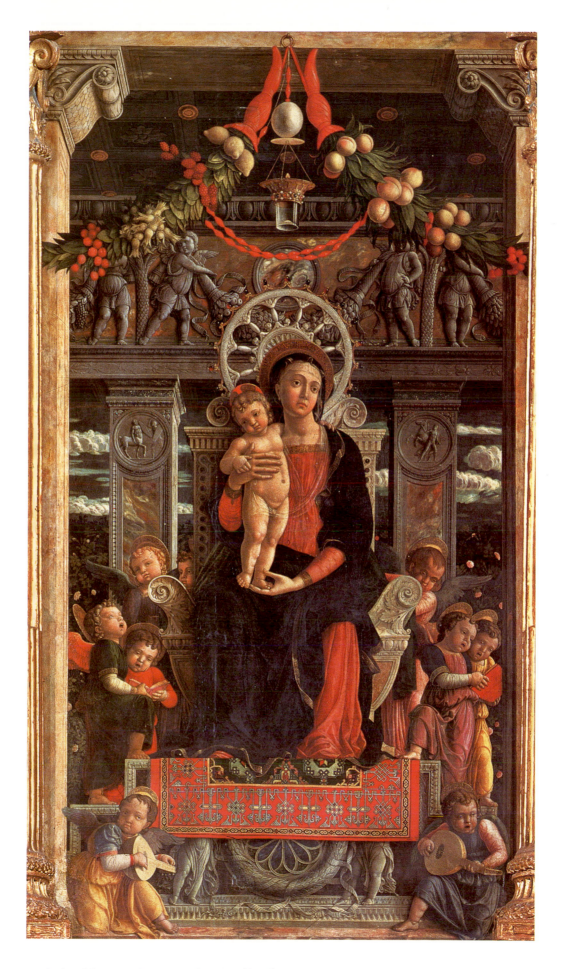

7 Andrea Mantegna, San Zeno Altarpiece (detail). Verona, San Zeno

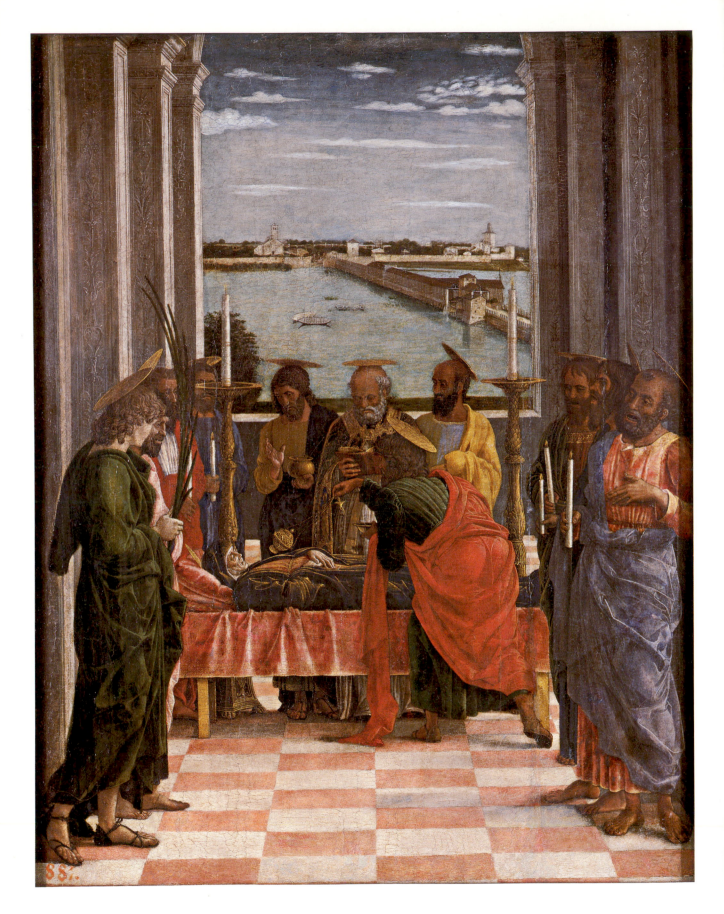

8 Andrea Mantegna, Death of the Virgin. Madrid, Museo Nacional del Prado

III
Andrea Mantegna,
St Luke Altarpiece,
Pietà (detail from fig. 110).
Milan, Pinacoteca di Brera

format and optical diminution. The half-figures of the saints on the left are also seen *di sotto in su*, although there is little of this to be seen in their counterparts on the right, in keeping with the fact that there are plentiful indications that the principle of a unified viewpoint has not yet fully established itself. Wherever one looks there are inconsistencies and small discrepancies. In the case of the central figure of St Luke, the artist seeks to 'hollow out' a spatial niche in the abstract gold ground by having the semi-circular back of the marble throne curve backwards – a rather splendid seat for a scribe – and by having the circular table top, seen from below, curve forwards. The cylindrical figures in the side-panels also set strong three-dimensional accents. At the same time, however, although the same base-line runs through all the panels – so that the figures appear to be occupying the same existential space – the side figures are in a considerably smaller format, that is to say, here the determining factor is the importance of the figures and not our view of them. The viewpoint of the beholder can justify the changed format on the vertical axis but not on the horizontal axis. Indeed, the half-figures in the upper side panels are bigger than the standing figures below, which are in fact closer to us. We might almost be tempted to wonder whether, as in a Byzantine mosaic decoration, the larger format was chosen for the upper tiers in order to counteract the inevitable diminution as one gazes at it from below. Overall we see figures arranged next to each other and above each other, in places more closely connected by various illusionistic motifs than in the Venetian polyptychs which are purely an assembly.

The St Luke Altarpiece is a clear manifestation of the dichotomy between an outmoded altarpiece structure and a modern sense of design, which could only conceive of the pictorial content as part of some imaginary spatial whole. But by now completely new ideas were circulating as to how to solve the problem of the combination of the central motif and the subsidiary figures, which also revolutionised the form of the altarpiece. Cumulative rows of figures were now replaced by the notion of the *convivium* of the *sacra conversazione*, where there is not a narrative connection between the subsidiary figures and the central figure so much as a form of co-existence, a shared conversation. The idea itself came from Florence and had first been seen in the paintings of Fra Angelico and

Domenico Veneziano; it then became known in Padua, also in three-dimensional versions, through Donatello and his workshop,[71] as early as the 1440s. In 1456, when Mantegna was commissioned by the Abbot of San Zeno in Verona to make an altarpiece, the modern solutions developed by the Florentines had already turned the polyptych into a wholly antiquated matter. In fact it seems nothing short of remarkable that in 1453/54, when Niccolò Pizzolo had already planned the relief decorations for the altarpiece in the Ovetari Chapel as a Renaissance retable with a *sacra conversazione*, Mantegna should have retained the traditional form, divided into individual compartments, for the St Luke Altarpiece.

82

Like all the most important works in the history of art, the San Zeno Altarpiece – Mantegna's first Renaissance altarpiece – is a synthesis of the most diverse impulses, not simply the solution to an individual task or a single developmental trend, but a response to the full force of the historical situation at that time. Mantegna's San Zeno Altarpiece is by no means the first *sacra conversazione* to be painted in Northern Italy. Ten years earlier in their Church Fathers' Altarpiece, Giovanni d'Alemagna and Antonio Vivarini had already created a Venetian version of the type of *sacra conversazione* composition that we know best from the paintings of Fra Angelico, but which was also favoured by Benozzo Gozzoli and other artists. Moreover Fra Angelico[72] had already incorporated the throne of the Madonna into a pilastered marble wall, thus creating a unified spatial stage with rhythmic subdivisions in the architectural backdrop. The dividing line that had previously been marked by the frame – around the outer edge of the picture – had now been relocated within the picture itself, as part of the pictorial architecture. An accumulation of individual compartments had now become a single panel, a unified pictorial space.

plates 6, 7

112

The Venetian Church Fathers' Altarpiece varies the Tuscan schema by treating the architectural backdrop less as a monumental wall with the throne incorporated into it, than as a lateral extension of the throne, which has its own platform and above all its own side closures. The figures are executed in a mixture of flamboyantly Gothic and – in the

112
Antonio Vivarini
and Giovanni d'Alemagna,
Triptych.
Venice, Gallerie dell'Accadem

113
Reconstruction of the High Altar
by Donatello in the Santo in Padua
(after J. White)

panelling on the rear wall – Renaissance styles. The important feature is the fact that the many different figures are drawn together in three main groups: the central group with the Madonna and the angels attending her, and pairs of assisting saints on either side. The latter are no longer presented frontally but are seen at an angle and one behind the other, parallel to the side walls of the throne canopy. It almost seems like an echo of shrine triptychs with wings projecting diagonally forwards. And in the Florentine *sacra conversazione* compositions we again see the assisting figures move away from the flat plane to form a semi-circle.

113 Mantegna takes up this idea, but amalgamates it with the structural principles of the three-dimensional Renaissance retable designed by Donatello for the high altar in the Santo. This connection with the work of Donatello can be assumed to be correct, although to this day it has not been possible for scholars to come up with a reliable reconstruction of the altarpiece in the Santo. No doubt Mantegna and his assistant, Niccolò Pizzolo, copied its aedicule form, a classical micro-architecture with segmented gables ending in scrolls. In Donatello's hands, the aedicule was not just a temple-like façade, but an airy structure rather like a loggia inhabited by statues. By adding two internal columns, Mantegna divided the façade into three, with a single, unified space behind it – in all likelihood Donatello's altarpiece followed the same plan. In both cases, the columns are part of the plastic structure of the altarpiece, it is only the pillars behind these that are painted. Thus the painting itself is in fact entirely illusionistic, a simulated view into a hall which – as we see from the sky and the clouds in the gaps between the pillars at the sides and the back – recedes three-dimensionally and is depicted with open air around it. Illusionistic painting which had its beginnings and its home in wall painting has now also made the altarpiece its own.

86 e, f The motifs of the illusionistic tricks in the San Zeno Altarpiece are the same that Mantegna had already used in his wall paintings. In the St Christopher frescoes it is a painted not a real column, on either side of which we can look into the interior of a single scene; here, as already mentioned, we see the *trompe l'œil* pillars. In order to confuse us and to blur the aesthetic boundaries yet further on the San Zeno Altarpiece, there is – as in the upper zones of the fresco walls – a sequence of festoons that runs through real and painted architecture. Which of the two spaces do the swags belong to, the real or the imaginary? For while they draw attention to the locus of the foremost picture plane, they also connect the outside and the inside of the aedicule, and since they are hung in such a way that they are intersected at their lowest point by the dividing columns, they ultimately form a band linking three different sections.

The moment of tragic expression is of course not restricted to the human physiognomies, and the character of Mantegna's draperies also undergoes far-reaching changes. The system of the transparent garment is retained, but the main lines on the garments become restless in the extreme, and since they appear to be of stone, the result is an agitated, furrowed, even cracked relief, which could be understood as a symptom of the deep inner turmoil of those wearing the garments. But since the earth-crust has this same texture, with the tension between a stone-hard substance and an explosive energy that is tearing it asunder – as we see particularly well in the scene on the Mount of Olives – it is clear that the figures' inner turmoil is part of a cosmic upheaval. Later on Mantegna found an ideal vehicle for this expressive style in the medium of drawings and engraving; his work in this field was long to be highly influential, on the young Dürer for one, whose late Gothic Expressionism owed so much to Mantegna's apocalyptic prints.

Mantegna himself did not immediately continue with the spiritualisation of 'pagan' classical forms that was evident in his last Paduan work. Even before he had finished the San Zeno Altarpiece in Verona the decision had already been made. He had accepted an invitation from the court of the Gonzagas in Mantua. As court painter to a Renaissance prince, his main concern would now be the problems of secular art, and no doubt he saw this situation as his best chance of pursuing his dream of the Antique. His time as a painter of religious themes in Padua was over, and with that a chapter closed in the history of Venetian painting in the second half of the 15th century, leaving us now to turn our attention to the younger members of the Bellini family, Gentile and Giovanni.

118 Donatello, Entombment of Christ, Sarcophagus relief. Padua, Sant' Antonio

THE YOUNGER
BELLINI GENERATION

In the second part of our discussions we will continue to explore the foundations of Venetian painting, concentrating as we do so on the second, crowning phase in the development of this creative process which in fact spanned many decades. For what we generally understand by the term 'Venetian painting' – namely a highly independent school – was, like Rome, not built in one day. In its formation, this supra-personal artistic phenomenon absorbed influences from the most diverse sources, even if one single artist, that is to say Jacopo Bellini, is rightly described as its founding father.

The artists we will mainly be focusing on are those of the second generation, artistically and biologically – that is to say, the younger members of the Bellini family. Jacopo Bellini's role can be summed up as that of *pater familias*, both in a spiritual and a biological sense, the originator of this particular art of painting. However, in any evaluation of Jacopo's output, we have to bear in mind the rather unusual state of research into his work; moreover there are certain facts which should not be forgotten, lest there be any misunderstanding. As chance would have it, so few of his paintings have survived by the founder of this school – whose strength was colour and the specifically painterly aspects of pictorial composition as opposed to 'disegno' favoured by the Florentine artists – that we can only have a very incomplete picture of his work. By contrast, the fact that two of his Sketchbooks have survived means that we know the draughtsman Jacopo very well in his capacity as an inventor and constructor of pictorial compositions. We are disproportionately well informed about Jacopo's pictorial fantasy compared to the little we know of how his pictorial ideas were realised in colour.

There is just one side of his painting that we know well and that is his portraits of the Madonna. From his images of the Madonna we can see that his style grew out of International Gothic, and that he long continued to pay allegiance to its ideals. Initially Jacopo appears to be conservative and outmoded, the representative of an epoch that had long since been superseded in Florence and the Netherlands. It is not until around 1440, following contact with the new Tuscan art and perhaps also with Alberti – the pioneer in the new art of perspective – that he came to a turning point and ventured into new artistic territory. Jacopo takes up the idea of using perspective to organise the pictorial space, but immediately also sees this as an opportunity to fully integrate figures into the pictorial setting. For Jacopo Bellini, the notion of the topography or landscape takes precedence over the event taking place in that setting; the event itself is a dependent variable which often – at least in his freely experimental drawings – has an episodic quality and can sink into the anonymity of pure staffage. In many of the compositions in the two drawing albums, we see the incipient victory of open spaces over figural forms, and it seems that the seed for the autonomous landscape painting of the veduta has been sown. As far as his subject matter is concerned – be it St Jerome in the Wilderness, St George and the Dragon, St Christopher, or the Annunciation – the impression is that these are simply excuses for depicting different scenarios. At the same time, the spectrum of individualised settings ranges from topographical portraits to fantasy landscapes and fantasy architecture to outright Utopias.

There is yet another aspect in which Jacopo Bellini connected with the new era and paved the way for the future: besides copies after the Antique, the Sketchbooks also contain free inventions *all'antica*, as we see for instance in his *Triumph of Bacchus*. Thus Jacopo was one of the first exponents of an important area of Renaissance art, in advance of the Florentine artists and, as such, one of the co-creators of a specifically Humanist art. His work clearly anticipates all the different qualities that are to distinguish Venetian painting for the next three hundred years, although – unless we are very much deceived – he cannot claim to be the greatest of Venetian artists. The dull, joyless colours of his compositions have little to do with the coloration now regarded as typical of the Venetians, unless we are in fact to regard the sprinkling of gold dust on the clothes of the Madonna as an early version of the famous gold light which, after about 1500, was to become one of the most unmistakable – indeed inimitable – traits of the Venetian school.

Looking back in the light of history, the pictorial world of Jacopo Bellini – as it is revealed by his two collections of drawings – seems almost like a last will and testament, or a programme, whose particular points were followed up only later, in stages, by his heirs each in their own way. Subsequently, Venice produced much greater painters than Jacopo Bellini, yet none surpassed the total grasp of creative possibilities that his work prophetically broached, not even the greatest, not even Titian.

Jacopo's pupil and executor of his estate – as well as inheriting his artistic estate in the physical form of the Sketchbooks – was Jacopo's older son Gentile. Of all the Bellinis, Gentile was to achieve the highest worldly honours, elevated into the nobility by emperor and sultan alike, and working as a 'court painter' to the Doges, although – or perhaps because – he was the most conservative of all. It is hard to gain a clear picture of Gentile's artistry, for once again few of his works have survived and of those that have, many are in a deplorable state. Nevertheless, it would be difficult not to recognise Gentile's contribution to the development of painting in his native city, with his own particular speciality, his strengths and his weaknesses.

9 Gentile Bellini, Madonna and Child with Donors. Staatliche Museen zu Berlin,
 Preussischer Kulturbesitz, Gemäldegalerie

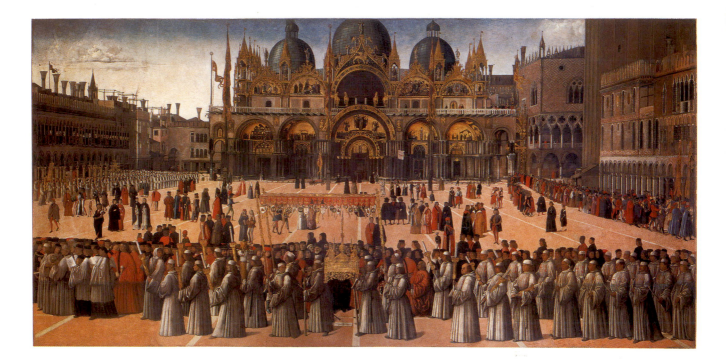

10 Gentile Bellini, Procession in St Mark's Square. Venice, Gallerie dell'Accademia

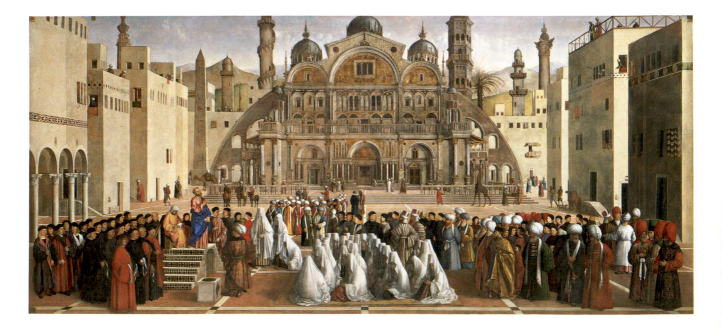

11 Gentile Bellini, St Mark preaching in Alexandria. Milan, Pinacoteca di Brera

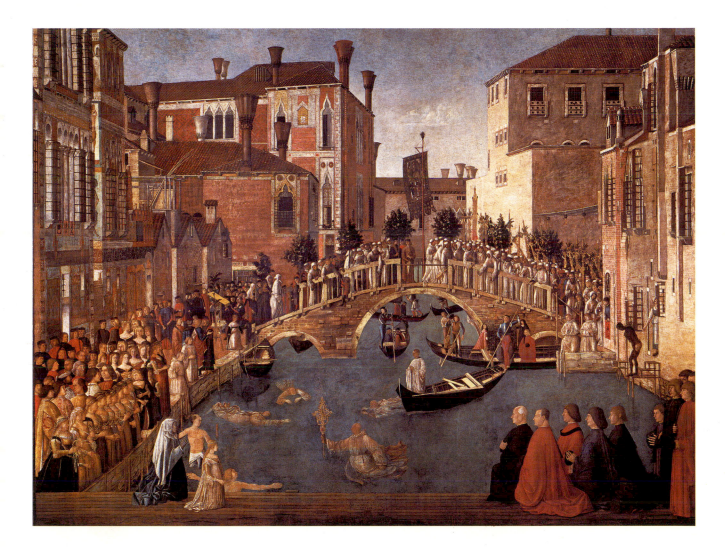

12 Gentile Bellini, Miracle of the Cross on San Lorenzo Bridge. Venice, Gallerie dell'Accademia

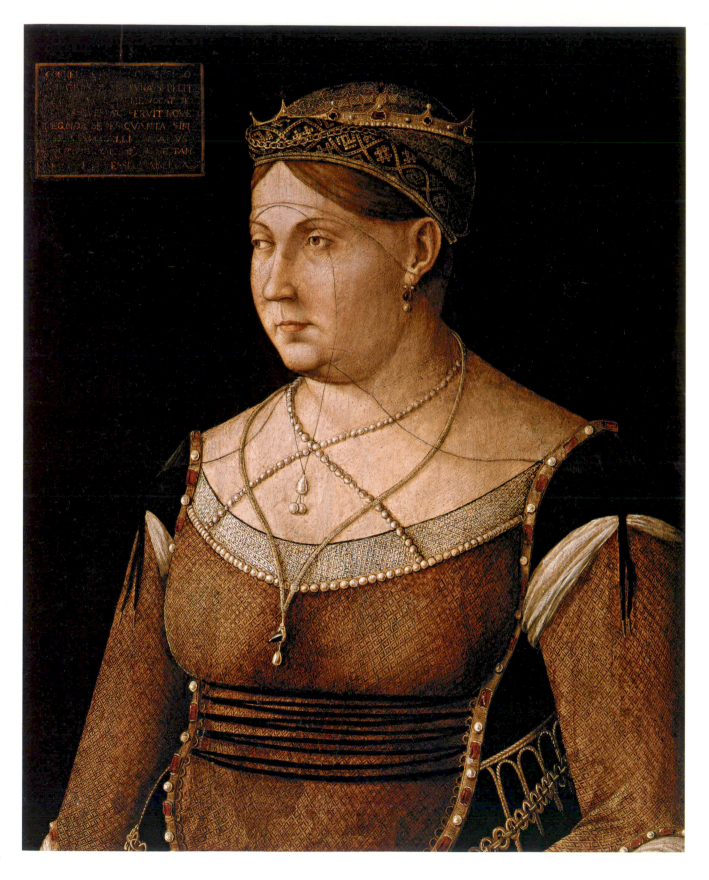

13 Gentile Bellini, Caterina Cornaro. Budapest, Szépmüvészeti Múzeum

Gentile Bellini

Gentile was most probably born in 1429 and was active for many years in his father's workshop – into the 1460s. After his father's death he took over the workshop and remained official head until he himself died in 1507.[73] We have documentary evidence that this workshop, which included Gentile's younger brother Giovanni, carried out collaborative commissions and that Gentile stated in his will that any of his own works left unfinished on his death were to be completed by Giovanni. As a result it is not always easy to identify the individual contribution and style of the various family members in the output of this collective. And it is even harder to pinpoint the artist's own development with any degree of certainty. Although authenticated works by Gentile from different decades have survived, the fact that they cover different genres of painting – such as portraiture, depictions of the Madonna, multi-figure narrative scenes – means that they appear too much like *membra disiecta* for us to be able to arrange them in any real chronological sequence. To illustrate this last point, I should just like to mention in passing the strange fact that the supposedly earliest surviving paintings by Gentile, the organ wings in San Marco, clearly owe a great deal to Mantegna, or more precisely, that the style of the figures, the pictorial space and the landscape suggest that Gentile was a diligent pupil of his brother-in-law Mantegna, rather than of his father Jacopo. By contrast, in the last decade of Gentile's life, just before and after 1500, he produced crowd scenes with no trace of Mantegna's influence. Indeed, if we were to judge his work by these last pictures alone, we would surely conclude that Gentile's art developed in a straight line from his father's art – without interruptions and without any outside influences.

In 1577, Venice was devastated by a catastrophic fire. This conflagration destroyed almost all Gentile Bellini's most important paintings. Gone were the canvases with episodes from the life of the Virgin that he painted in 1460 as his father's assistant for the Scuola di San Giovanni Evangelista. And the Old Testament pictures, including a drowning of the Pharaoh in the Red Sea, which he painted for the Scuola Grande di San Marco, had already been lost in 1483. Of the few works that have survived, there are three scenes
127; plates 10, 12 depicting the *Miracle of the Cross*, which Gentile painted towards the end of his life between 1496 and 1504 for the Scuola di San Giovanni Evangelista. A fourth history painting that has come down to us, was painted for the Scuola Grande di San Marco and depicts the sermon of St Mark in Alexandria. Having been started in 1504 it was unfinished at the time of Gentile's death. In compliance with the artist's last will and testament, it was
plate 11 subsequently completed by his brother Giovanni.

The paintings in the sequence of depictions of the *Miracle of the Cross* are the most Venetian of all things Venetian. If nothing other than these paintings had survived of that city on a lagoon, we would still be able to construct a vivid picture of the self-contained world of Venice, of a city that is without equal, we would even know something of its life – not only of aspects of its architectural appearance. In some cases, the preparatory
119, 120 drawings for these paintings have been found, and they confirm what our own immersion in the nature of these paintings already tells us, namely that the pictorial imagination of the painter is kindled by the setting and its individual physiognomy and not by the event depicted. By 'setting' we mean existential space, that particular unity of a city and

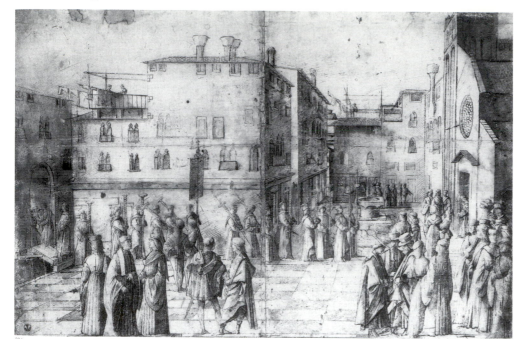

119
Gentile Bellini,
Miracle at the San Lio Bridge.
Pen and ink drawing.
Florence, Galleria degli Uffizi,
Inv. 1293 E

its inhabitants that is manifested in the very localised nature of life in that milieu, indeed the visible aspect of a whole civilisation. Whatever the contents of the painting may be, the real hero of the narrative is Venice.

The primacy of the stage over the drama enlivening it, with the densely peopled architectural view as the actual subject matter of a picture, was already a feature of Jacopo Bellini's work, in whose hands the veduta had already become a pictorial form in its own right. In the work of Bellini the father, the emphasis was still on the architectural fantasy, on utopian vistas albeit with Venetian motifs. But in his son's case the emphasis is on the

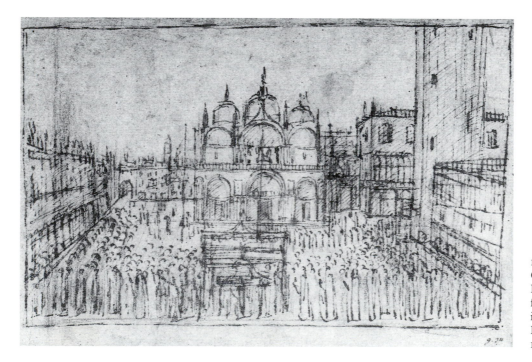

120
Gentile Bellini,
Preparatory drawing
for Procession
in St Mark's Square.
London, British Museum,
1933-8-3-12

121
Gentile Bellini,
Miracle of the Cross
on San Lorenzo Bridge.
Venice, Gallerie dell'Accademia
(colour plate 12)

realism of the architectural portrait, and if – as in the sermon of St Mark – an exotic setting, such as Alexandria, is required, which the artist knows from his own experience, then he simply transposes St Mark's Square into an Oriental environment with allusions to landmarks in Constantinople, such as the Theodosius Column or the Obelisk.

What is rather surprising, is that the later vedutas had less spatial depth than the earlier ones. Jacopo allows us to look into courtyards (Louvre 75 v) more often than he presents us with views of squares, but the axis leading into the depth is always a main structural line in the composition; our gaze is drawn into the depth, and we are given an at least partially possible view 'through' the scene, as it were exemplifying the perspective. In Gentile's case, as in the *Procession in St. Mark's Square*, although the open 'free' space is wider, and there is a greater distance between the rear and the front edge of the picture, at the same time the composition is structured by means of two frieze-like expanses of space, placed one above the other like two tiers: one showing the massed figures at the front of the 'stage' and the other showing the architectural backdrop to the scene – with the latter constructed from the façade of San Marco as a planar foil to the bulk of the procession in the foreground.

At first sight it may seem that the composition of the *Miracle of the Cross on San Lorenzo Bridge* deviates from this system of layered planar expanses. But the comparison with Jacopo's drawing of a canal veduta shows that this picture is no exception. Gentile's veduta is a horizontal format, not vertical, which as it were broadens out the canal leading into the depth and in effect turns the bridge into a flat backdrop. Although the crowd of onlookers on the left bank of the canal, together with the house fronts behind them, forms a single line of perspective, the fact that the crowd, without the slightest hint of an interruption – such as a change of spatial direction – also extends across the bridge, means that the line of the bank of the canal merges into the flat arches of the bridge, which are themselves parallel to the picture plane, thereby effectively taking the edge off the perspective. The spatial depth is 'ironed out', turned into a plane.

Within the mass of figures, the spatial articulation is predominantly produced by diagonal layering, such as the diagonal line of the kneeling figures of the Cypriot Queen

plate 12

7

139
Giovanni Bellini,
Transfiguration (detail).
Venice, Museo Correr
(colour plate 14)

not only au fait with the compositional concept of Mantegna's depiction of Christ on the Mount of Olives for the San Zeno Altarpiece in Verona but also with Mantegna's glyptic *114* style, and has moreover used these in his design for the *Transfiguration*. The San Zeno Altarpiece, the last work from Mantegna's time in Padua was not commissioned until 1456. Even if the same style is to be seen in certain earlier works, it is unlikely that Giovanni Bellini's *Transfiguration* could have been painted before 1455. Bellini depicts a terraced rock formation, with Apostles sleeping half-way up it, lying close together in an arrangement similar to that used for the sleeping Disciples on the Mount of Olives; meanwhile the rocky outcrop at the top serves as a podium for the three upright figures of Jesus conversing with Moses and Elias. It is worth noting that in terms of the iconography of this subject, it was perfectly legitimate to present a Transfiguration on Mount Tabor as a companion piece to the Prayer on the Mount of Olives. In both cases Christ is engaged in dialogue with heavenly figures, while His three favourite Disciples, who had accompanied Him into the lonely mountain region, lie asleep below. Although it has to be said that on the occasion of the Transfiguration the Disciples become aware of the theophany as they awaken.

Very much in the style of Mantegna, the group of figures stands still like statues. The choice of a vertical format allows the artist to structure the composition like a monument, forming a plastic whole from the stratified rock and the sculptural figures. The figures are clad in the 'petrified' transparent garments first introduced by Mantegna. These are descendants of classical sculptures transposed into a pictorial world, where they have awakened to new life, albeit with the exception of two figures, namely the Old Testament prophets Moses and Elias. While their heads are depicted in the style of Mantegna, much foreshortened as we look up at them from below, their monumental draperies are not

transparent nor are they intended to be so. Their bulky, macroscopic forms are defined by the pose or the movement of the figures, but they do not imply a body clad in a garment so much as they constitute a three-dimensional, tectonic form of their own. These are compositional principles that originated in Tuscany, and were first seen with their full monumental impact in the paintings of Masaccio. Examples of similarly monumental drapery had long been accessible to the Venetians in paintings by Castagno and Uccello, both of whom had worked in Venice and had carried out major commissions there. It seems that we have here a second, constitutive element in Giovanni's art, which tells us that even as a young man Giovanni was far from being slavishly beholden to Mantegna's aesthetic principles. It almost seems that by juxtaposing two neo-classical styles of drapery – the Paduan Christ figure and the two figures of Moses and Elias, robed in the Tuscan style – that he was consciously aiming to convey the opposition here between the Old and the New Testament.

The aspect of this *Transfiguration* which, even at first sight, distinguishes it from Mantegna's paintings, and which certainly was the deciding factor in its correct attribution to Bellini, first proposed by Cavalcaselle,[80] is of course not the introduction of figures that were entirely alien to Mantegna's style – which to this day has been almost entirely neglected – but rather the very different use of colour. Of course, Mantegna, too, treats light as a means of introducing order into the composition; in his case, too, the light and dark values are all consistently in keeping with an assumed external source of light illuminating the scene from the side. But in Mantegna's case, light always plays a subservient role, it never impinges on the independence of the local colours. Each local colour generates its own light and shade, with the result that the paler areas of a blue ground, for instance, might have very little in common with the paler areas of a red or a green. In Bellini's *Transfiguration*, however, the very light has a colour of its own which is apparent in combination with or even in addition to the ground colour. It is a lemon-coloured light, which is not only seen as it refracts with other colours, nor simply as a means to model three-dimensional forms, but is also perceptible in its insubstantial, purely optic nature as a coloured glow. And just like the brightly lit areas, so, too, the shaded areas also have a particular tone in common – a coloured chiaroscuro somewhere between brown, green

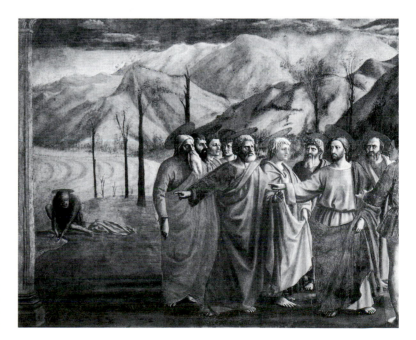

140
Masaccio,
Tribute Money,
Fresco in the Brancacci Chapel.
Santa Maria del Carmine, Florence

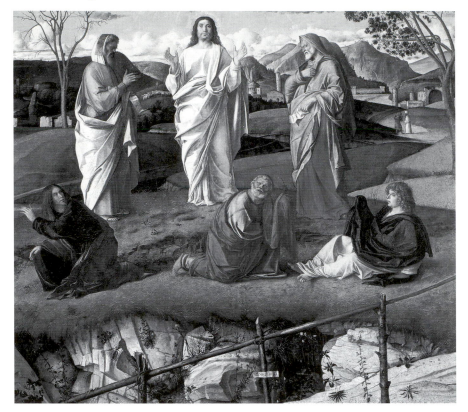

141
Giovanni Bellini,
Transfiguration (detail).
Naples, Galleria Nazionale
di Capodimonte
(colour plate 15)

and black – which is generally concentrated in landscape backgrounds and, in a faintly melancholic way, has an immensely calming effect on the eye. Here we already have a foretaste of how light will be used to create atmosphere in later Venetian painting. In this particular case, the painter has used the darkness of the distant landscape as a contrast to heighten the brightness in the sky above it: a whitish yellow gradually giving way to blue, against which the three figures on the mountain top stand out powerfully. These, too, are painterly effects that one would be hard put to find in Mantegna's work.

Two decades later, Giovanni portrayed the same theme in a horizontal-format com-position, splendidly ignoring the need to create the setting demanded by the subject. *141; plate 15* Mount Tabor has become a plain, or at best a high plateau, as the cliff face in the fore-ground would appear to indicate. In order to at least imply the altitude of the scene, the painter decided to include a railing in the foremost part of the scene leading from diag-onally below the picture up onto the pictorial 'stage'. The factual circumstances had to yield to the formal parameters: the new landscape ideal of a flat expanse extending across the painting was neither suited to a vertical format nor was it compatible with a moun-tain rise dispelling any notion of open spaces.

The first examples we encounter of just such a landscape, extending into the pictorial depth rather than upwards, are in Jacopo Bellini's Sketchbooks, marking the demise of *57* the terraced landscapes inherited from Antiquity and revived in the late Middle Ages. In terms of the history of landscapes, the craggy rock formation in the foreground is a last echo of that earlier landscape convention, as are the more dramatic *Madonna of the Quarries* by Mantegna or the *Virgin of the Rocks* by Leonardo da Vinci. The ancestry of the *142, 143* flat landscape is rather different. Jacopo had responded to the quattrocento reformers in Tuscan painting by taking the new magic formula for organising pictorial space – namely perspective – and applying it to open spaces, to the landscape, instead of to interiors or

architectural views as was the custom. Architectural settings were inherently geometric, in such a way that the laws of perspective could readily be demonstrated. In the case of an open landscape, the challenge was to find visible equivalents in nature which could convey the implicit presence of invisible lines of vision, albeit without imposing some *58* alien order on nature. Like Ambrogio Lorenzetti and the Limburgs, Jacopo found suitable material in the cultivated landscape, in nature that had been domesticated, tilled and ordered by human hand. Ploughed furrows and territorial divisions provide a natural geometry at ground level, while the verticals – 'disguised' as trees or upright figures, distributed throughout the scene – allow the eye to read the meaning of their decreasing size as they recede into the distance. So the 'art' of the painter is to portray this as subtly as possible, for the strength of the illusion of reality depends on the extent to which the whole can create the impression of a purely chance arrangement.

Twenty years after Giovanni had set out on his career as an artist, as we can see from the Naples *Transfiguration*, the new concept developed by his father in the 1450s suddenly captured his attention, and Jacopo deposed the younger Mantegna as a source of inspiration. At last Jacopo's teaching bore fruit and a specifically Venetian style of landscape painting emerged in a wholly painterly form. For it was Giovanni's very particular qualities as a painter that were to be of such crucial importance in the realisation of the new landscape concept.

plate 16 The figures in the *Transfiguration* are now no longer positioned on rocky outcrops, one above the other, but at various distances on the same plane. The Apostles only appear to be below Christ and His companions because they are down on the ground and closer to the lower picture edge. At the same time, great care has been taken to ensure that this first, lower group of figures cuts as little as possible into the group behind. The standing figures are placed in the spaces between those crouching or cowering forms, and it is as though their shocked withdrawal sideways and their humbly bowed heads expose the sight of the three supernatural figures in dialogue. Compared to the earlier version of the

142
Andrea Mantegna,
Virgin and Child
(*Madonna of the Quarries*).
Florence, Galleria degli
Uffizi

143
Leonardo da Vinci,
Virgin of the Rocks.
Paris, Museé du Louvre

144
Giovanni Bellini,
Transfiguration,
(detail from colour plate 14)

story, this is a much more dramatic narrative. In the Venice *Transfiguration* only Peter becomes aware of the vision, the others sleep on, and Peter has to twist his head upwards, with the result that the foreshortening is seen in the context of his excitement and the two zones seem to connect. In the Naples version Bellini did not seek to convey the supernatural nature of the group of three by placing them on a higher plane. Their heavenly dialogue takes place here on Earth, and that there is something extraordinary afoot is only evident from the behaviour of the three Disciples, who look as though they would dearly like to escape the awesome event just behind them. The impression that Christ and His companions are figures from beyond, despite their feet being firmly planted on the ground, is greatly increased by the fact that Bellini has not only clothed Christ in white robes but also that he has depicted Him with His gaze turned heavenward and His hands raised, in just the pose that immediately calls to mind thoughts of Christ's Ascent into Heaven, when He in fact left this Earth. In the Venice *Transfiguration*, Christ, Moses and Elias show unmistakably by their gestures that they are in dialogue with each other, whereas the Christ figure in the Naples version faces directly forwards and seems utterly remote, separated by an invisible barrier even from the reverential figures on either side of Him.

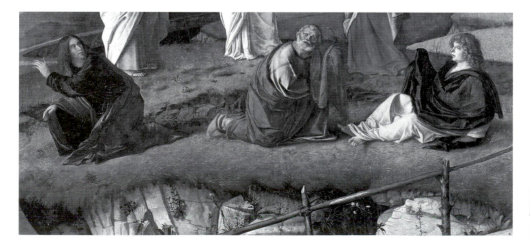

145
Giovanni Bellini,
Transfiguration,
(detail from colour plate 15)

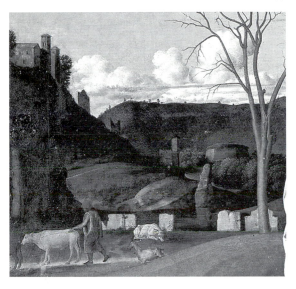

146
Giovanni Bellini,
Transfiguration,
(detail from colour plate 15)

The strongest light falls on Christ: yet another means to heighten the visionary aspect of the central figure. A suitably gentler light illuminates the colours on the garments of the figures to either side of Him. Dark, dingier and hence heavier colours – chestnut brown, olive green and dull blue – are reserved for the figures of the Disciples close to the ground. This is balanced in turn by the paler cliff-face below, which prevents the composition as a whole from becoming too ponderous. On the plateau and the mountain ranges in the distance, the main colour is a velvety brown-green, providing a common backdrop for all the figures. The surface of the earth is not marked out by the furrows and faintly visible winding paths favoured by Jacopo – although admittedly we can only go by his drawings – instead the linear organisation of the pictorial stage is replaced by a distinctive colour regime. The darkest tones occur at the most distant point in the picture, where the colour of the vegetation merges into the semi-darkness of shady mountain sides. And keeping in step with the earthy tones of the areas of colour, sharp outlines soften with increasing distance; potential movement is embedded in the calm permanence of nature. In the distance no sounds are heard, not even from the genre-like detail such as cattle returning from the field, just visible in the darkening background. A mood of peaceful repose spreads sinuously over the entire picture, pervading it. We have taken our first steps towards the landscape idyll.

Between the fixed points of the two *Transfigurations* it is not hard to relate moments in Giovanni's development to particular compositional aims. But it is advisable to proceed with caution here, because insight gained in one area cannot simply be applied to other areas of the artist's work, since, to a certain extent each conforms to its own conditions, and cannot be synchronised with others. At the same time, it should also be noted that purely narrative compositions like the *Transfigurations* only occur very sporadically in Giovanni's œuvre. Nevertheless, it seems natural at this point to consider one such composition in detail, namely his famous depiction of Christ on the Mount of Olives, known as *The Agony in the Garden* and now in the National Gallery in London. On one hand the significance of Mantegna's art as a source of inspiration is very evident; on the other hand there is no mistaking the originality of the aims that Giovanni Bellini set himself in this work.

plate 18

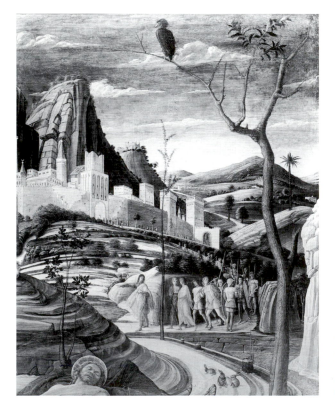

147
Jacopo Bellini,
Judas leading the Roman Soldiers;
Agony in the Garden
London Sketchbook, fol. 43 v, 44

148
Andrea Mantegna,
The Agony in the Garden (detail).
London, National Gallery
(colour plate 17)

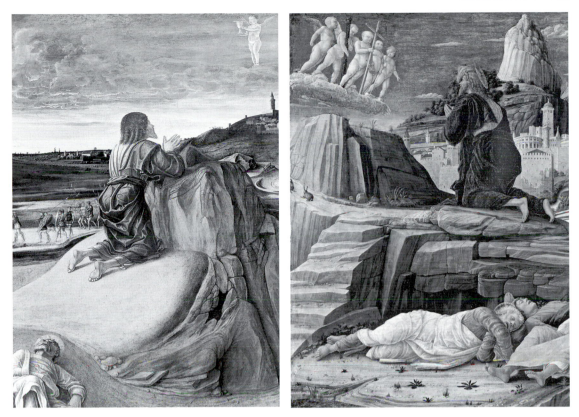

149
Giovanni Bellini,
The Agony in the Garden
(detail).
London, National Gallery
(colour plate 18)

150
Andrea Mantegna,
The Agony in the Garden
(detail).
London, National Gallery
(colour plate 17)

Christ on the Mount of Olives. The comparison frequently made between the depictions of Christ praying in the Garden of Gethsemane by Mantegna on the one hand and by Giovanni Bellini on the other, is one of the most edifying in art history, particularly when their shared lineage is traced back to Jacopo Bellini. Jacopo's Christ kneels on a corkscrew rock formation, that ancient formulaic terrain that was not initially associated specifically with mountainous regions; it was simply read as landscape background. Christ and the Disciples are pressed closely into the hollows of the rock, becoming one with the landscape. To the right we see the city of Jerusalem, with the multitude streaming out from it and approaching along a serpentine path. In both halves of the composition our eye has to clamber upwards into the spatial depths.

Mantegna has turned the corkscrew mountain into a perspectively stratified rock formation, the main section of which consists on one side of a horizontally layered lower section, which serves Christ as a platform, while the Disciples lie closely pressed up against the lower edge; on the other side it consists of a vertically stratified section crowned by a group of angels floating in the sky above it. The serpentine path with the approaching multitude is not placed separately to one side, but accompanies and continues the winding sweep of the mountain. The horizontal layering of the scene as a whole is echoed in the stratified slope in the distance; at the same time there are also a number of strong vertical accents, the bare tree trunk in the foreground by the right-hand edge of the composition, the brow of the hill on the far left with a flight of rough hewn steps leading up to it, and finally the figure of Christ Himself. These verticals resonate all the more clearly due to the towers in the background and the precipitous mountain peaks. Figures and landscape all serve one single, rigorous sense of order.

Mantegna resolved the dichotomy evident in Jacopo's composition by choosing a very 'tall' landscape format; it is not until Giovanni addresses the subject that we see a more

elongated panel. If one approaches this work with Mantegna's *Agony in the Garden* in mind, then it seems that everything has been extended laterally. The horizontals clearly dominate the scene. Christ does not kneel above the Apostles; instead a gentle slope leads diagonally up to the figure kneeling in prayer and then further upwards, following the line of vision of Christ in prayer up to the angel appearing in the clouds. At every stage the gaze has to cross considerable empty spaces as it moves from one figure to the next. The pictorial space is not filled up with rocky formations, only allowing glimpses into the distance on either side: in Giovanni's *Agony in the Garden* open spaces characterise both the foreground and the distance. Even the rocky hill that rises up to Christ like a prayer stool seems rather lost, an isolated interruption in an otherwise open expanse. The inspiration for this came from the flat landscapes favoured by Jacopo in his late years. Perhaps it was not so much a memory of his father's achievements, not so much a backwards glance as the fact that the legacy inherited from his father had simply come into its own, having been unable to bear fruit at the time of Giovanni's first depiction of the *Transfiguration* when he was still in thrall of Mantegna's influence. We know of no depictions of the Garden of Gethsemane from Jacopo's late period, but there is a drawing of *St Jerome in the Wilderness* which contains precisely the landscape schema that Giovanni chose in *38* preference to the arrangement in Mantegna's *Agony in the Garden*. The horizontal strip of sea in the middle ground of Jacopo's landscape has become the road along which the multitude is approaching. In Giovanni's composition this horizontal strip is echoed by other parallel strips, which are created by having the ground alternately between grassy areas and bare earth. In view of the definition of the pictorial space by means of this sequence of parallel horizontals, one behind the other, the function of the meandering paths, leading into the distance, takes on no more than a secondary role; it is only on the far right and far left of the composition that we still see the familiar, dramatically foreshortened serpentines.

What immediately distinguishes Giovanni Bellini's *Agony in the Garden* from that of Mantegna, is not so much the different spatial structure as the innovative coloration – with the light becoming a decisive unifying factor in the composition. The illumination of the scene is highly individual. The sun has already sunk behind the horizon, creating a sharp contrast between the still light sky and the mountain sides already cast in shade. A second concentration of brightness occurs in the foreground – not entirely rationally – in the barren void between the sleeping Apostles and Christ, while the other side of the rock formation and the green patches at its feet are slipping into darkness. Even before we can identify the events taking place in this landscape, the illumination of the scene – both uniting and dividing it – has set the tone, which then affects our response to each detail. This radical creation of a mood through light – aided by the theme of the painting – was, however, a special case, and if we look at it more closely, it soon becomes apparent that there is still an inherent discrepancy between the calming effect of the mood of the lighting and the uneasy furrows and folds in the Mantegnesque garments. The London *Agony in the Garden* must have been painted before the Naples *Transfiguration*, where these two compositional elements are perfectly balanced.

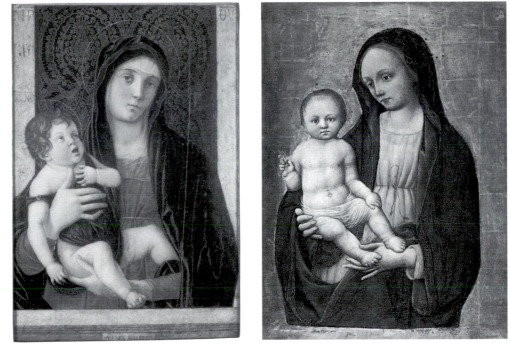

151
Giovanni Bellini,
Madonna dell'Orto.
Venice, Madonna dell'Orto,
lost (colour plate 19)

152
Antonio Vivarini,
Madonna and Child
giving Blessing.
Venice, Gallerie dell'Accademia

Paintings of the Madonna. Let us now turn to Giovanni Bellini's paintings of the Madonna
– not only because he was to make this subject so very much his own, but also because
he tirelessly addressed it anew at every stage of his artistic career, to the extent that it
provides an unequalled opportunity for us to examine the entire course of his stylistic
development. Accustomed to seeing examples of Giovanni's concept of Marian imagery
in the paintings of all the leading Renaissance artists – by which we mean the half-length
figure of the Mother of God – we all too easily accept Giovanni's practice simply as a
matter of course, which has no need of further comment, quite unaware of just how 'un-
historical' our supposition is. For as soon as we delve a little deeper, it becomes clear that
in Early Renaissance painting – unlike in the trecento – there were very few schools pro-
ducing half-length depictions of the Madonna; indeed, in the case of the great painters of
the Florentine quattrocento, for instance, these were very much the exception, and in cer-
tain cases – such as Masaccio for one – would scarcely have been imaginable. And so it is
that a painter such as Botticelli produced a whole number of images of the Madonna,[81]
but only very seldom as a half-length figure pure and simple; generally he would add
ministering angels or would extend it into a three-quarter figure. And if we look at the
work of Fra Angelico, the quattrocento painter whose art manifests the deepest of
religious feeling and whose devotion for the Madonna was certainly no less than that of
other painters, we find not a single half-length depiction of the Virgin. During the 15th

152
century, the classical home-ground of simple, icon-like images of the Madonna was
Venice, and of all the artists in the Venetian school of painting, which flourished until
the 18th century, Giovanni Bellini was the painter of Marian portraits *par excellence.* In his
case one could almost talk in terms of a genre of Madonna painting, just as one talks of
landscape painting as a genre in the 17th century.

151; plate 19
 Of all the paintings of the Madonna by Giovanni Bellini, just one is still in a church to-
day, that is to say, in a chapel in the Church of Madonna dell'Orto in Venice. While we
cannot be certain whether it was exceptionally intended from the outset as an altar paint-
ing, it would be a perfectly possible – in a church named after a painting of the Madonna

153
Michele Giambono,
Madonna and Child.
Rome, Galleria Nazionale

which was miraculously discovered in a neighbouring garden. The fact is that images of the Madonna of this kind and format did not serve in the quattrocento as altar paintings in places of public worship, but were used for private, intimate devotion, for services in private households. This had not always been the case. In Byzantium there were famous icons of the Virgin in public, sacred places, although of course not as altar decorations in the Western sense of the term. As the Byzantine Madonna in all her various iconographic variants – Eleousa (the Merciful), Glycophilousa (sweetly kissing), Platytera (wide as the Heavens) and so on – were assimilated by the painters of the Italian trecento, the half-length figure of the Madonna won a central position on altarpieces in public places devoted to the cult of the Virgin. Particularly in Sienese painting in the trecento, but also in other regional centres, it frequently appears as the central section in a low, multi-panel altarpiece.[82] Somewhat surprisingly, it then disappears from the altarpiece in the first half of the quattrocento. The reason for this could be that the altarpieces were now being designed differently, and that there was a tendency to do away with multi-part structures. And it would seem that a half-length figure of the Madonna was not deemed suitable as the sole altar painting, nor had it functioned as such in the trecento either. Strictly speaking, the focus of the trecento altarpiece was not any kind of image of Madonna, but rather an early precursor of the *sacra conversazione*, that is to say, a composition with a number of figures. Only on an abstract intellectual level, when items are omitted and the side-wings are deliberately removed, does a bust of the Madonna wrongly appear as the sole image. As yet, no detailed research has been carried out which would tell us when a painting of the Virgin Mary, imbued with the special aura of a miraculous image of mercy, was first allowed to take up sole occupancy of an altarpiece.

By far the majority of the Venetian half-length images of Madonna were certainly made for private devotion at home. Works by Giambono[83] and Jacopo Bellini could stand as typical examples from the first half of the century. Giambono's panels present a whole number of subtle variations of the Glycophilousa theme that was so popular in the International Gothic Style, both north and south of the Alps. Credit for her popularity should

153, 8

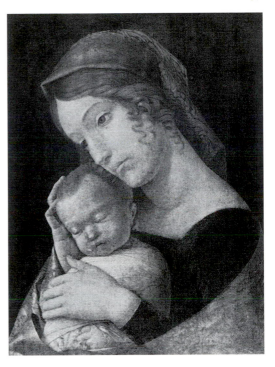

154
Andrea Mantegna,
Virgin and Child.
Staatliche Museen zu Berlin,
Preussischer Kulturbesitz,
Gemäldegalerie

go to the Limburg Brothers, although this is certainly not to say that they invented the iconographic motif. In the Marian imagery of the Gothic era, the pendulum swings from the notion of the Virgin Mary as the Queen of Heaven, enthroned above the clouds, to that of the *Madonna humilitatis*, close to the ground, a mother feeding her child. The Glycophilousa in the International Gothic Style introduces a new aspect into the image of the Virgin as a mother. The tender mutual embrace expresses the sense that Mother and Child are there for one another: a devotional image which pays scant heed to the devotee kneeling before it.

In his more mature works, Jacopo Bellini presents a diametrically opposed reading of the subject, although the style of figure is not so very far from that of Giambono. Jacopo's Mother and Child face directly towards the worshipper, Mary presents the Child as formally as possible, so that He may give His blessing in a fitting pose. Sometimes the Child has even adopted the correct pose Himself, but since His footing is as yet unsure, He has to be supported by His mother. Perhaps the most characteristic of these is the panel in Lovere, in which Mother and Child appear in almost heiratic frontality and with parallel central axes. And it is not without reason that the Virgin is suddenly wearing a crown again. Yet it seems as though a veil of some kind were lying over the figures, softening the rigour and the rigidity of the composition. The half-length figure is explained by the fact that the Child is standing on a balustrade, on a parapet, as though He were blessing the faithful from the window of a 'benediction loggia'.

plate 3

This type was the starting point or at least a main source of the paintings of the Madonna by Giovanni Bellini. In some of his very early Madonnas, the overall structure is extremely similar to it, although Giovanni avoids the rigorous frontality and the hieratic expression of his father's images of the Madonna. In Giovanni's case, the heads of Mary and the boy Jesus are gently inclined sideways towards each other, the gesture of blessing becomes somewhat more perfunctory or is omitted altogether and replaced by playfully genre-like movements on the part of the Child. As well as this, Giovanni replaces the rounded forms in his father's paintings with more articulated, varied modelling

of lying on His mother's lap, the tiny Child is placed on the cold marble of the parapet, with a pillow under His head. In this rather precarious position, He is worshipped by Mary with her hands clasped upright in prayer. While this is clearly an Adoration of the Child, it is not simply an adaptation from a Birth of Christ, which, as we know, frequently included the Virgin kneeling in worship before the Child in the 15th century. Certainly it would have made perfect sense to take the motif of Adoration from the Nativity and to transfer it into a composition that was clearly intended as a devotional image, yet some further explanation is still needed for the Child's sinking-into-sleep.

The analogy of sleep and death was too familiar in the Middle Ages for there not still to have been a readiness in the quattrocento to read the sleeping Child Jesus as a pre-figuration of the Redeemer sacrificed on the Cross. Nevertheless, in the work of the Vivarinis, who, as we have already mentioned, first introduced this motif, I can find no indications that this notion did indeed play a part in the genesis of this motif. In Giovanni Bellini's case, however, it seems to me that it is very much within the realms of probability that this was an allusion to Christ's death at the Crucifixion. Scholars have long been aware that the pose and form of the Child in this painting by Bellini resembles the figure of Christ in certain Northern depictions of the Pietà, specifically in details such as the right arm hanging loosely downwards and the left shoulder turning upwards parallel to the picture plane. It is possible that Bellini – who did after all include a painted version of a sculpted Pietà group in one of his very late works – may well have been inspired in this early image of the Madonna by a carved statuette of the Pietà. Numerous Pietà statuettes were and still are to be found in the Venetian hinterland, the *terra ferma*, for the North virtually had a monopoly on this devotional genre. Bellini will certainly have been familiar with the form. Moreover, it is perfectly possible that the Vivarinis themselves found their motif of the Madonna worshipping the sleeping Child in the same Northern art milieu and in fact took it from sculpted images. In Friulan altarpieces, which take the Venetian form, but where the figures are made using the techniques and language of Gothic wood carving, this motif seems to be present even before 1450 – however, the chronology of these provincial sculptures is as yet somewhat uncertain.[86] If we could be sure that the Friulan Madonnas came first, then this would mean that this Madonna type

160

160
Altenstadt Pietà,
Salzburg School, ca. 1400.
Feldkirch, Dominican
Convent

161
Enguerrand Quarton,
Pietà (detail).
Paris, Museé du Louvre

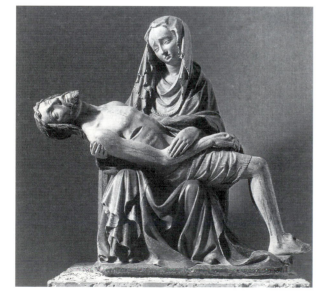

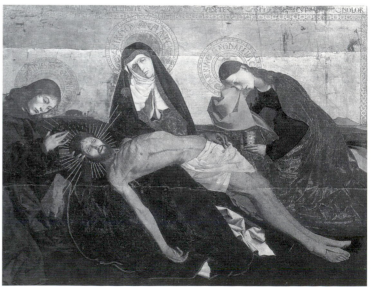

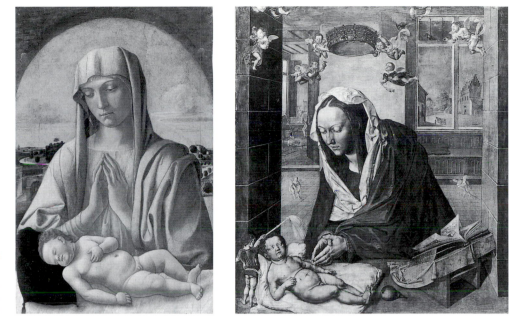

162
Giovanni Bellini,
Madonna and Sleeping Child
(Davis Madonna).
New York, Metropolitan
Museum of Art

163
Albrecht Dürer,
Marian Altarpiece (detail).
Staatliche Kunstsammlungen,
Dresden

also first appeared as a sculpted figure and was later transposed into painting. It looks very much as though Bellini's Madonnas had more than one Northern root. To confirm this interpretation we could point to some analogous instances with their origins in western 161 Europe, for instance the renowned painted Pietà of Avignon, by Enguerrand Quarton, in which the Virgin is praying to the corpse of Christ lying across her lap.[87] As well as this there are various French miniatures which represent a remarkable fusion of Pietà and Epiphany. Common to all is a cross-fertilisation of sculptural and painterly attitudes.

A number of paintings, although some may simply be workshop replicas, show that in the 1470s Giovanni Bellini was experimenting with a new version of the theme of the 162 Madonna worshipping the sleeping Christ Child. He relinquishes the strictly frontal pose of the Madonna, thereby also doing away with the symmetry of the compositional structure: Mary turns sideways in a three-quarter profile towards the Child, her prayer loses its hieratic quality and becomes more of a spontaneous response. The relationship between Mother and Child is much more active, and as we know, Dürer took this same pose 163 as the basis of his Marian altarpiece in Dresden. Bellini, however, soon abandoned the motif of the Child asleep; it is as though the Child has awakened, and is now gazing out at the viewer a little sleepily.

There is one significant early 16th-century painting – either by Bellini or Basaiti, there is no general agreement – which returns to the notion of the sleeping Christ Child, but the Madonna is no longer a half-length figure. We see more than three-quarters of her, and she is depicted seated on the ground, in a meadow with a wide expanse of land- plate 21 scape behind her. This was the period when the Holy Family resting on the Flight to Egypt had become topical in German and Netherlandish painting, giving painters an excuse to portray the Mother and her Child as part of a landscape idyll.[88] And so, too, in Bellini's case, the landscape – which the Venetian painter treats more as background than ambience – sets the mood for the figures. The intention is to convey the harmony between the calm of nature and the gentle slumber of the Child. And the Child no longer lies parallel to the lower edge of the picture, but is placed pointing diagonally inwards on His mother's lap. Virtually parallel to the Child is His mother's arm as she raises her hands

164
Donatello,
Chellini Madonna,
Bronze relief.
London, Victoria & Albert Museum

in prayer, this in turn is echoed in the line of the shoulder leading up to her gently inclined head. Thus while the diagonals are accentuated in the two figures, in the landscape the emphasis is on horizontals and verticals. The strongest unifying factor is the sunlight, which penetrates the colours on the figures, the landscape and the sky, and imbues the whole scene with its calm quietude.

However, it would be wrong to imagine that the developments that led to the theme of the Madonna actually worshipping the Child were without any influence from outside. In the quattrocento the most dramatic stimuli always came from Florence, and so it was in this case, too. It is true to say, as we mentioned earlier, that the Florentine painters in the early quattrocento contributed little to the development of the half-length figure of the Madonna. At the same time, however, the Florentine sculptors were hugely influential – Donatello, for one, whose activities in Padua in the late 1440s provided Northern Italy with an object lesson in Florentine art. Of the various Madonna types favoured by Donatello, all portray a dramatically intense relationship between Mother and Child. A Madonna relief of this type, now owned by the Victoria & Albert Museum, could very *164* well have served as a source of inspiration for Giovanni Bellini's *Madonna of the Meadow*. In Donatello's case a rail of sorts partly explains the energetic-looking, upright posture of the Child. The inclined head of the Mother counters the energy of the Child, and she gently holds His arm. It is interesting to note the manner in which the Madonna's shoulder is the hinge for her movements, it is from there that she bends down towards the Child. In Bellini's case, the outline of the Madonna runs almost diagonally all the way from the elbow. The angle of her head is much milder than in Donatello's relief, and does not have the same spontaneity. But the main difference between the Florentine and the Venetian Mother and Child is in the role played by the gaze in each. In Donatello's relief, Mary is gazing at the Child, while the Venetian Madonna's gaze is much more vacant, it is a purely contemplative looking: Bellini's figures are poised on the threshold between waking and sleeping.

If we look at it correctly, then it could be said that the half-length depictions of the Virgin worshipping the Christ Child are a physical expression of the devotional nature of this very unusual genre. Our relationship to the image, which in this case has the old iconic role and significance of a substitute for the divine object of worship, is expressed within the picture. The Madonna worships on behalf of the faithful; however, the depicted oneness of Mother and Child at the same time weakens the relationship to the devotee kneeling before the image: the mortal worshipper turns back into an onlooker. A satisfactory solution to the problem of the devotional image would evidently only be found if the activation and intensification of the Mother-Child relationship did not negate the dialogue – crucial to the survival of the devotional image – with the faithful beholder, that is to say, when the Mother and Child, despite their own deep bond, turn towards the believer approaching in worshipful devotion or are already facing directly towards him or her. From the 1460s onwards, we see Giovanni Bellini constantly striving for a solution along these lines.

Giovanni thus resolutely returns to the standard frontal Mother and Child which his *plate 3* father had never strayed from. The Child is positioned, one could say presented, for worship by His mother, albeit not so stiffly as in Jacopo's case and not always with a hand raised in blessing. This is still a child, that is to say, not yet able to stand properly. In just *165* one, relatively early Madonna and Child, Giovanni closely follows his father's hieratic version with the Child standing upright, issuing a blessing. And it is symptomatic that with the spherical Child's head he is also returning to the type preferred by his father, and

165
Giovanni Bellini,
Madonna and Blessing Child
(Contarini Madonna).
Venice, Gallerie dell'Accademia

166
Giovanni Bellini,
Madonna 'dei cherubini rossi'.
Venice, Gallerie dell'Accademia

in fact casting aside for good the longer, more articulated form which both he and the young Gentile had adopted from the Squarcione tradition. But the Madonna's grasp on the Child is not merely a gesture, as in Jacopo's case, for here – as in all non-hieratic variants – it is a mother's concerned hold on her child, a protective grip. And it is only ever as a result of the closest physical contact that the heads of Mother and Child almost touch. As far as possible, Giovanni avoids placing their heads in parallel next to each other, by depicting either the head of the Child or that of the Madonna frontally and the other inclined to one side in a three-quarter view. Generally, only one pair of eyes gazes out at us, with its line of sight crossed by the eyes of the other. The gaze of one touching that of the other is the non-corporeal complement to the Mother embracing the Child.

One of the most perfect solutions of this compositional idea is the so-called *Madonna degli alberetti* at the Accademia in Venice, one of the few paintings by Bellini that we can date with certainty. It was made in 1487 at a time when he was painting his major, many-figured Madonna compositions, the outstanding versions of the *sacra conversazione* in San Giobbe and in the Church of the Frari. This small painting of the Madonna has acquired its name from the two trees symmetrically flanking the Cloth of Honour behind the Madonna, like the paradise palms framing divine personages or the figures of the Blessed in early Christian and early medieval paintings. The Cloth of Honour, sometimes brocaded, appears much earlier in conjunction with this Madonna type, a colourful replacement for the gold leaf of older Byzantine and Byzantinesque icons of the Madonna, as alluded to by the MP θY in the Brera painting. The motif of the Cloth parallel to the picture plane guarantees the stability of the composition as a counterweight to the volatile movement of the figures. But it seems that Bellini soon felt that the flat plane of the Cloth was both restrictive and detrimental to the illusion, so he started to include

167; plate 22

203; plate 30

a strip on either side with a vista of the distant landscape. While the inclusion of the two *alberetti* does not detract from the illusion of an open expanse, the accentuation of the verticals heightens the dignified character of the composition.

Of course we should not forget that in Bellini's œuvre there are numerous variants of the Madonna types discussed here, or rather, that amongst the works produced by his workshop and his assistants, many of which are known by his name today, there are certainly many more Bellinian versions of the Madonna. Very few can definitely be attributed to the Master. Of these, there are some that show that Bellini was experimenting with a three-quarter figure of the Madonna, whose lap could be used for the Child to sit on. The aim was to monumentalise the half-length figure by increasing the format, as in the narrative devotional images with their three-quarter figures and no scenic ambience that had continued to occupy the imaginations of painters in Northern Italy ever since Mantegna's *Presentation in the Temple* and Jacopo Bellini's *Mourning of Christ*. This in turn opened up the possibility of presenting the theme of the *sacra conversazione* with half-length figures. Worthy of particular note are above all two versions of the *sacra conversazione* with female saints assisting; for in these Bellini succeeded in giving visual form to the motif of worship at the same time as having the central group with the Madonna facing directly towards the beholder, that is to say, without detracting from the dialogue with the believer contemplating the scene. Towards the very end of his life, Giovanni Bellini returned one last time to the theme of the devotional image of the Madonna. In this late work, he took the elements of the *Madonna degli alberetti*, made thirty years earlier, and transposed them into the new, generous spaces of a composition with a relatively large, three-quarter length figure. The two narrow views of the landscape on either side of the Cloth of Honour have very noticeably widened, and have in effect grown together into one landscape, which provides a strong, horizontal counter-balance to the upright of the Madonna and Child in the centre.

166

99, 27

168

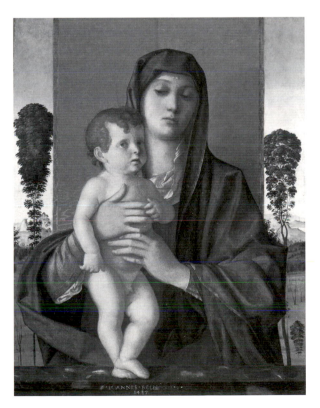

167
Giovanni Bellini,
Madonna 'degli alberetti'.
Venice, Gallerie dell'Accademia
(colour plate 22)

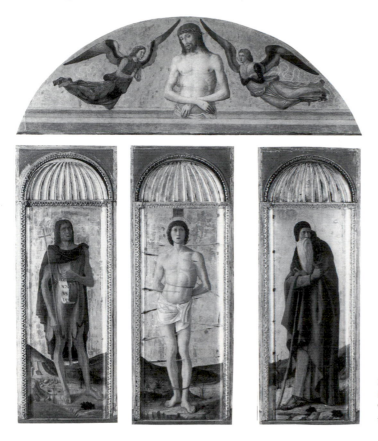

182
Giovanni Bellini,
Triptych 'della Carità' with St Sebastian.
Venice, Gallerie dell'Accademia

harmony between the stasis of death, the peace of nature, the silence of unworldly contemplation and the mute stillness of pure vision.

As it becomes apparent to us how consistently Giovanni Bellini returned to certain themes throughout his life, while other themes in quattrocento religious painting, common in the work of his contemporaries, left little or no trace in his work, not even in replica altarpieces or variants, we naturally tend to see this as a sign of an independence in his choice of themes that was extremely unusual in his day, a very unmedieval recognition of the autonomy of artistic creativity – albeit also a self-imposed discipline, which presumes a clear awareness of the specific nature of his own gift. An example of this is the great rarity of themes of religious history in his work, and above all the total absence of a polyptych, that specifically Venetian altarpiece type, which admittedly was at its height during the dying Gothic era, but which even a revolutionary like Mantegna had to pay tribute to in his youth. Of the works to emerge from Giovanni's workshop in the early days, there are only a few triptychs, and even then who precisely was responsible for their design and realisation is a matter of considerable controversy. I am thinking here of the four triptychs that were painted for the Chapels in the Church of Santa Maria della Carità. The closest we can come to establishing when these were painted is to take the date of the dedication of the altarpieces, 1471, as the *terminus ante*. These triptychs are small, three-part anconas with lunette closures, and, in terms of their structure, the first pure Renaissance altarpieces in Venice. One is tempted to assume that Giovanni had at least a part in the making of these heavily overpainted – 'dis-restored' – altarpieces, however unlikely it seems that he had overall responsibility for them. A number of full-length and half-length figures on these altarpieces can be seen from Giovanni's œuvre to be his inventions, but generally these are the earliest examples of their type, which makes it hard

182, 183

183
Giovanni Bellini,
Triptych 'della Carità' with Birth of Christ.
Venice, Gallerie dell'Accademia

simply to categorise them as workshop replicas. Interestingly, a whole number of connections can be found linking these altarpieces – the style of their figures, that is – with
184 another altarpiece of uncertain origin, namely the San Vincenzo Ferrer Altarpiece in the
Basilica of Santi Giovanni e Paolo in Venice, which is regularly reattributed every few
years, to Giovanni Bellini, Bonsignori, Lauro Padovano, Alvise Vivarini and others. And
here, once again, there are individual elements and figures that are demonstrably close to
authenticated works by Giovanni, while others are scarcely compatible with his œuvre as
a whole. This would be of only limited interest, if it were not that this, too, is a relatively
early work from the Giovanni Bellini circle, indeed, that it is in fact the earliest painted
Renaissance altarpiece in Venice. As in three of the four Carità altarpieces, we see before
us a juxtaposition of three individual figures, only that this time the saints are standing in
real space, and not against a gold ground. And in the upper section with the half-length
figures there is another innovation. The central Angels' Pietà is framed not by busts of
185 saints, but by an Annunciation scene with half-length figures. The innovative element
here is not only that the upper section contains a narrative but also that the depiction of
the Annunciation is cropped, as it were, to match the half-length figures of the *imago
pietatis*. Of course, scholars have not failed to observe that a similar, very unusual half-
length depiction of the Annunciation occurs at exactly the same point in an altarpiece by
186 Antonello da Messina, the polyptych of San Gregorio which is still in Messina today.
Antonello, who painted this altarpiece in 1473, went to Venice in 1475 on the invitation of
the City Fathers and remained there for over a year. Does this therefore mean that the
Vincenzo Ferrer altarpiece in Venice was influenced by Antonello's ideas, did he take
sketches of earlier works with him to Venice? That would be entirely plausible if the
Venetian altarpiece was not made until after Antonello's arrival in Venice. But this is by

187
Jacobello del Fiore,
Coronation of the Virgin.
Venice, Gallerie dell'Accademia

The Pesaro Altarpiece. Although not otherwise documented, this great altarpiece is signed by Giovanni Bellini and unanimously recognised as his work, painted for the Church of San Francesco in Pesaro and today on display there in the city museum. It is the first altarpiece of monumental proportions that we know of by the Master and which, regardless of who was responsible for the works we discussed earlier, marks a major change in his style. There is no longer any hint of a multi-part structure in the main body of the piece, the only subsidiary images are contained within the frame. Two pilasters, placed at the corners of a predella, support a wide architrave decorated with foliage curlicues, which was originally crowned with a rectangular top section. The tectonic character of the structure of the altarpiece is, however, considerably weakened by the fact that the plinths and the flanks are broken up into a sequence of illustrations, with the result that the load-bearing function of the pilasters, for instance, only becomes properly apparent in their capitals. Furthermore, fitted inside this architectural frame there is a square picture, which has its own frame embellished with a shallow relief pattern. The square outer form is echoed inside the picture, and reappears, proportionately smaller, on the backrest of the throne as an inlaid depiction of a landscape view. Hence the square not only determines the external format of the composition but also the inner dimensions of the pictorial structure. We will return later to the extremely unusual inclusion of a landscape view in the backrest of the throne, a motif that was never seen again elsewhere. Suffice it to mention here that all seven pictures in the predella zone are also virtually square.

188; plate 29

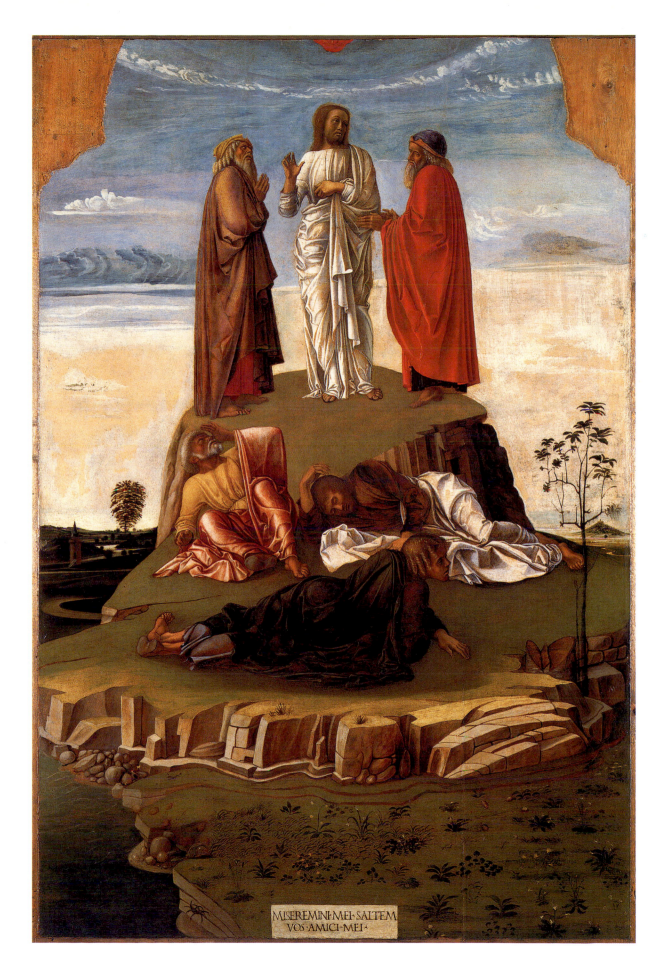

MISEREMINI·MEI·SALTEM
VOS·AMICI·MEI·

14 Giovanni Bellini, The Transfiguration. Venice, Museo Civico Correr

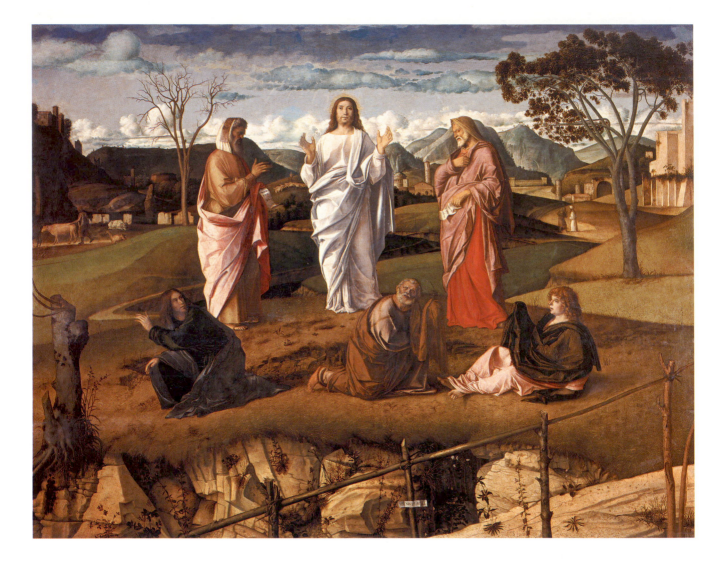

15 Giovanni Bellini, The Transfiguration. Naples, Galleria Nazionale di Capodimonte

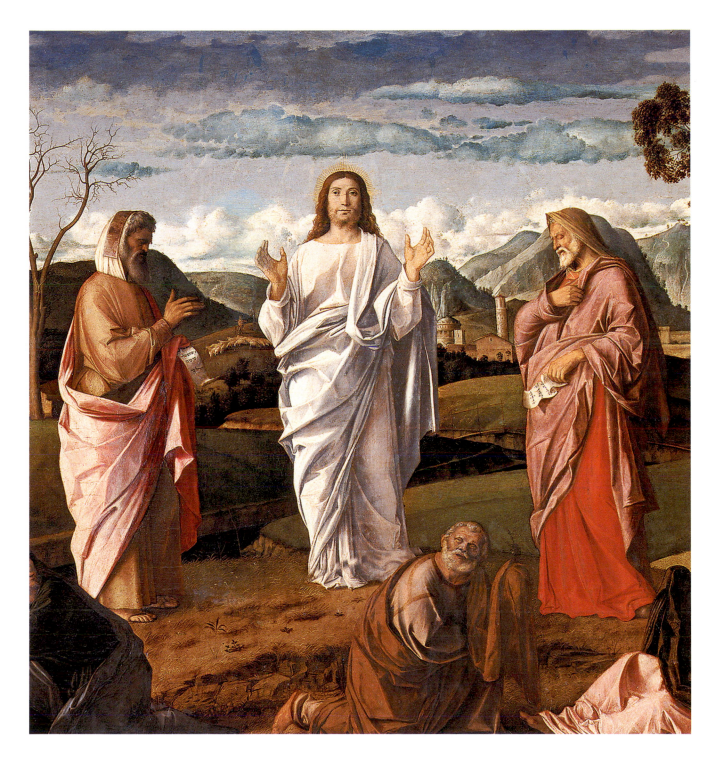

16 Giovanni Bellini, The Transfiguration (detail). Naples, Galleria Nazionale di Capodimonte

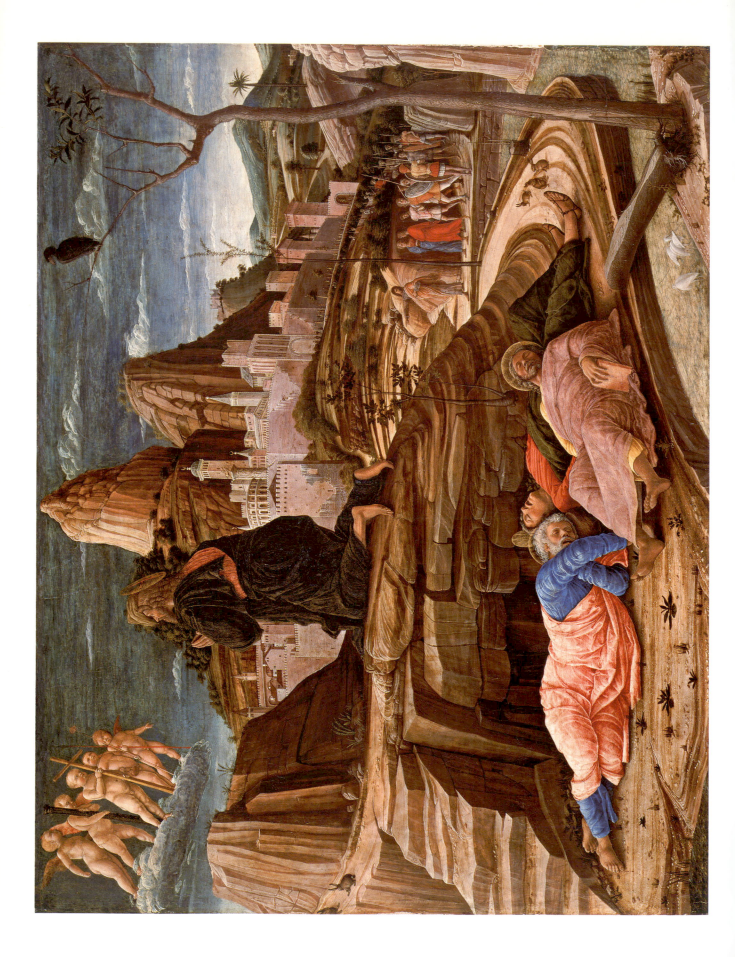

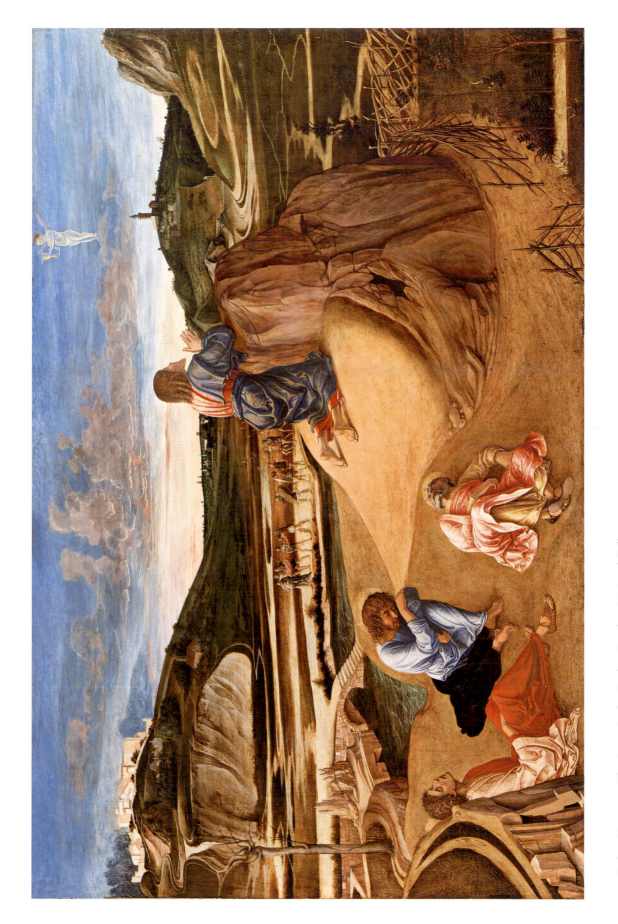

17 Andrea Mantegna, The Agony in the Garden. London, National Gallery

18 Giovanni Bellini, The Agony in the Garden. London, National Gallery

19 Giovanni Bellini, Madonna dell'Orto. Venice, Madonna dell'Orto (lost)

IOANNES BELLINVS

20 Giovanni Bellini, Madonna and Child (Lochis Madonna). Bergamo, Accademia Carrara di Belle Arti

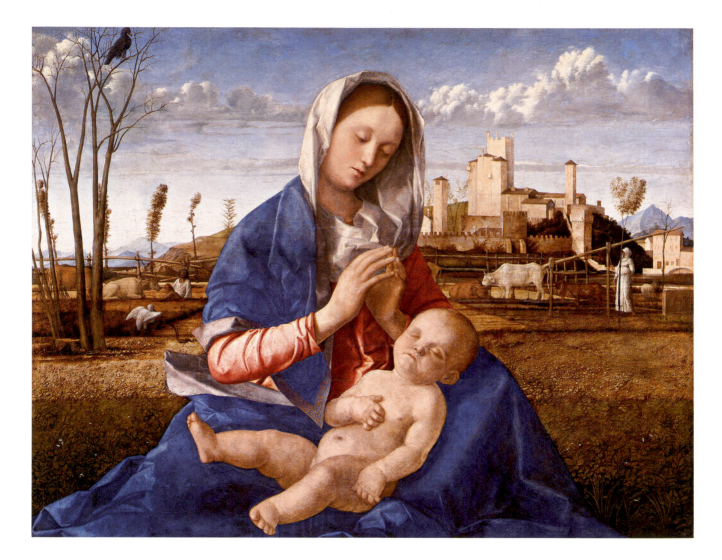

21 Giovanni Bellini, Madonna of the Meadow. London, National Gallery

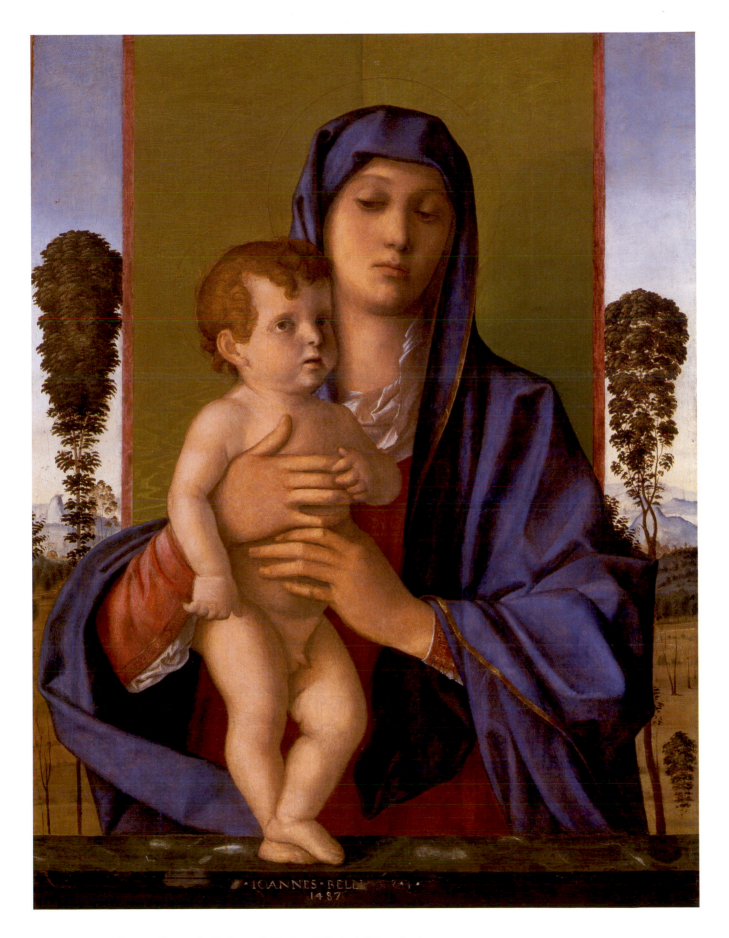

22 Giovanni Bellini, Madonna 'degli alberetti'. Venice, Gallerie dell'Accademia

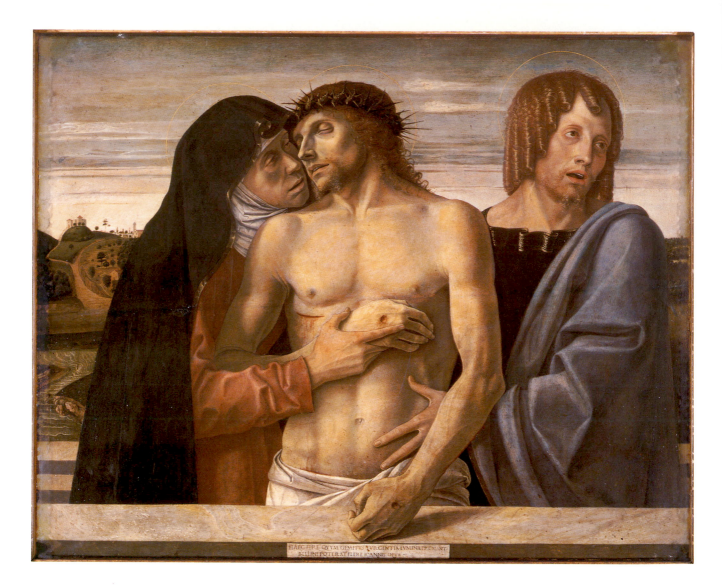

23 Giovanni Bellini, Pietà with the Virgin Mary and St John the Evangelist. Milan, Pinacoteca di Brera

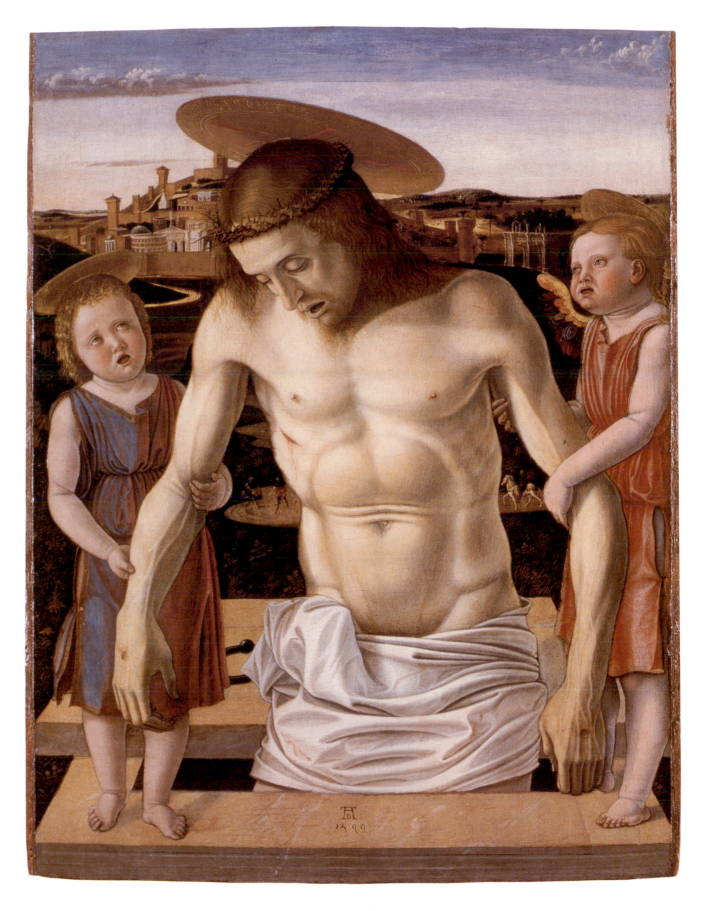

24 Giovanni Bellini, Pietà supported by Two Putti. Venice, Museo Civico Correr

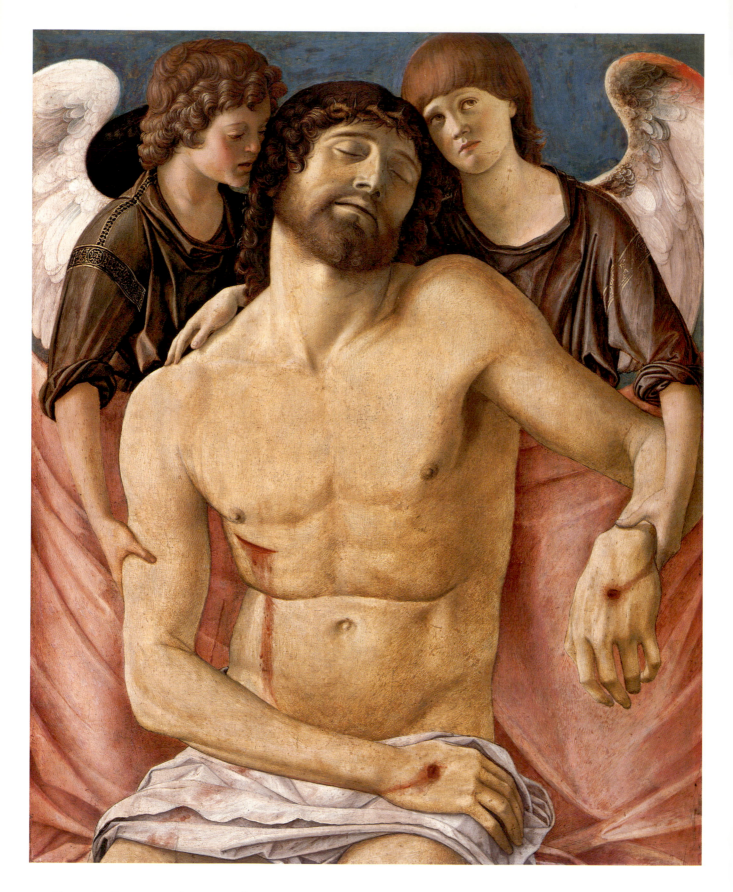

25 Giovanni Bellini, Pietà with Two Angels. Staatliche Museen zu Berlin, Preussischer Kulturbesitz, Gemäldegalerie

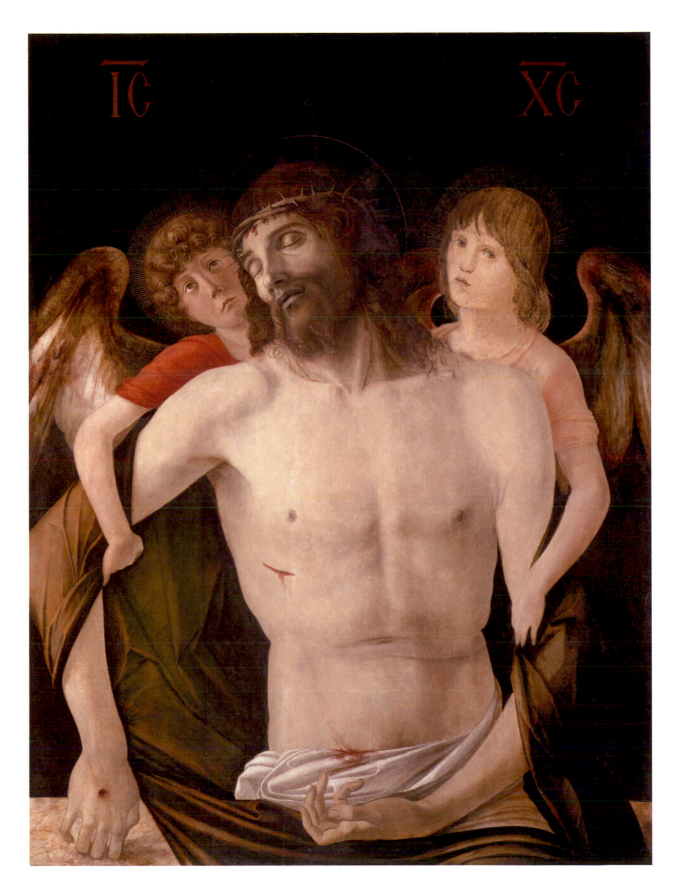

26 Giovanni Bellini, Pietà with Two Angels. London, National Gallery

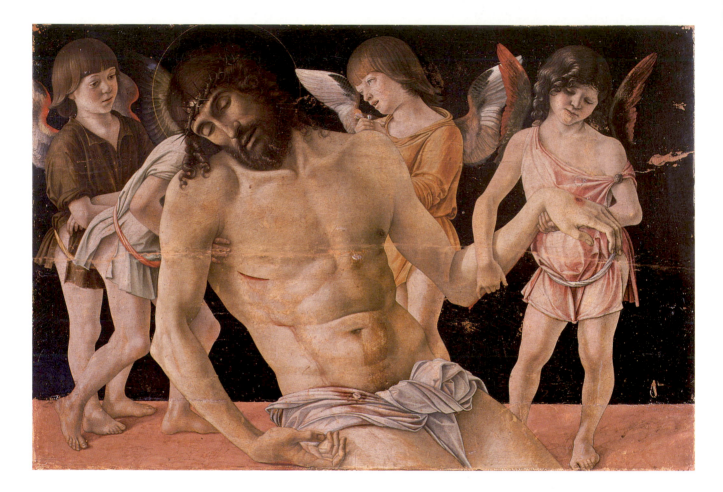

27 Giovanni Bellini, Pietà with Four Angels. Rimini, Museo della Città

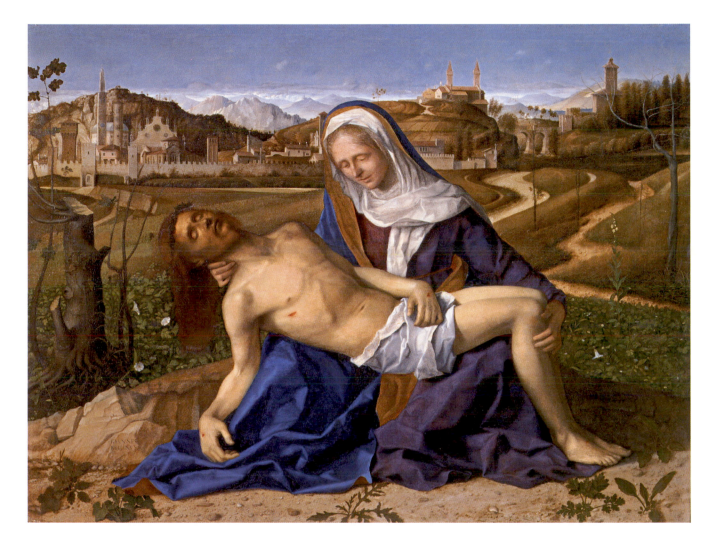

28 Giovanni Bellini, Pietà 'Donà dalle Rose'. Venice, Gallerie dell'Accademia

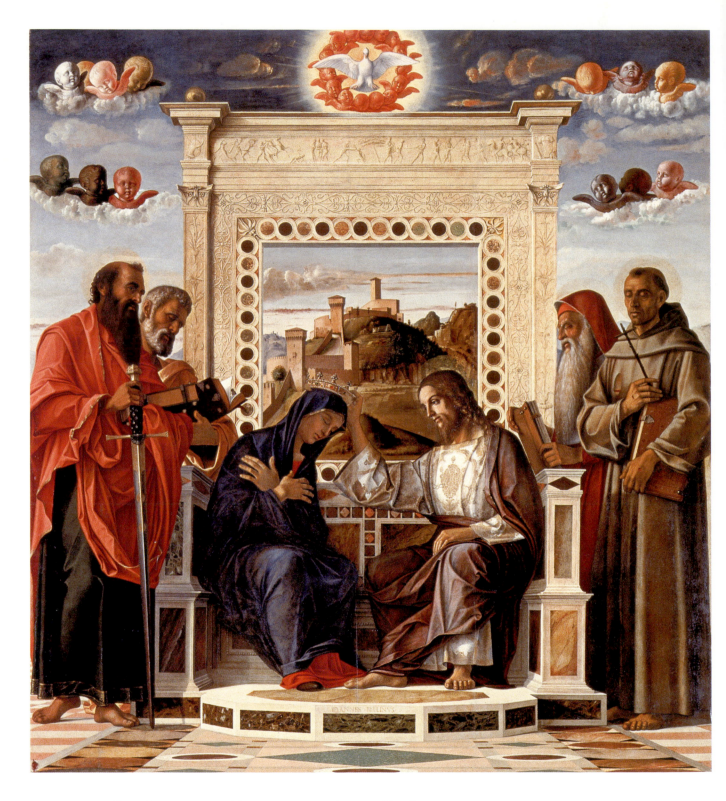

29 Giovanni Bellini, The Coronation of the Virgin. Pesaro Altarpiece (detail). Pesaro, Museo Civico

The iconography of the composition is similarly unique, that is to say, the Mother of God is being crowned in the company of only four saints, the two princely Apostles and the Saints Francis and Jerome. It is true that especially in Venice there was a long tradition of presenting the ceremony in which the Virgin Mary is crowned the Queen of Heaven within a circle of saints, but that circle was made up of all the saints, in an amphitheatre-like arrangement, crowned by a pyramid with God the Father at its highest point. Thus the Coronation of the Virgin and the Communion of Saints merged into one. The scene here is set on a supernatural, festive platform in no specific location. One could of course take the eight figures of saints standing in the niches in the pilasters to either side as the meagre remains of those other endless throngs of saints. However, in the Pesaro Altarpiece the four chosen ones do not worship the divine protagonists like the *communio sanctorum*, but merely assist in the ceremony in the manner of the most eminent ecclesiastical

187

188
Giovanni Bellini,
Pesaro Altarpiece.
Pesaro, Museo Civico

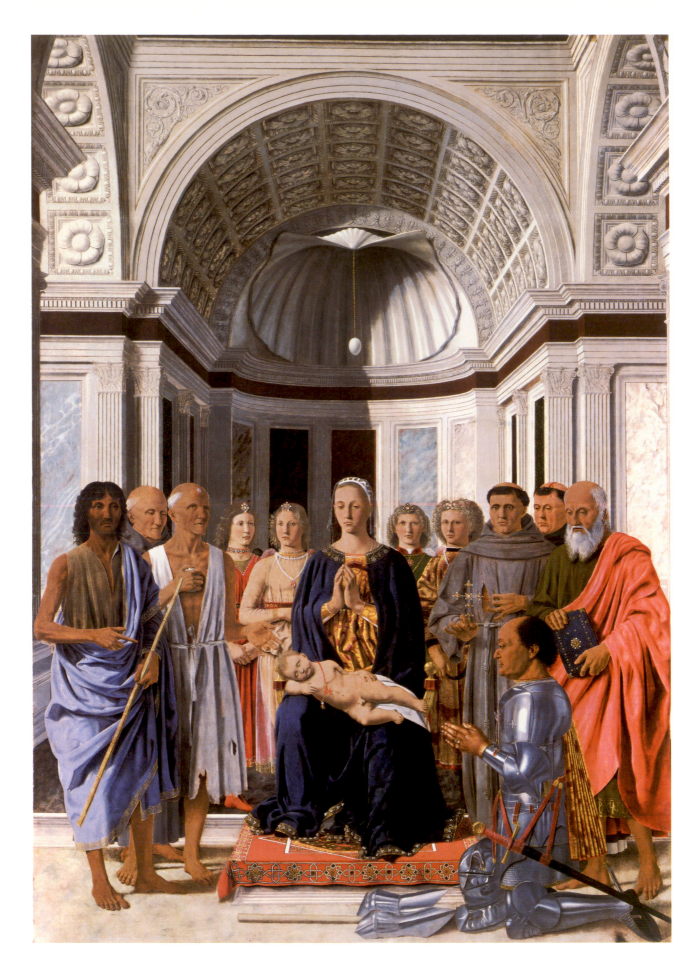

31 Piero della Francesco, *Sacra Conversazione*. Milan, Pinacoteca di Brera

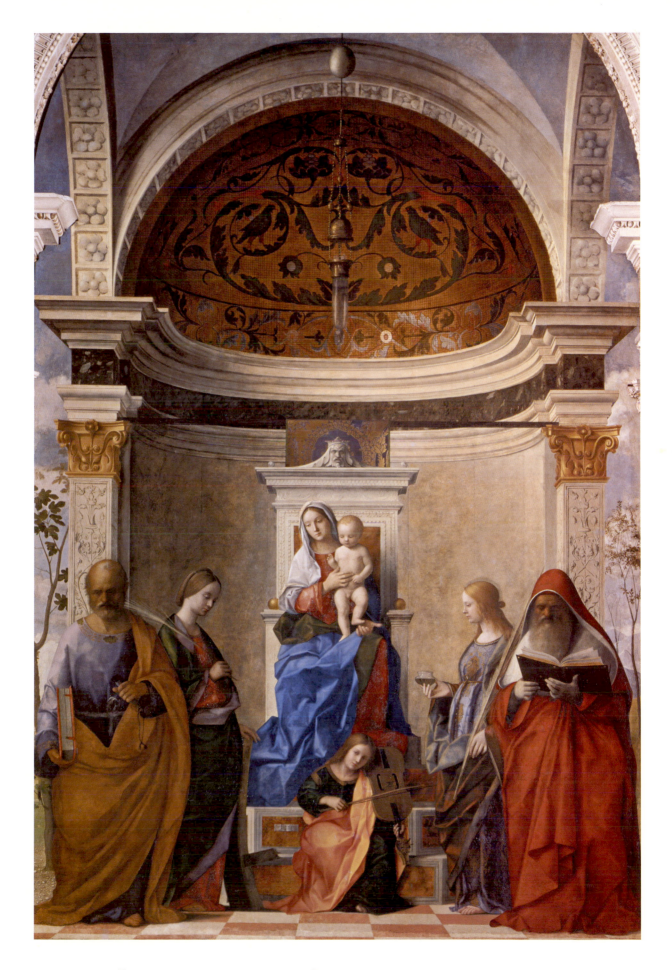

32 Giovanni Bellini, *Sacra Conversazione*. San Zaccaria Altarpiece. Venice, San Zaccaria

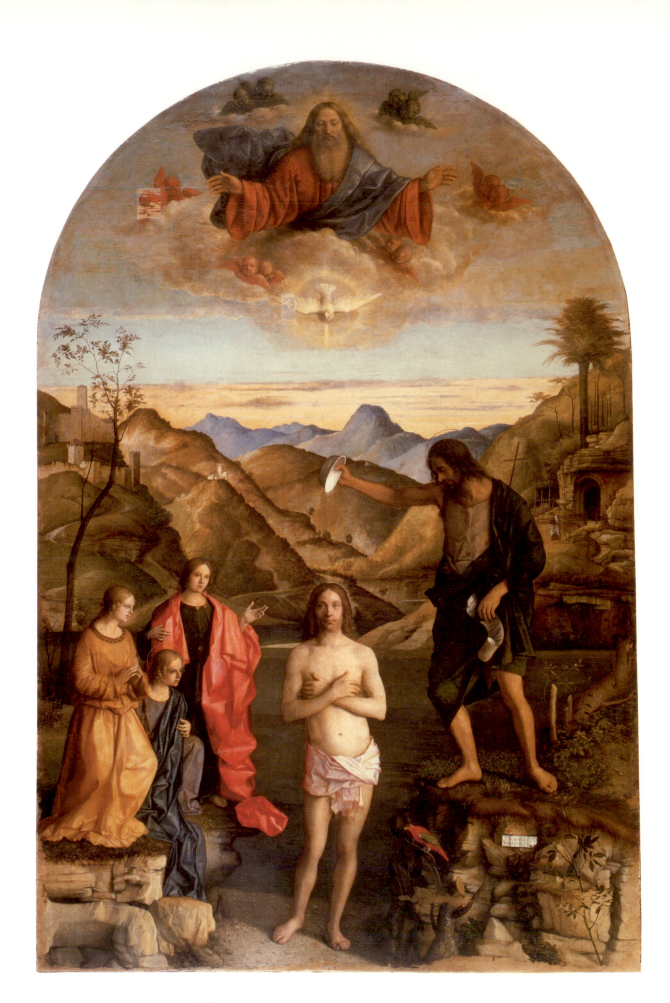

33 Giovanni Bellini, Baptism of Christ. Vicenza, Santa Corona

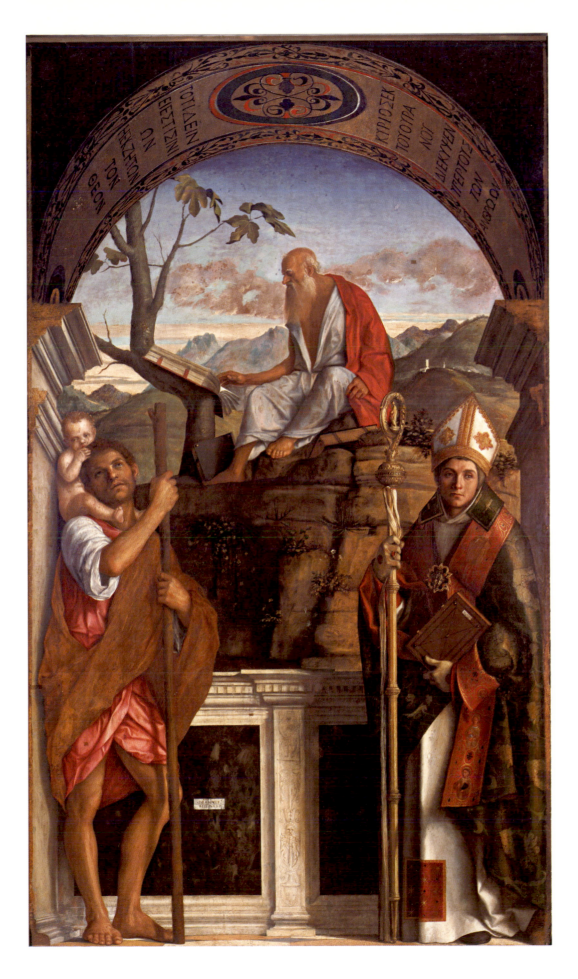

34 Giovanni Bellini, San Giovanni Crisostomo Altarpiece. Venice, San Giovanni Crisostomo

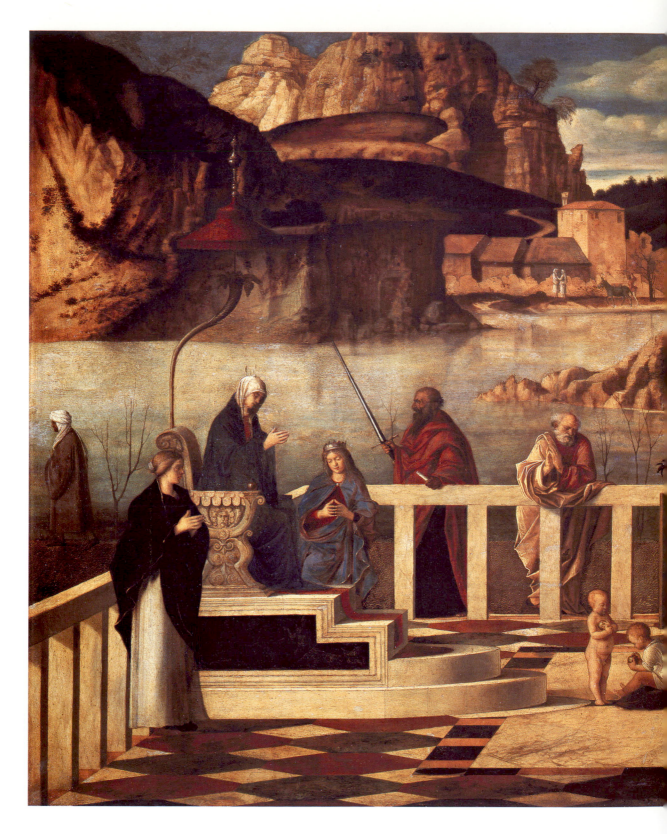

35 Giovanni Bellini, Sacred Allegory. Florence, Galleria degli Uffizi

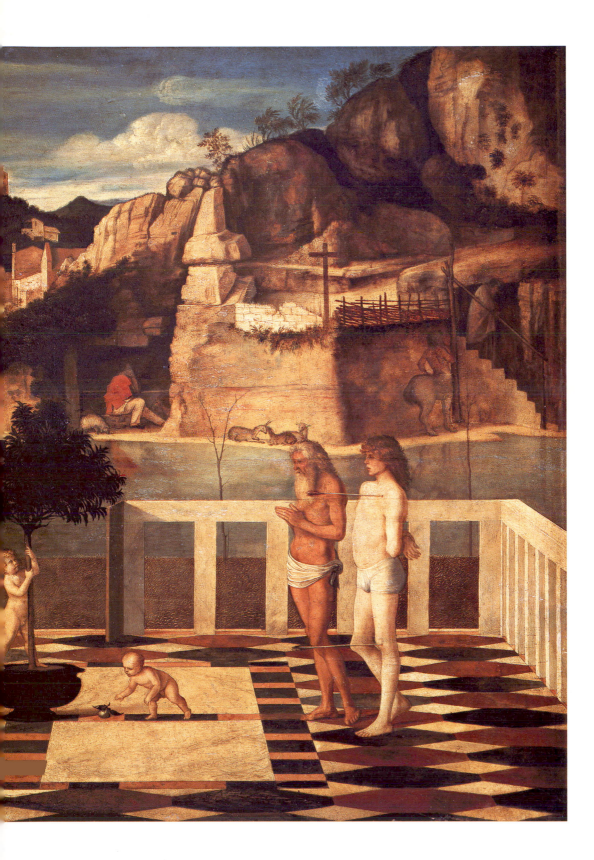

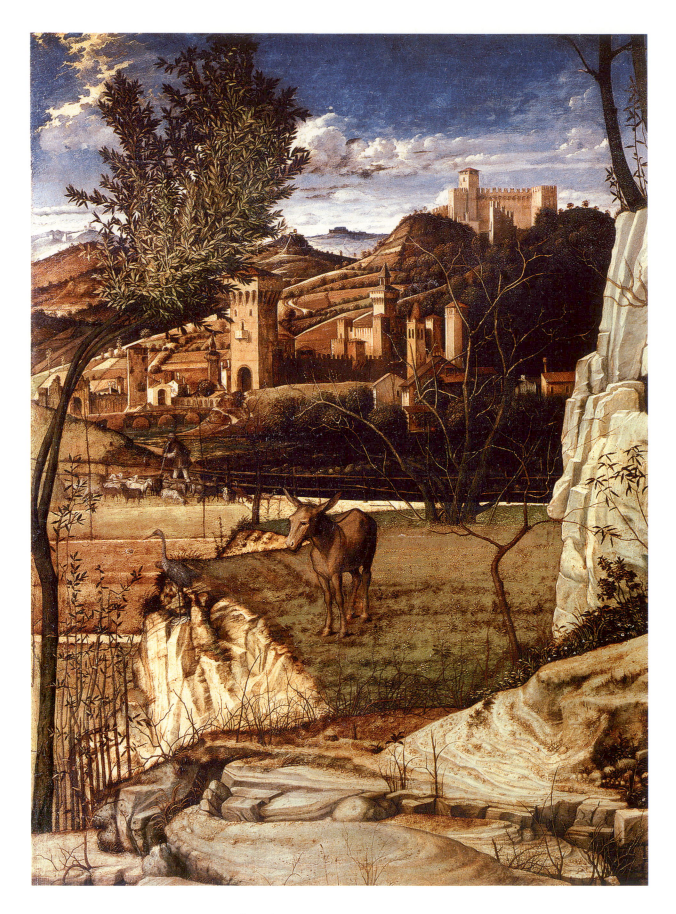

36 Giovanni Bellini, St Francis in Ecstasy (detail). New York, The Frick Collection

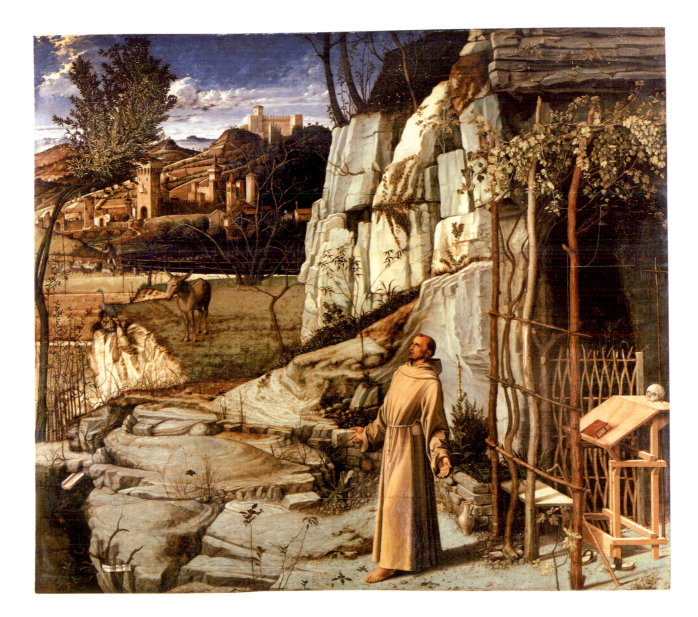

37 Giovanni Bellini, St Francis in Ecstasy. New York, The Frick Collection

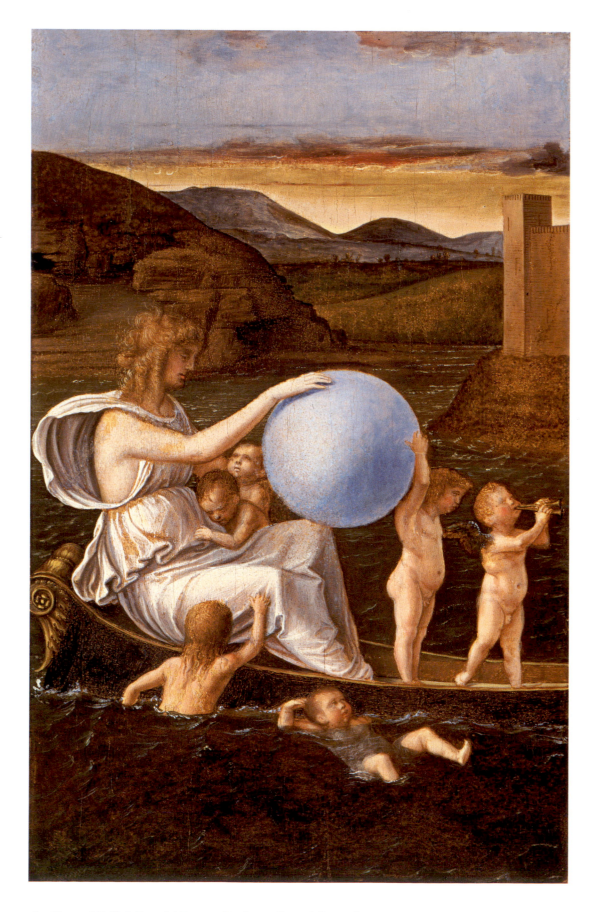

38 Giovanni Bellini, 'Restelo' Fortuna. Venice, Gallerie dell'Accademia

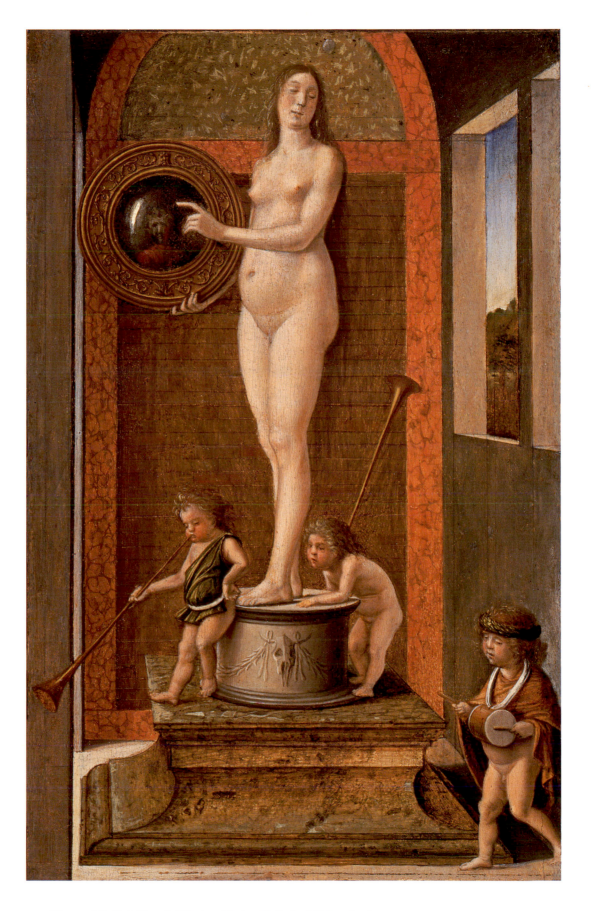

39 Giovanni Bellini, 'Restelo' Vanitas. Venice, Gallerie dell'Accademia

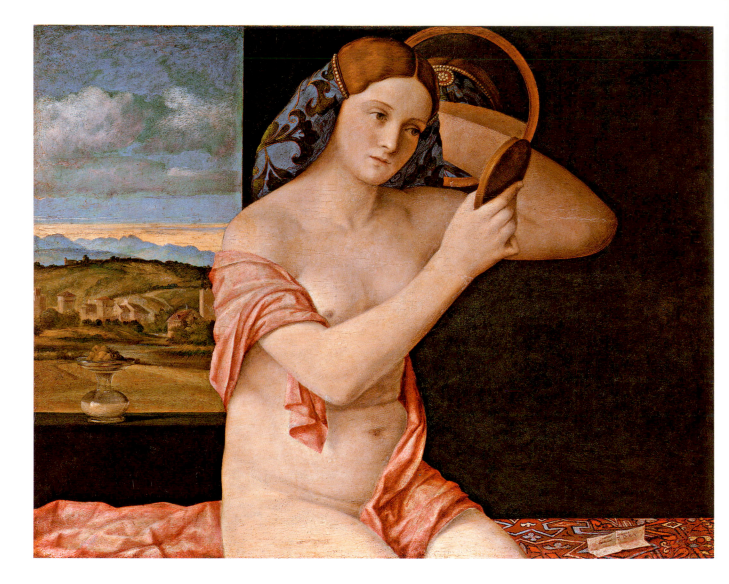

40 Giovanni Bellini, Woman with a Mirror. Vienna, Kunsthistorisches Museum

deeper choir with a flat rear wall.[92] We do not know precisely where Piero's altarpiece originally stood. If it was intended for the rear wall – and there are many indications that this was the case – then Piero's panel would have constituted a 'correction' to the existing building by means of painterly illusion, for it has at its centre a *trompe l'œil* semi-circular closure. Whether this might have been discussed with the architect we cannot say. Nor do we know precisely who the architect was, although the suggestion that it was Francesco di Giorgio has met with the most approval. Whatever the case, even if it did not match the architecture in every respect, Piero's painting was certainly conceived as an integrative component in the interior design of this church planned as a mausoleum, that is to say, the piece was not so much an independent altarpiece-microcosm as a wall-painting of sorts. Of course, placing this piece alone against the neutral wall of an art gallery does not do justice to its real essence, nor does it properly demonstrate the idea of a work that is intended as a constituent part in a *Gesamtkunstwerk* that is greater than itself. The pictorial architecture is not so much an atmospheric setting as an illusory architectural construction: the work of art helps to complete the form of the building. No wonder, that the monumental forms of the pictorial architecture seem to draw attention to themselves more than the figure composition, particularly since the coffered barrel vault and its decorations – which are seen again in detail on the belt arches to either side – are imbued with a classical monumentality that seems to be anticipating the High Renaissance. Longhi described it as "Una sacra conversazione ... preordinato, e compito nell' aula bramantesca, prima del Bramante". Others have seen in Piero's pictorial architecture an echo of Alberti's Sant'Andrea in Mantua. But we will perhaps approach more closely to the truth if we assume that the likely architect of San Bernardino, Francesco di Giorgio from Siena, was the *spiritus rector* here, for specifically in his case – as both architect and painter – and more generally in the older Sienese painting of the quattrocento, we know of examples of identical pictorial architecture, albeit not on quite such a monumental scale, as for instance in the work of Lorenzo Vecchietta as early as the 1440s.[93]

The innovative aspect of the altarpiece in San Bernardino, the church dedicated to a saint born in Siena, lies in the connection to the real architecture of this sacred interior. As a rule, when there is talk of the beginnings of illusionism in painting in the Modern

199
Urbino, San Bernardino
Ground plan

past. If, despite this, it seems that a particular meaning attaches to Bellini's angelic concert, then this is due to the fact that it is only in the silence of the gathering painted here by Bellini that the musical accompaniment can properly come into its own. It is only here, in Bellini's composition, that we see the trio of angels instead of the steps to the throne; and the lute held parallel to the picture plane by the highest of the three angels reduces the sense of spatial depths emphasising the plane on which all the figures come together.

Having taken over the basic structure and classical details of the architectural setting, Bellini gave it a typically Venetian aspect by introducing – or reintroducing – a semicircular apse, with the half-dome above the heavy architrave apparently decorated in gold mosaic above a line of dancing seraphims in the Byzantine style along its lower edge. This adds light and colour to the architecture, and the golden light softens the harshness of this stone-built world.

However, in the position where one expects to encounter gold in a picture from the quattrocento, that is to say, in the saints' halos, there is none. Even in his early days as an artist, when he was still under Mantegna's spell, Bellini never adopted the halos his teacher used to paint, which looked almost like discs of solid metal, and he generally reduced his own to no more than a delicate band. Thus gold no longer appeared as a local colour in his paintings. In the San Giobbe Altarpiece there is an echo of Mantegna's motif, in that the throne is topped with a marble disc directly above and behind the Madonna's head. And now, high up behind the throne, gold fills a wide lunette as though countless small glass squares were reflecting the light, in effect forming a halo for all the figures together. There are two light sources in the San Giobbe Altarpiece: the natural light entering from the right and the sacred light reflected from the mosaic above. The two intersect to create a very specific interior light, with the result that instead of there being a neutral overall tone, the scene is imbued with a muted coloured glow. In the same way that Jacopo Bellini once derived the gold highlights in his paintings from the gold threads in Byzantine draperies, now his son has taken advantage of the reflected light of Byzantine gold mosaics, using it to distil a painterly sheen which infiltrates the whole space and all its various aspects both corporeal and non-corporeal. And so it was that the famous gold light of Venetian painting was born from the mosaics of Byzantium.

This is the point where we come to the second constitutive factor in the Giovanni's development, that is to say, the influence of the painter Antonello da Messina.

201
Antonello da Messina,
Annunciation.
Syracuse, Museo Nazionale

202
Jan van Eyck,
Ghent Altarpiece,
Annunciation.
Ghent, St Bavo

Around 1500, or so tradition had it in Naples, Antonello da Messina was a pupil of the Neapolitan painter Colantonio, which meant that he was so to speak a 'grand-pupil' of René d'Anjou, who had instructed Colantonio in the Flemish style of painting. That there is a core of truth to this legend is without doubt. Netherlandish painting certainly provided one of the stylistic roots for Antonello's art, and most probably he did study the Flemish technique in or near Naples, where it seems to have been well-known during René's short regentship between 1438 and 1442. It is not only his small-figured early works that bear the stamp of Netherlandish influence, but also mature works such as the *201* Syracuse *Annunciation*, which despite – and with – its classical column owes a debt to the *4, 202* bourgeois interior of the Mérode Altarpiece and to the light in the *Annunciation* on the Ghent Altarpiece. For Antonello plays the same game with his so very classical, plastic column that Van Eyck plays in the Ghent *Annunciation* with the edges of the altarpiece frame, that to say, they cast a shadow into the picture from the viewer's side, thereby creating an interior where one looks through light into semi-darkness and beyond that into light again. Antonello has clearly fully grasped Van Eyck's handling of the interior: "An interior as a partial shield from the bright sunlight, chiaroscuro as an interior colour."[95] At the same time, he also drew on the same source for the means to achieve this real experience in artistic terms. In that sense it is fair to say that Antonello learnt the technique of painting in oils from the Netherlandish artists via Colantonio, although it is also true to say that oil substances had long been known to Italian painters as binding agents. The point of the so-called discovery of oil painting by the Netherlandish artists was the fact that they were the first to think of using oily ingredients and transparent glazes to give paint a new quality, that is to say, a lustre of its own, which meant nothing less than being able to express the omni-presence of light through paint. The founders of Netherlandish painting turned their craft into an *ars nova* by using paints that were, so to speak, self-luminous, thus combining the real light that illuminated the painting with the notion of light emitted by the picture itself. Antonello penetrated deep into these mysteries. Scholars have often pointed out the enamel-like character of the paint surface of his pictures, meaning no doubt that they appear to reflect the light. It is almost as though the paint substance 'glows' when light falls on the picture surface. In this respect Antonello was very much alone in Italian painting for a long time, the sole exponent and herald of the new painting *more fiammingo.*

It is eternally to the credit of Giovanni Bellini to have discovered the importance of translucent, glowing colours and the practice of painting with coloured glazes as a means to realising the specifically Venetian 'artistic purpose' and, in doing so, to have laid the final foundation stone for typically Venetian coloration. And we should point here to a parallel phenomenon which dramatically illuminates similarities in the historical situation – despite the different national characteristics – of two artistic milieus that are so often compared. Just as Jan van Eyck was struck by the diaphanous colours of Gothic stained glass windows, realising how perfectly they suited the new way of seeing, so, too, Giovanni Bellini now discovered the suitability of the gold mosaics of his native city as a motif for inclusion in his paintings. Amongst the most conservative painters in and around Venice, that is to say, in the Murano School, gold was still being used as a background when it had long fallen out of favour in the Netherlands and in Tuscany.[96] For in the unified pictorial space, seen from one viewpoint, the painter could only portray things as they appeared, and there was no room for anything extraneous like a golden overlay. Indeed Alberti had already spoken out in his treatise against those painters who used gold as a substance and did not, as he said, imitate or try to recreate the sheen of gold. The younger Bellinis avoided gold as a pictorial ground and generally also chose not to use it for saints' halos; they preferred gold lights, although without indicating how these arose.

The San Zaccaria Altarpiece. Giovanni did not paint his next *sacra conversazione* until the
16th century. This is the San Zaccaria Altarpiece completed in 1505. In it he returns once *205; plate 32*
again to the scheme of the San Giobbe Altarpiece, although with the composition monu-
mentally simplified to comply with the new era's ideals of classical grandeur. Instead of
six saints, now we see four, instead of three angels making music there is just one. And if
one looks back at the San Giobbe Altarpiece from the San Zaccaria Altarpiece, the for-
mer seems rather disjointed and restless. Indeed the contrast between the two could serve
as an example of the difference between the quattrocento and the cinquecento as de-
scribed by Wölfflin, as an illustration of the process of simplification and clarification, as
in the contrast between Ghirlandaio and Fra Bartolomeo.[100] The only difference is that
here the process occurs within the work of a single artist, and in fact led to the successful
breakthrough to the final synthesis in the work of an old man close to the end of his life.
And Wölfflin's characterisation of the new sense of style also applies to Bellini's *sacra
conversazione* of 1505: "The classical style returns to the elemental arrangement of verticals
and horizontals and to primitive representations with purely frontal or profile views."
The perspectively foreshortened rank of saints is divided into two purely frontal views,
and two profiles, although these cut into each other in such a way that each pair appears
to be one optical entity. All the other changes compared to the San Giobbe Altarpiece
follow along similar lines: In San Giobbe the Madonna has a trio of angels at her feet,
while in San Zaccaria there is just one angel, partly obscuring the hem of the Madonna's
gown whose drapery sweeps steeply upwards towards the height of the throne, so that
the centre of the picture consists of a single vertical which is continued in the lamp sus-
pended from the ceiling directly above. In San Giobbe a wide 'lampshade' hangs above
the Madonna. And Giovanni also corrects his earlier composition at the sides. Instead of
an architrave set orthogonally on the columns or pilasters, in the later work the ribs of a
cross-vault rise immediately upwards until they are intersected by the altarpiece frame,

204
Giovanni Bellini,
Sacra Conversazione,
San Giobbe Altarpiece (detail).
Venice, Gallerie dell'Accademia
(colour plate 30)

which is itself part of the composition. And now it becomes apparent that the frontally placed male saints correspond to the columns behind them, as it were forming verticals with these. So here we see the old Venetian practice of integrating figures into their setting taking on a new meaning and function as a unifying factor in the composition. Three powerful verticals, albeit intersected by the heavy architrave of the apse, underpin the structure of the composition. Thus, as in San Giobbe, the altarpiece as it were adds a niche-like extension to the chapel, that is to say, it is illusionistic.

The extent of the illusion in the pictorial architecture is evident from the fact that there is one architectural detail which appears at first sight to be an anachronism, or at least not a specifically classical feature: the item in question is the groin vault in the apse. Clearly the topographical situation of the altarpiece means that this vault is part of the church nave, planned with its cross-vaults in the late quattrocento (1480). In Bellini's painting, the shadows under the vault prevent the linear nature of the vault from standing out too strongly, just as the lines and volumetric features of all the forms are softened by the way that their coloration blends with the overall hue of the space. The atmosphere of the painting, with its shadows and highlights, reduces surface detail and transforms figures and objects, together with their local colours, into an intangible painterly *fluidum*, which is in the first instance coloured light or shade and only secondly hair, flesh, marble or fabric. Compare, for instance, the head of St Jerome on the Pesaro Altarpiece, painted thirty years earlier, with his appearance in San Zaccaria. Although Bellini's technique was already eminently painterly in Pesaro, one could still clearly identify the flow of the long beard, the slant of the forehead, the sunken eye-sockets and the shape of the nose; in San Zaccaria one suspects these rather than actually seeing them. The path to the simple and the monumental involves optical reduction. And hand in hand with this dispersal of matter into an atmosphere where all that is visible has acquired a new smoothness, there

195
207

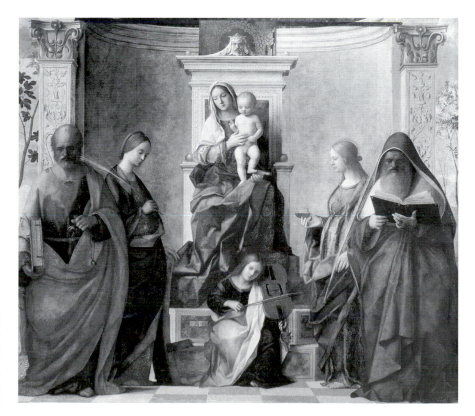

205
Giovanni Bellini,
Sacra Conversazione,
San Zaccaria Altarpiece
(detail).
Venice, San Zaccaria
(colour plate 32)

is a hitherto unheard of deepening of the underlying silence. The muted gathering embodies a state of absorption-in-thought as though engulfed by the silence of the twilight around it.

If one looks more closely at the San Zaccaria Altarpiece, there is one detail that does not quite fit my suggestion that this composition constitutes an illusionistic continuation of the real space, or at least there seems to be a slightly disturbing discrepancy. On either side of the apse the pictorial space seems to open up to the outside. And in that sense one could not consider this a continuation of the real space of the church's interior. Only, as the altarpiece in San Giovanni Crisostomo shows, it seems that, for Bellini, in the dream logic of the work of art, illusionistic painting and a view to the outside through the walls of a church interior were perfectly compatible. While this composition is not a *sacra conversazione*, but a painting of three saints, nevertheless it can best be understood as an off-shoot of the *sacra conversazione*. The position where the two saints are standing could be against the wall of the church with the altar painting, except that the background does not depict a wall, a curtain or an apse: instead we find ourselves looking over a low marble parapet into the open air, to a rocky hillock in the foreground and mountain ridges on the horizon. The saints, close enough to touch in the proscenium, virtually sharing the same existential space as the viewer, making it appear as though the scene behind them is real, encouraging us to believe the pictorial magic that has apparently caused the wall to disappear.

It is as though we were looking through an archway, between the two saints standing there like guards with their staffs. And there is a striking contrast between the holy guards facing directly towards us and the profile of St Jerome engrossed in his studies a short distance away. It was certainly a daring move to give the centre of the composition over to a figure seen only in profile. That figure is fitted into the archway like the filling of a lunette, benefiting from the framing and the distance. While the Coronation of the

205

plate 34

206
Albrecht Dürer,
St Jerome in his Study,
Engraving

207
Giovanni Bellini,
St Jerome and St Catherine,
San Zaccaria Altarpiece (detail).
Venice, San Zaccaria
(colour plate 32)

Virgin in Pesaro has a landscape view in the backrest of the throne occupying the centre of the composition, the main accent falls on the divine personages seated on the throne, close to the viewer. But now, in this case, the figure seated on the ground in the background landscape, taking no notice of the viewer, is the immediate focus of our gaze.

206 It is perhaps worth mentioning that one year after this depiction of St Jerome was completed – hence at almost the same time – Dürer made his famous engraving of St Jerome in his study, which despite the difference in the choice of location is comparable in the sense that both the Italian and the German artist distanced the main figure from the viewer in order to demonstrate the withdrawn life and isolation of this hermit scholar. In Bellini's case the discontinuity of the space and the addition of the guards guarantee that no one will disturb the scholar studying outside. The viewer is reminded to keep very quiet.

38, 59 In itself, the depiction of St Jerome of course has its own predecessors in compositions focusing solely on St Jerome's life as a hermit, and these go right back to Jacopo Bellini. These are in a sense the open-air equivalent to the better-known motif of St Jerome in his scholar's study. Northern artists primarily associated the open air with the notion of the penitent St Jerome, in which case nature had to be imbued with a very different tone. The inhospitable atmosphere of the isolated location had to be demonstrated, and even if it was not exactly a desert, then it at least had to look like a wilderness. The Venetian landscape around St Jerome was to be desolate but at the same time a depiction of nature in a state of paradisical innocence, where all creatures co-exist in peace and the wild lion becomes a domestic animal. When Jacopo Bellini embarked on his magnificent silver-point drawing, this Venetian convention provided him with an excuse to indulge in a detailed picture of an expansive landscape. His son took up the same theme, but shifted the focus in order to convey the notion of a rocky cave or niche as appropiate for a scholar's study. The pictorial space is broken up into sections, with a huge rocky cliff extending the full height of the picture on one side, blocking our view into the distance, and only allowing us to look through on the other side, beyond the Saint who is reading, to the wide

expanse of the flat landscape. Bellini's work was most probably made during his middle period, that is, during the 1470s. But since none of the many variants of the composition can stand as the artist's own work in the face of rigorous critical scrutiny, it is difficult to be more precise in any assessment of this painting. Hence I prefer to study the landscape art of the later, mature Bellini in works where there is little reasonable doubt that they are by the artist's own hand.

The Stigmatisation of St Francis. The landscape composition in the Frick Collection in *plates 36, 37*
New York, which we will turn to next, has the same treatment of a wilderness landscape as the depiction of St Jerome, only known to us from copies. In one of the predella im-
ages on the Pesaro Altarpiece, Giovanni simply adopted the traditional iconography of the
legend of the stigmatisation of St Francis. The Saint is seen kneeling, receiving the *196*
wounds, his companion sits to one side of the cave, meditating. In the New York paint-
ing, Giovanni allowed himself the poetic licence of doing without a companion for the
ascetic, and of depicting St Francis experiencing his vision standing up. His arms opened
wide, the Saint steps towards the heavenly vision that is visible to him alone; one might
almost be tempted to take this for 'Poverello' singing his hymn to the sun, not the St Fran-
cis receiving his stigmata. Nor is the scenery particularly ascetic either: a pergola, a bench
and a desk all make the entrance to the cave rather inviting. A clear love of life is evident
in the affectionate depiction of nature flourishing and germinating, which prevents even
the monk's refuge from appearing barren, cold or hostile. But at this point I should like
to cite the words of the venerable Adolfo Venturi in his uncommonly perceptive charac-
terisation of the essence of this landscape vision: "In tal guisa la spelonca del frate diviene
una nicchia adorna dalle piante e del sole, la povertà divien gaia nella festa primaverile."[101]
In this atmosphere of "cheerful poverty" – where animate and inanimate nature are in
harmony with each other – we see a new departure in landscape painting, for in the works
of art that have come down to us from the past, this must be the earliest Italian painting
in which landscape is no longer an accoutrement or simply a background tapestry, but has
become the central feature of the composition.

 The human form is by no means a prop, but is nevertheless fully integrated into the
cosmos, albeit in a manner that involves an odd, typically Venetian mixture of objective
spatiality and subjective optics. The figure of St Francis is caught against the 'backdrop' of
the cliff-face, although – as we can see from the small wall at the foot of the cliffs – on
the left the rock formation runs parallel to the picture plane while on the right it runs
diagonally forwards from the depth of the composition. These two spatial directions are
marked again by the position of the figure's arms. The pointed conical form, created by
the arms, and 'echoed' in the shape of the rocky niche behind the figure, imperceptibly
connects the depth and the picture plane, without the two coming into conflict. What
is happening here could perhaps be described as an optical alliterations of forms, which
are exactly as they appear, and others, that only resemble the former by dint of their per-
spectival foreshortening. Thus, for instance, the rock formation behind the diagonal
silhouetted outline of the slope seems to continue upwards through the picture as a pro-
jecting form, while in reality what we are seeing are stacked rocky forms receding diag-
onally into the depths, with that same directional line being echoed in other lines in the
background landscape.

The Baptism of Christ. It is necessary to bear in mind this subtle balance of spaces and
planes – which is so difficult to put into words – this extremely skilled translation of space
into planar values, in order to understand the landscape style of Giovanni Bellini's last
years, which at first sight looks almost like the complete repression of depth of any kind

208; plate 33 and an unconditional return to planar composition. The main instance of this style is the *Baptism of Christ*, painted between 1500 and 1502 for the Church of Santa Corona in Vicenza. The figures are arranged facing the viewer, almost all along the same line, parallel to the picture plane. Behind them – and above them too, because the middle-ground has been quite swallowed up – a wall of hills extends across the horizon almost like a scenery in a tapestry landscape. With the exception of the rocky step at the front edge of the picture, which has an element of tactile relief, everything is dissolved into painterly values which spread over the picture surface like a diaphanous veil. It is a triumph of optics that the pictorial depth and even bodily forms are expressed by the refraction and gradation of spatial light and shade alone.

Giovanni Bellini's art thus grows organically into the art of the High Renaissance. Effortlessly it has shed all its quattrocento traits and in its generous simplicity, macroscopic view, calm grandeur and transfiguration it now bespeaks a style that is no less deserving of the description classical than are the works of Raphael, Leonardo, Fra Bartolomeo or Titian – all of whom were a generation or even two generations younger than Bellini. The term 'classical' has to be understood purely as an artistic attitude, as a timeless quality; it should not be taken to imply a rebirth of Antiquity. In other words: the works by Giovanni that we have discussed so far – and which form by far the greater part of his life's work – are not Humanist as such. This is not simply a consequence of the fact that these works can all be described as religious art. Mantegna's art is a prime example of painting that – even when the subject matter is sacred, as is the case in more than half of his works – adopts an 'antique' style and stands as a pictorial expression of Humanist thinking and views. In complete contrast to this, even the most Mantegnesque of Giovanni's works never even attempt to conjure up a lost world. Mantegna's fiction is the dream of an archaeologist whose marble world has come to life, without losing its stony

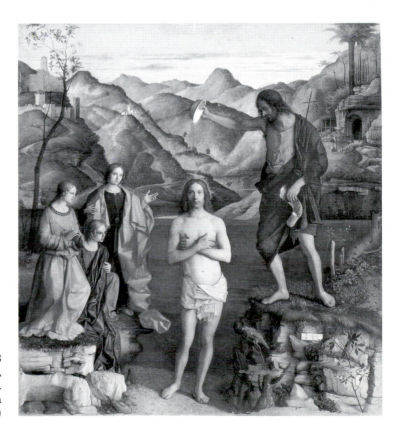

208
Giovanni Bellini,
Baptism of Christ (detail).
Vicenza. Santa Corona
(colour plate 33)

substance. In the mildly diffused light that Bellini cast over Mantegna's motifs right from
the outset, the latter did not long retain their rigidity but turned increasingly into their
polar opposite, forming the least tangible of all pictorial worlds, until in his mature works,
it is virtually impossible to make out the divisions between reified substance and insub-
stantial atmosphere. In his hands the warmth and light of the Venetian milieu absorbed
and assimilated the colder essence of a long past era of heroism.

Allegories and Myths. In the last quarter of the 15th century however the Humanist wave
did touch Giovanni Bellini in one aspect at least: at around the same time as Tuscan Early
Renaissance architecture was making its presence felt in the frames and structures of his
altarpieces. Four or five non-religious works by Giovanni have come down to us, whose
subject matter has its roots in the ancient world, and whose style is not simply a version
of the style he used in his religious paintings. Mantegna remains essentially the same artist
whether he is painting the Triumphs of Caesar or the Adoration of the Magi. In Giovanni *209, 210*
Bellini's allegorical and mythological paintings we see a whole new side of his artistic na-
ture, and one that could scarcely have been expected from the Bellini renowned for his
paintings of the Madonna. In his religious paintings, Bellini is not a story-teller nor is he
an inventor; conservative in his choice of subject matter he is a man of vision who paints
the quietude of existential stasis and the deeds of soundless light. By contrast, his secular
paintings are *invenzioni*, as even his contemporaries and clients called them, and what he
invented in these paintings was so new, independent and unique, that to this day – despite
the best efforts of scholars – it has not been possible to fathom with any real certainty the
meaning of the narratives he devised for these works. Indeed the paintings herald the ar-
rival of a new type of artist in the field: the painter-poet – a very modern phenomenon
compared to the specialist Renaissance artists of the Florentine quattrocento.

 This should not be taken to imply that the subject matter was entirely dreamt up by
the artist. Far from it, in the age of Humanism the rule was that in the case of secular
paintings the *concetto* would be devised by a man of letters, with the agreement of
the client and perhaps also in consultation with the artist who was to execute the work.
However, we do know from a remarkable passage from just such a man of letters to a
client, that out of deep respect for Giovanni's artistic genius, none would dare to prescribe
themes for him to illustrate that he did not find agreeable. Isabella d'Este[102] had sent the
Humanist and poet, the future Cardinal Pietro Bembo, to Bellini in order to persuade

209
Andrea Mantegna,
The Triumphs of Caesar.
London, Hampton Court Palac

2
Andrea Mantegn
Adoration of the Mag
Florence, Galleria degli Uffi

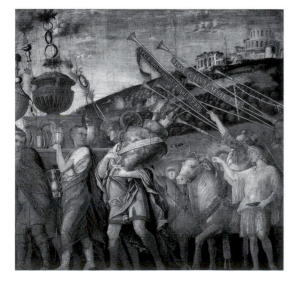

211
Giovanni Bellini,
Feast of the Gods.
Washington,
National Gallery of Art

him to create a mythological painting for her studio, the *grotta* in her residence in Mantua. She already owned two such paintings by the hand of Andrea Mantegna. An earlier attempt – to which we shall return shortly – had misfired, and Bembo approached his mission with caution. He reported to the 'blue stocking' princess about his dealings with the great painter, "che molto signati termini non si dian al suo stile, uso come dice di sempre vagare a sua voglia nelle pitture", in other words, that a precisely prescribed programme would not suit his style since, as he himself said, Bellini was accustomed to allowing his imagination free reign in his pictures – one is almost tempted to add "as the mood took him" to the translation. Bembo had the admirable sensitivity – which demonstrates his deep psychological understanding of the nature of artistic inspiration – first to acquaint himself by visits to Bellini's workshop with the themes that could be compatible with his style, which would be suited to "invenzioni a modo suo", and it was only then that he approached the artist with a concrete proposal. There is a pagan *poesia*, that was painted by Bellini after this time, that is to say, after 1507, and which was completed in 1514. The work in question is a *Feast of the Gods* (now in the National Gallery, Washington) – although the landscape was later entirely painted over by Titian. However, it is highly doubtful that this is the painting Isabella had commissioned, because this surviving Bellini mythology was paid for in the year 1514 by Isabella's brother Alfonso d'Este of Ferrara, and in the 1540s it was seen by Vasari in Alfonso's *camerino*. Whatever the case, one thing may safely be concluded from Bembo's letters and his reports about Bellini, namely that Bellini had now reached a point where his artistry was free of the constraints of his craft and that – in full awareness of the new dignity and autonomy of his profession and his creativity as an artist – he was not prepared to shackle his inventiveness, indeed that he loved to let his imagination to take flight, or as we would say: "*vagare a sua voglia*". But, if it was difficult to pin Bellini down to a specific literary programme at the time, then it is hardly surprising if we cannot come up with one now that matches the facts of the painting in every last detail.

The earliest surviving example from this category of Bellini's output is the group of five allegories in the Accademia in Venice, which once adorned a *restelo*, that is to say, a mirror. Dressing-room mirrors, set in decorative frames and used to finish internal walls, seem to have been a typical feature of Venetian interior design. In our case, however, only the pictures have survived, without the frame. Some scholars believe that there must originally have been a sixth panel, although none of the suggested reconstructions can be more than a tentative hypothesis. The criteria on which such reconstructions are based are generally iconographic in nature, that is to say, individual pieces are linked together according to the meaning that one thinks one can see or detect in the individual composition, and according to the overall plan that one has assumed for the work as a whole, in keeping with the 'moral' that it is supposedly illustrating. Hence, one older exegesis links the female figure in the boat, the nude woman with the mirror and the men carrying shell; the reason given is that the first panel portrays uncertain fortune, the second shows Prudentia (Previdenza) – hostile to the gambler – and the third portrays the shame which is the reward of those who indulge in games of chance. Meanwhile, in one of the most recent attempts at an explanation, the moral of the sequence is held to be that one can either use a mirror wisely or not, and that the artist's intention is to contrast the blessings of good fortune with the horrors of misfortune. How widely such interpretations range may be seen in the excellent catalogue of the Accademia in Venice.[103] And so it is, that one view sees the depiction of the harpy-like creature – with bound eyes and two jugs in her hand – as a portrait of *Summa virtus*, while another sees her as Fortuna or even Nemesis. The attributes used to lend weight to these interpretations feature in different contexts and hence lead to very different and – as we have said – completely contradictory interpretations. One cannot help but wonder if Bellini did not simply ignore the usual meanings of certain symbols, preferring to devise his own emblematic meanings, even to the extent of creating a secret code of his own.

212–216; plates 38, 39

There is no doubt that the images were organised in a concentric arrangement, as there is similarly no doubt that the signed picture of the shell-carriers must have constituted the lower right corner. It is probable that the scenes on the left had negative symbols while those on the right were positive. This would be all the more likely if, as is very possible, the two jugs carried by the harpy-like creature with the bound eyes contained Good and Evil and were not the mixed jugs of Temperantia as suggested by one exegesis which was long regarded as authoritative. If that were the case, then the harpy balancing on two spheres would be Fortuna rather than Nemesis, which would in turn raise doubts as to the meaning of the female figure in the boat with the sphere – the attribute of Fortuna – who was long taken to symbolise Good Fortune. Meanwhile, the strange, barely tenable allegory of the huge shell being carried by two men has to be associated with Evil. A man is lunging out of the shell, while a snake – that he has caught with one hand – is aiming for his open mouth. Perhaps the implication is the uncovering of a hidden vice or shame. And it is just as unclear whether the female nude, pointing to a mirror with a grimacing face in it, is a Vanitas, Vana Gloria (that would tally with the blowing *putti*), a Veritas, Truth uncovered, or perhaps even a Prudentia. And the meaning of the panel with Bacchus on a chariot being drawn by *putti* is equally obscure. The problem in this case is the character of the second figure, whose sinewy body and drawn face contrast sharply with the soft, almost bloated figure of Bacchus. It looks as though the armed man hurrying by – his fluttering cloak an indication of speed – might be tempted by Bacchus with his dish laden with fruit, in which case this could be read as a juxtaposition of sensual indulgence and virtuous fighter. But this interpretation has also been rejected – albeit without the alternative seeming any more convincing.

212
214

215

216; plate 38

212 b; plate 39

212 a

212 b

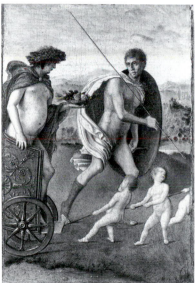

212 c

212 d

212
Giovanni Bellini,
Five Allegories ('Restelo').
Venice, Gallerie dell'Accademia

a) Fortuna; b) Vanitas;
c) Perseverance; d) Envy or Sloth;
e) Summa virtus

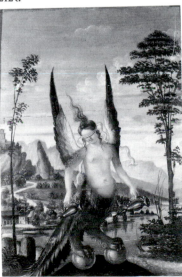

212 e

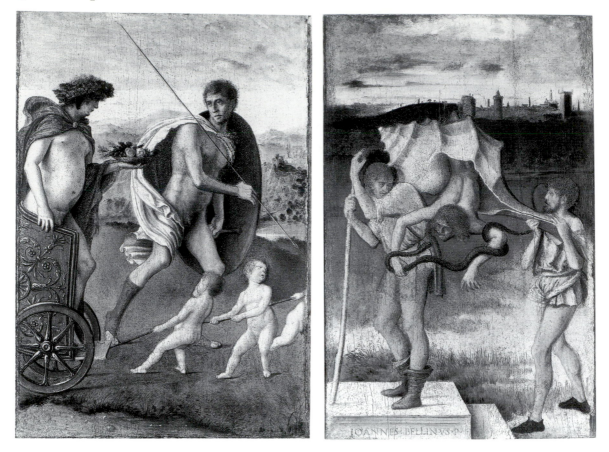

Three of the five panels depict movement. As we have seen, this was unusual for Giovanni Bellini. In all three cases the movement unfolds parallel to the picture plane as though on a frieze; typically the figures themselves are less dynamic than the accessories which suggest movement, fluttering garments for instance, as does the feeling that we are seeing only a moment in a larger scene. We do not see the tip of the boat, Bacchus' chariot is only just entering the picture while the first of the *putti* pulling the rope is already cut off by the edge of the composition. The inner unity of two of these panels is generally achieved by exactly the same means as on a Greek relief, that is to say, by the lead figure turning back in towards the centre[104]: a segment of a lateral movement thus becomes a balanced whole. This principle had already been grasped by Jacopo Bellini and applied in the few mythological compositions to be found in his Sketchbooks. Not only was he depicting classical subject matter, the style was also *all'antica*. It was not without reason that the Bacchus of the allegory and his chariot had already appeared in Jacopo's drawing of the triumphal procession of Dionysus. And it is worth mentioning in passing that the static composition with the female nude holding a mirror is strikingly classical in its approach: the figure stands on a round pedestal like a classical statue of a goddess. Once again the forerunner for this can be found in the Sketchbooks, where Jacopo Bellini had a tendency to depict his saints as though they were figures on a monument or memorial.

At the same time it is of course entirely non-classical to embed a frieze composition in a landscape or an interior. The relationship of figures to background scenario is more or less the same in the two landscape settings as in the predella images on the Pesaro Altarpiece, and the transition from the front of the 'stage' to the background is disguised by the way it is painted. The most important unifying factor in these panels is the ambient light.

213, 214
Giovanni Bellini,
Perseverance and Envy
from the 'Restelo'.
Venice, Gallerie dell'Accademia

73

78–80

191–197

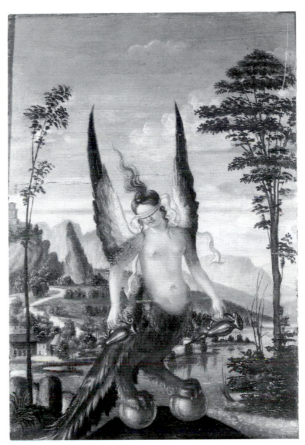

215
Giovanni Bellini,
Summa virtus from the 'Restelo'.
Venice, Gallerie dell'Accademia

plate 38 By contrast, in the seascape the figure is fully integrated into the scenario as a whole. The choppy surface of the sea creates a continuum as well as serving to measure out the distance by the constantly decreasing size of the waves. The lines of the hills cutting into each other seem like solid versions of the lines on the waters below.

It seems to me that, as soon as one tries to fathom the formal structure of this composition, different ways start to emerge by which we might manage to identify the thematic ideas that are the key to the secret of this picture. If Bembo found it necessary to feel his way into Bellini's style, in order to be able to suggest a suitable theme, we have every reason – regardless of the methods generally favoured today – to be guided as to the picture's contents by how we see it, albeit always exercising the level of caution appropriate to any experiment of this kind. If we examine the question as to how the illusion of movement is created in this composition, then we would have to start by citing certain aspects which, from our experience, suggest notions of movement to us. Generally we assume directional movement when we see a boat, as in this case, where all the occupants are facing in the same direction, and the garment of the seated female figure is fluttering in the opposite direction. And this is confirmed by the fact that the small figure who has fallen into the water is drifting in the opposite direction. The unusual aspect of this image of movement is that it is only generated by the vessel itself, while the figures on it are entirely undisturbed. The crucial point here is the impression of volatility, the inconstant nature of the relationship between the figures and their surroundings: the boat will pass by, the landscape will remain. Despite the one-sidedness of the directional vector, Bellini was able to centre the composition, although not as in the other two panels, where this is achieved by the leading figures turning back in towards the centre. Instead he

216
Giovanni Bellini,
Fortuna from the 'Restelo' (detail).
Venice, Gallerie dell'Accademia
(colour plate 38)

depicts a sphere in the centre resting on the knee of the female figure and against the back
of one of the putti. It does not rest there securely or rigidly; on the contrary we feel that
at any moment it could roll away, rotating on its own axis. Thus the centre of the paint-
ing is occupied by an object which, by definition, is at peace in eternal movement. The
most mobile of all forms stabilises Bellini's composition.

By virtue of its innate characteristics, the sphere, the globe – Bellini's *putto* mimics
Atlas bearing the globe of the Earth on his shoulders – had been an attribute of Fortuna
since the Renaissance. Previous to this she had carried a wheel; both symbolise the 'in-
constancy' of Fortuna and today we still speak of the wheel of fortune. In a floor mosaic
in Siena Cathedral,[105] designed by Pinturicchio, the nude figure of Fortuna is shown 217
standing with one foot on a sphere and the other on a boat. Surely, we have no choice
other than to read the figure in the boat in Bellini's painting as Fortuna? Bellini's Fortuna
is much more comfortable than Pinturicchio's: she is sitting in the boat and not obliged
to balance on two unstable footholds like an acrobat. And although it may sound a little
comical, if one were to give the picture a title it would have to be: The globe of Fortuna
passes by (or, approaches?). For Bellini, who lived by his sight and his vision, it seems that
the other idea – arising from a literal translation of the conceptual notion of inconstant
fortune – may have been more amusing but was much too abstract. Hence he transposed
the circumstances of the allegory of good fortune into a realistically possible situation. He
creates a natural connection between the personification of good fortune and her attrib-
utes, which does not conflict with the natural laws of perception. The allegorical mean-
ing of the attribute – depicted as a real object – is only apparent as a subtle allusion. This
is entirely in keeping with Bellini's pictorial imagination as we know it from his sacred
paintings, as in the *Transfiguration* for instance or in the *Coronation of the Virgin* where
distant heavenly visions descend to the Earth that he himself knew. And it seems to me
that Bellini proceeded no differently in this painting of a secular subject. He transformed
the abstract allegorical substratum into flesh and blood, at the same time retaining the
necessarily 'ideal' quality of the scene by shrouding his figures in classical garments or
similarly classical nudity. In view of this, we can with perfect justification describe him as
a painter-poet.

217
Pinturicchio,
Floor inlay (detail).
Siena Cathedral

When we look at the five allegories in the Accademia in Venice, the overall pro-gramme, along with certain details, is not clear; but at least we do know the purpose for which this ensemble was painted, that is to say, these small panels would have adorned a Venetian interior. In the case of the *Sacra Allegoria*, which went from the collection of the Habsburgs in Vienna to the Uffizi in an unfortunate gallery exchange in the late 18th century, we do not even know its purpose, and are still rather groping in the dark. Is it perhaps a cabinet painting that existed entirely in its own right? In that case, it would be one of the very earliest of its kind. We tend to forget all too easily that such paintings have not existed since time immemorial and that they were in fact only popularised by the Dutch in the 17th century. But what if this painted poesia were the product of the artist's imagination alone, not commissioned – a first in art history – what if it were in fact de-claring its complete independence as a social form, not the product of patronage, not even part of the decor of a palace or a private residence, a painterly microcosm with its own centre of gravity? Could we even be so bold as to describe it with that much maligned notion of "l'art pour l'art"?

In an article well worth reading, Wolfgang Braunfels[106] has explored all the interpreta-tions and titles that have been associated with this painting over time – Christian allegory, an allegory of the tree of life, an allegory of Misericordia and Justitia, *Sacra Conversazione*, mystery play, an allegory of Paradise. Finally, despite alluding to that same comment by Bellini referring to the free-floating nature of the artistic imagination that we mentioned earlier, Braunfels arrives at the conclusion that this is Giovanni Bellini's Garden of Par-adise. For our part, we will do no more than simply describe the picture, in the same way that one would recount the events on a stage where the characters had been speaking in an unfamiliar foreign language. We do not know what is being played, although many of the characters and aspects of the scenery seem familiar. Let us first consider where we know them from and where that takes us in terms of ideas and meanings.

plate 35 We see a balustraded terrace looking out over the slightly lower shores of a lake. Once the eye has traversed the water it arrives at the immensely varied rock formations and cliffs on the other side of the lake. On either side the rocks rise up to such a height that they are cut off by the top edge of the picture, partly blocking out the sky. On the archi-tectural stage in the foreground we see a number of male and female figures, some of whom can be identified by their typical characteristics as particular saints, on the right Job and Sebastian, on the left Peter and Paul; as well as this there are two female figures – less readily identifiable – on either side of a throne, occupied unmistakably by none other than the Virgin Mary. All the figures – with the exception of St Paul and St Sebastian, whose hands are not free – have their hands clasped in prayer, and the focus of their attention can only be one of the four small children playing in the centre: one is holding onto the orange tree planted in a tub, while the others are playing with fruits from the same tree. In all probability, the figure sitting on a cushion, apparently contemplating an orange, is the Child Jesus. Although there are no other external indications of His iden-tity, He is the only one wearing any clothes. Associations with the Tree of Life and Par-adise – that is to say, mystical Paradise – come to mind; in view of the balustrade around the tree in the foreground one might almost be tempted to regard this as a *hortus conclusus*, if it were not for the fact that one tree does not make a garden. If we then seek help in the relevant pictorial traditions, the first work we remember might be the early panel by Giovanni Bellini showing the Risen Christ allowing His blood to flow into a chalice held aloft by a kneeling angel. In this allegory of Christ's suffering, the way that the tiled sur-face on which Christ is standing is separated from the landscape behind Him is reminis-cent of the allegory in the Uffizi – the only difference being that the open balustrade in one is replaced by a low parapet decorated with a figural bas-relief in the other. Also, in

218

the Uffizi allegory the central figure is not surrounded by others but appears in isolation. A marble stage against a landscape background appears one more time in Bellini's work, namely in the *Coronation of the Virgin* in Pesaro, although here the polarity of the stage in the foreground and the landscape in the distance becomes a counterpoint of an ideal, timeless world and the earthly world, by virtue of the fact that the 'real world' is in effect presented as a framed picture. And in this connection, no doubt we will recall the fact that the saints assisting at the *Coronation of the Virgin* serve as *pars pro toto* for the Communion of Saints, who generally appeared as massed ranks in the Venetian tradition; furthermore we might well recall that a late example of this genre – and perhaps the most famous – Tintoretto's Coronation of the Virgin was entitled *Paradiso*, albeit a Paradise that is located somewhere high up in the clouds as in Dante's description of Heaven. Bellini depicts Heaven as an earthly landscape, and creates an idealised stage before our very eyes on which the Higher Beings may be seen, far from the constraints of earthly temporality and spatiality – a deeply Venetian solution.

190; plate 29

187

In this dreamlike world, where Paradise has as it were settled on the surface of the lake, the earthly landscape has retreated from our grasp: it is in the distance on the other side of the lake, only accessible to our gaze. And even then, although we can see that the Earth on the other shore is populated, what precisely is happening cannot be distinguished with any certainty. We see a shepherd in a cave, animals grazing, a centaur: memories of hermits' abodes come to mind, but nothing really becomes clear. Just as we cannot extricate the shepherd from his cave, so, too, the other individual lives seems to be woven into the landscape background, almost as though just below the level of normal consciousness. At the same time, the distance renders any life or movements silent, it just slips by. In this

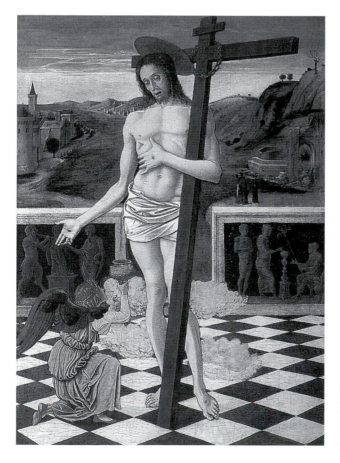

218
Giovanni Bellini,
The Blood of the Redeemer
(Sanguis Christi).
London, National Gallery

respect there is no difference to life in Paradise, which is similarly silent. With the sole exception of the figure of St Paul – who seems to be holding up his sword threateningly towards the Muslim figure leaving the scene – all the figures focus in silent prayer on the children, innocently playing on the centre cross of the tiled floor; it almost seems like a scene from the legendary decoration of the *Infantia Salvatoris*. In a sense, this composition could be regarded as a dreamlike vision of Paradise and Earth, in which even the visionary cannot explain every detail that he saw in his mind's eye. Illustrations of medieval revelations, like that of the Apocalypse, are waking interpretations of visions. Bellini does not provide an ex post interpretation, but he conveys the mystical atmosphere surrounding this vision of Paradise all the more compellingly and persuasively. I would therefore agree with Wolfgang Braunfels, when he says: "If one seeks to discover the precise place and time of the particular moment portrayed in this scene, one will not only be left without an answer, but one will have broken the code of conduct that these works of art expect of us."

There are good reasons for concluding that the *Sacred Allegory* was painted in the late 1480s. The painted *poesia*, which we still need to consider, came right at the end of Giovanni's creative life and was completed in 1514, or at least, that is when Alfonso d'Este paid for it. The mythological painting known as *The Feast of the Gods or Bacchanal*, signed and dated by Bellini, is now in the National Gallery, Washington, and its precise meaning seems quickly to have been forgotten – even Vasari and others were already describing it inaccurately. Its literary sources[107] were only identified fifty years ago by a French scholar. This work was in fact inspired by Ovid's *Fasti*, specifically by the passage in which Ovid recounts the origins of Priapus's sacrifice of the ass. At a feast in honour of his father, Priapus – the son of Dionysus or Bacchus – had tried unsuccessfully to woo a beautiful nymph named Lotis. Later he came across her asleep in a coppice; having overindulged in wine, he bent over her and was just taking hold of the hem of her skirts when Silenus's ass brayed loudly and raucously, wakened the nymph from her sleep and made Priapus the laughing stock of his fellow drinkers and the rest of the company. Out of revenge, Priapus then sacrificed the ass. In a woodcut illustration for a Venetian edition of Ovid's works, which appeared in 1501, this scene is portrayed in a rather clumsy manner; at the same time one of most splendid woodcuts in *Hypnerotomachia Poliphili*, which appeared in Venice in 1499 and was one of the most successful novels of the Humanist era, also depicted Priapus and the ritual sacrifice of the ass, ensuring that all those with an interest in culture would certainly have known of the legend.[108] There can be no doubt that Bellini knew these illustrations and their literary contexts, and that his own composition alludes to this same Feast of Bacchus where this 'gallant' episode is said to have occurred. But before we look more closely at Bellini's relationship to the literary source, we have to say a few words on the subject of the state of preservation of this work which was later overpainted by Titian.

Thanks to X-ray photography, we now have a good idea of how Bellini's mythological painting looked before Titian 'modernised' it, as Vasari reported. Bellini's classical coppice was a wall of trees behind a flat 'stage' crowded with figures: a woodland as a background relief of the kind already being used by Pollaiuolo in his engravings and which we see in Bellini's own work in the *Assassination of St Peter Martyr*. Titian, clearly considering the wall of trees to be too flat and monotonous, divided it into two sections, and made a distinction between the left-hand side of the picture and the right-hand side, by recessing the terrain on the left and turning it into a wooded hillside. The element of drama thus created also reflected the traditionally rapturous Dionysian nature of the episode, which the cinquecento painter clearly found lacking in the very un-orgiastic bacchanal painted by his predecessor.

That Bellini did not slavishly follow the passage from Ovid will hardly come as a surprise to us. Nevertheless, the poetic license that he allowed himself goes so far that the scene in his composition almost seems to contradict the poet's description of the situation. In Ovid's account, night had already fallen, and Priapus discovered Lotis sleeping in a secluded spot, "*secreta cubilia nymphae*". In Bellini's painting the god of the gardens and woodlands, dressed as a gardener, is approaching the beautiful Lotis in the presence of the revelling gods, amongst whom Mercury stands out as an interested onlooker. We see the ass that is to spoil Priapus's game, but Silenus – the ass's owner – does not look in the slightest like a Silenus, that rotund old tippler whom Jacopo Bellini – and the artists of Antiquity – used to portray as an unashamed nude. The only figures that appear in their 75 familiar classical guise are the satyrs. Beyond that, only a few of the gods can be identified by their attributes – Jupiter by his eagle, Neptune by his three-pronged fork, Mercury by his helmet and caduceus – and even then, one has to look very closely to discover these almost hidden clues. None of the gods appears as a classical nude, with the result that – were it not for the satyrs and the gods' accoutrements – one might easily imagine this to be a perfectly normal company of ordinary mortals enjoying a repast in the country, a "*déjeuner sur l'herbe*", or at most a gathering in the open air mimicking the gods indulging in a bacchanalian revelry.

In a study devoted to this *Feast of the Gods* by Bellini, its author once sought to explain all these various anomalies by suggesting – purely speculatively – that this composition could have been painted to celebrate a marriage, specifically that of Alfonso d'Este and Lucretia Borgia. On this basis, he interpreted the participants at the bacchanal as mythological portraits, thus reading the features of Alfonso into the face of Neptune, and those of his brother Ippolito into those of Mercury, etc. Meanwhile the abnormally emaciated Silenus could be explained as a portrait of Pietro Bembo, Isabella d'Este's advisor who could have been given a leading role in this painting as the supplier of the theme and as the *spiritus rector* of this mythology. In short, the painting was taken as some-thing of a *roman à clef*. However, this bold hypothesis has since proved to have been skating on rather thin ice because later X-ray examinations have shown that certain details crucial to this interpretation were most probably not present in the first layer of the painting by Bellini. Even the presence of the gods' attributes in the first version now seems questionable. It could be that the existing signs identifying the different figures are already the fruits of interpretation by the second hand to work on this painting, namely Titian. Perhaps it was Bellini's intention specifically to have this scene played out by a largely anonymous gathering. In that case, it would make perfect sense that even Silenus does not conform to the classical iconography and that Bellini gave him such a very unexpected appearance.[109]

As I now see it, the first step to a better understanding of the many open questions surrounding the *Feast of the Gods* will have been made if we take full account of the intended anonymity of the image, which is consistent with Giovanni's tendency to 'alienate', as already observed in his religious allegories. The immediate consequence of this is that instead of searching for possible additional literary or non-artistic sources of inspiration it is up to us to view this work more carefully than before in the light of the pictorial traditions of depicting mythological subject matter. Before the time that themes from Ovid's writings were deemed worthy of monumental painting, they had already been addressed in book illustrations. There were a number of Latin verse and Italian prose editions of Ovid's works illustrated with woodcuts. In addition there were also the illustrations – some of the highest artistic quality – for *Hypnerotomachia*, a neo-classical romance which reworked many of Ovid's themes. If we again place the rather crude illustration of the Priapus legend from the *Ovidio Volgare* of 1501 alongside Bellini's *Feast of the Gods*,

then we cannot fail to observe that the costumes in the two are not so very different and that in both cases they are equally far removed from Antiquity: Silenus, for instance, is a bearded old man, neither fat nor naked. Since the woodcut depicts only the episode with the nymph – seen sleeping in the company of other nymphs – the comparison can go no further as such. Nevertheless, it would be fair to say that Bellini's notion of Ovid in 1514 is stylistically on the same level as the *Ovidio Volgare* of 1501. If we then glance briefly at a drawing of a composition in the Vendramin Collection in Venice and attributed there to Giorgione,[110] it seems all the more certain that Bellini's version pre-dates the advent of the classical style for mythological landscapes and figures. It is only a prelude to it. On the very threshold to the promised land, Giovanni Bellini came to a halt.

Perhaps we are too easily distracted by the three satyrs and our knowledge of the treatment of similar mythological themes in Renaissance and Baroque Classicism. If we eliminate the satyrs, who seem more like echoes of Antiquity – strewn across the composition to give it an exotic air – then we are left with a light-hearted gathering at the edge of a wood, where the figures' behaviour is not so orgiastic as to warrant the scene being described as a bacchanal. The scene might be better described as a society piece, where a relatively large group has gathered for a particular purpose: a sociable meal, a banquet, or a picnic – a society piece where participants express their convivial pleasure by wearing a wreath of laurel or of vine leaves, but are not otherwise characterised as individuals in any great detail. Hence this work is not really a group portrait – not enough attention was paid to the individual physiognomies for that; all the same, as in a proper group portrait, the front row here is on the ground, half-lying, sitting or kneeling, the second row behind them is standing, more or less frontally. Thus we have an extremely loose, painterly group portrait, with few real narrative moments – the figure stealing up on the sleeping girl and the noisy ass are only woven into it as peripheral anecdotes. The artist has distilled a very human situation from the mythological subject matter; the classical context is in fact simply a beautiful pretext, an allusion which gives added charm to this composition for the Humanist viewer.

219
Giovanni Bellini,
The Assassination
of St Peter Martyr.
London, National Gallery

We bid farewell to Giovanni Bellini by turning to his portrait of a *Woman with a Mirror*, the only work by the hand of our Master which can be studied in the collection of the Kunsthistorisches Museum in Vienna. It has a *cartellino* with the rather unusual in- *plate 40* scription "Iohannes bellinus faciebat M·D·X·V", which tells us that Bellini was in his late eighties when he painted this work, a year before his death. Apart from the subtlety with which this portrait is painted – which is matched in other late works by Bellini – this composition is new in every respect and has no immediate forerunners. Consequently, we find ourselves in some difficulty when it comes to the title. Is this simply a beautiful young woman, glancing at her hair in the mirror, or could she be Venus, that is to say, could this be a mythological painting? Amongst Bellini's artistic successors – Titian, Veronese, Tintoretto and Rubens – whenever the subject in a similar pose is nude, the assumption is that this is the classical goddess Venus. Thus, logically, we ought to read Bellini's young woman with a mirror as Venus, despite her Venetian hair style and head-dress. If the figures in the 'Bacchanal' can be seen as gods, despite being clothed, then this nude beauty should all the more be recognised as a goddess. This ambiguous mixture of a private human scenario and allegorical mythology is, as we know, typical of Bellini's style.

We naturally recall the Restelo panel with the nude female holding a mirror, where we *plate 39* could not be sure whether she represents Vanitas or Prudentia, and if the compositional motif were not so strikingly different, it might be tempting to assume a connection between the moralising allegory and the female nude in Vienna. After all, Venus performing her toilette in Renaissance paintings is none other than a secularised Vanitas. But the overtones are different and the ideological super-structure has changed, although the pictorial motifs and their deeper existential meaning will surely outlive whatever ideologies they may appear to serve. The motif of a woman contemplating her own beauty has a particular appeal as an artistic problem in the sense that the painter and his model are, as it were, gazing at the same picture. The fact that the woman is looking at her mirror image means that she can correct it before it becomes a painting. But this particular task also brings with it an awkward problem concerning the depiction of space. If we are to see the whole of the subject, then we cannot at the same time be looking into the reflective surface of the mirror. The solution in the Restelo panel is that the mirror is presented frontally to us, although we now of course do not see a reflection of the face of the nude female carrying it, but that of another. Similarly, in Titian's early image of Vanitas we do not see her face in the mirror; Veronese, Tintoretto and Rubens all portray Venus facing away from the viewer, so that she – and the viewer – can see her image in the mirror. Bellini resorts to two mirrors, in the manner of a 'reflex lens': one into which the young woman is looking into, and into which we cannot see; and a second mirror where the opposite applies. Nevertheless, we do not see a reflection of her face. The second mirror hangs on a wall parallel to the picture plane. Bellini has placed the wall directly behind the young woman: a flat, black, otherwise unspecified background against which the young woman and the mirror stand out. On the other side of the painting, however, the viewer's gaze can soar out through a window into the landscape in the distance. As in his later depictions of the Madonna, this is a three-quarter portrait which creates the impression that we are only seeing part of the foreground, almost as though through a frame, in such a way that the continuum of spatial depth is replaced by a series of optical levels, one behind the other. Different pictorial techniques are perfectly combined in this painting – frame, mirror image, window view. Perhaps, when we look at this work, painted by Bellini as a very old man, which heralds a new age of painting and pays allegiance to a new cult of beauty, we might be tempted to add our own subtitle: 'The Apotheosis of Vision.'

54 Cf. Bernhard Degenhart and Annegrit Schmitt, 'Gentile da Fabriano in Rom und die Anfänge des Antikenstudiums', in: *Münchner Jahrbuch der bildenden Kunst*, vol. XI, 1960, 59 ff.; For more on classical forerunners, cf. Degenhart and Schmitt, 1995 (as note 30) fig. 96; see also Andrew Martindale, *The Triumphs of Caesar by Andrea Mantegna in the Collection of H. M. the Queen at Hampton Court*, Edinburgh 1979.

55 Cf. Giovanni Pisano, *Pulpit in the Cathedral in Pisa: Venus Pudica*: White, 1966 (as note 39), 85, plate 36 B; Hans R. Hahnloser, *Villard d'Honnecourt: Kritische Gesamtausgabe des Bauhüttenbuches*, Paris, Bibl. Nat., Ms. fr. 19093, Vienna 1935.

56 Degenhart and Schmitt, 1960 (as note 54), figs 75, 77.

57 Ibid.

58 Cf. the Fugger Amazon sarcophagus, Vienna, Kunsthistorisches Museum, Antikensammlung.

59 Ibid., fig. 88; For more on the Roman *Allocutio* cf. Relief of the Constantine Arch, Rome (Martindale, 1979, as note 54, plate 193).

60 Cf. note 35; For more on the Ovetari Chapel Altarpiece cf. Peter Humfrey, 'The Bellini, the Vivarini, and the Beginnings of the Renaissance Altarpiece in Venice', in: *Italian Altarpieces*, 1994 (as note 14), 139 ff., fig. 103; Giordana Mariani Canova, 'Alle origini del Rinascimento Padovano: Nicolò Pizolo', in: exh. cat. *Da Giotto al Mantegna*, Padua 1974, 75 ff., figs 88/89; *La pittura*, vol. 2, 1990 (as note 35), 489.

61 For more on Guariento and Giusto de' Menabuoi (the polyptych and frescoes in the Paduan baptistry) cf. Davide Banzato, Guariento, in: exh. cat. *Giotto*, 2000 (as note 39), 176 ff., see also Anna Maria Spiazzi, *Giusto de Menabuoi*, ibid., 1990 ff.

62 Francesco Squarcione, *Polyptych*, Padua, Museo Civico: permanent catalogue of Il Museo Civico di Padova. Dipinti e sculture dal XIV al XIX secolo, ed. by Lucio Grossato, Venice 1957, 157 ff.; permanent catalogue, *La Quadreria Emo Capodilista. 543 dipinti dal' 400 al' 700. Testi di Davide Banzato*, Rome 1988; *La pittura*, vol. 2, 1990 (as note 35), 504; Michelangelo Muraro, 'Francesco Squarcione pittore 'umanista'', in: exh. cat. *Da Giotto*, 1974 (as note 60), 68 ff.

63 Sergio Bettini, Lionello Puppi, *La Chiesa degli Eremitani di Padova*, Vicenza 1970; For more on the frescoes in the Ovetari Chapel see Selected Literature: Andrea Mantegna, see also: V. Moschini, *Gli affreschi del Mantegna agli Eremitani di Padova*, Bergamo 1944; E. Rigoni, 'Il pittore Niccolò Pizzolo', in: *Arte Veneta*, 2, 1948, 141 ff.; Annegrit Schmitt, Bono da Ferrara, in: Degenhart and Schmitt, 1995 (as note 30), 229 ff.; Keith Christiansen, 'Prime opere: Padova', in: exh. cat. 1992 (see Selected Literature), 93 ff.; Andreas Hauser, 'Andrea Mantegnas Christophorus-Fresko', in: *Städel-Jahrbuch*, new series vol. 18, 2001, 59 ff.

64 For more on Castagno's frescoes in San Zaccaria in Venice cf. note 34.

65 Cf. note 32.

66 Andrew Martindale, *Simone Martini*, Oxford 1988.

67 For more on the depictions of the Church Fathers by Tomaso da Modena in San Nicolò in Treviso cf. exh. cat. *Tomaso da Modena*, Treviso 1979, 130 ff.; *La Pittura*, vol. 1, 1989, (as note 23), 119 f., with further reading.

68 Cf. Otto Demus, *The Mosaics of San Marco in Venice, I, The Eleventh and Twelfth Centuries*, Dumbarton Oaks 1984, vol. 1, Text, 171 ff., vol. 2, plates, 234–239; Cf. also *The Ascension of Christ*, dome mosaic, Saloniki, Hagia Sophia (John Beckwith, *Early Christian and Byzantine Art*, Harmondsworth 1970, plate 162) and the Verdun Altarpiece: Floridus Röhrig, *Der Verduner Altar*, Vienna 1979; Helmut Buschhausen, *Der Verduner Altar*, Vienna 1980.

69 See Selected Literature: Andrea Mantegna; cf. note 63.

70 For more on Antonio and Bartolomeo Vivarini (Pala, Padua, San Francesco) cf. Rodolfo Pallucchini, *I Vivarini*, Venice 1962; *La pittura*, vol. 1, 1989, (as note 23), 65 ff.

71 For more on Donatello see note 39; for more on depictions of the *sacra conversazione* by Fra Angelico and Domenico Veneziano cf. Peter Humfrey and Martin Kemp (eds), *The Altarpiece in the Renaissance*, Cambridge 1988.

72 Cf. Fra Angelico, *Sacra Conversazione* on the Pala di Fiesole or the Pala del Bosco ai Frati: Elsa Morante, *L'opera completa dell'Angelico*, Milan 1970, cat. nos 9, 115; Gabriele Bartz, *Giudo di Piero, known as Fra Angelico, ca. 1395–1455*, Cologne 1998, 18 ff., 44, 83 (*Madonna delle ombre*, Florence, Museo di San Marco).

73 See Selected Literature: Gentile Bellini.

74 For more on the treatise 'De artificiali perspectiva' by Jean Pélerin, Toul 1505, cf. *The Dictionary of Art*, ed. by Jane Turner, vol. 24, London/New York 1996, 334 ff.

75 For more on 'orientalised' images of the Adoration of the Magi, for instance in the works of Gentile da Fabriano, Antonio Vivarini and the Limburg Brothers, see A. Pertusi, *Venezia e l'Oriente fra tardo Medioevo e Rinascimento*, Milan 1966; Mirko Sladek, 'Lapis Angularis & Lapis Exilis. Giorgione und die persische Legende von den Heiligen drei Königen', in: *Wiener Jahrbuch für Kunstgeschichte*, vol. LI, 1998, 77 ff.

76 Cf. John Pope-Hennessy, *The Portrait in the Renaissance*, New York 1966 (London 1967).

77 Jürg Meyer zur Capellen, 'Das Bild Sultan Mehmets des Eroberers', in: *Pantheon*, 44 1983, 208 ff.

78 For more on Francesco Squarcione and Gregorio Schiavone cf. Alberta De Nicolò Salmazo, 'Padova', in: *La pittura*, vol. 2, 1990 (as note 35), 481 ff.

79 See Selected Literature: Giovanni Bellini.

80 J. A. Crowe, G. B. Cavalcaselle, *A History of Painting in North Italy*, 2 vols, London 1871; G. B. Cavalcaselle, J. A. Crowe, *Storia della pittura in Italia dal sec. II al sec. XVI*, Florence 1885.

81 Ronald Lightbown, *Sandro Botticelli. Life and Work*, London 1989; for images by Fra Angelico see figs 17, 189 in this volume.

82 Cf. Cannon, 1994 (as note 14). See also note 11.

83 Cf. also Jacopo Bellini, *Madonna*, Los Angeles, County Museum of Art (Eisler, *Jacopo Bellini*, see Selected Literature, fig. 41); for more on the *Madonna humilitatis* see note 15, 18.

84 For more on the Dublin *Madonna* cf. Borsi, 1994 (as note 46), 236 f., 314 f.

85 Cf. exh. cat. *Da Bellini a Tintoretto*, Padua 1991, 80. (*Madonna* by Lazzaro Bastiani) and permanent catalogue, Accademia (as note 1), 228 f. (*Madonna* by Bartolomeo Vivarini).

86 Cf. exh. cat. *Un museo nel terremoto*, Udine 1988, cat. no. 3095.

87 Enguerrand Quarton, *Pietà of Avignon*, Paris, Louvre (Jan Białostocki, *Spätmittelalter und beginnende Neuzeit*, Berlin 1972, p. 192, fig. 54).

88 Cf. Lucas Cranach, *Ruhe auf der Flucht nach Ägypten*, 1504, Berlin, Staatliche Museen Preussischer Kulturbesitz: Schade, 1977 (as note 48), plates 21/22.

89 Martin Schongauer, *Schmerzensmann zwischen Maria und Johannes*, copper engraving (Lehrs 34); Tilman Falk, Thomas Hirthe, exh. cat. *Martin Schongauer: Das Kupferstichwerk*, Munich 1991, 107 ff.

90 G. Bergamini, S. Tavano, *Storia dell'Arte nel Friuli – Venezia Giulia*, Udine 1984.

91 Roberto Longhi, *Piero della Francesca* (1927) con aggiunte fino al 1962, Florence 1975; Carlo Bertelli, *Piero della Francesca: Leben und Werk des Meisters der Frührenaissance*, Cologne 1992; Ronald W. Lightbown, *Piero della Francesca*, New York 1992; Birgit Laskowsky, *Piero della Francesca 1416/17–1492*, Cologne 1998.

92 For more on the Church of San Bernardino in Urbino cf. Ludwig H. Heydenreich and Wolfgang Lotz, *Architecture in Italy 1400 to 1600*, Harmondsworth 1974, 77 f., plate 70.

93 Cf. Carlo Bertelli, 'A Tale of two Cities: Siena and Venice', in: exh. cat. *The Renaissance from Brunelleschi to Michelangelo. The Representation of Architecture*, ed. by Henry A. Millon and Vittorio Magnago Lampugnani, Milan 1994, 373 ff.; Francesco di Giorgio Martini, *Trattati di architettura, ingegneria e arte militare*, 2 vols, ed. by C. Maltese, Milan 1967; Gustina Scaglia, *Francesco di Giorgio, Checklist and History of Manuscripts and Drawing in Autographs and Copies from ca. 1470 to 1687*, London/Toronto 1992.

94 Johannes Wilde, 'Die "Pala di San Cassiano" von Antonello da Messina', in: *Jahrbuch der kunsthistorischen Sammlungen in Wien*, new series III, 1929; permanent catalogue, Kunsthistorisches Museum, Gemäldegalerie I, Vienna 1960, 2 f.; Sciascia-G. Mandel, *Das Gesamtwerk von Antonello da Messina*, Stuttgart 1967; Giles Robertson, 'The Architectural Setting of Antonello da Messina's San Cassiano Altarpiece', in: *Studies in Medieval and Renaissance Painting in Honour of Millard Meiss*, New York 1977, 368 ff.; John Wright, 'Antonello da Messina: The Origins of his Style and Technique', in: Art History 3, 1980, 41 ff.

95 Cf. Pächt, *Van Eyck*, 1994, (as note 21).

96 For more on gold mosaics in Venice, cf. Ettore Merkel, 'Mosaici e pittura a Venezia', in: *La pittura*, vol. 2, 1990 (as note 35), 223 ff., see also Mirella Simonetti, *Tecniche della pittura veneta*, ibid., 247 ff.; Paul Hills, *Venetian Colour. Marble, Mosaic, Painting and Glass 1250–1550*, New Haven/London 1999; For more on the School of Murano cf. *La pittura*, vol. 1, 1989 (as note 23), 65 ff.

97 Titian, *Assunta*, Venice, Chiesa dei Frari: David Rosand, *Titian*, New York 1978; For more on Titian cf. also exh. cat. *Tiziano*, Venice/New York 1990.

98 For more on the walls of the Pazzi Chapel see Otto Pächt, *The Practice of Art History, Reflections on Method*, ed. by Jörg Oberhaidacher, Artur Rosenauer, Gertraut Schikola, London 1999, 53 ff.; The 'Palladian' motif in fact already existed in a monumental form during the days of the Roman Empire – for instance in Hadrian's Temple in Ephesos.

99 Albrecht Dürer, *Vier Apostel*, Munich, Bayerische Staatsgemäldesammlungen (Fedja Anzelewsky, *Albrecht Dürer, Das malerische Werk*, Berlin 1971, cat. nos 183, 184).

100 Heinrich Wölfflin, *Renaissance und Barock*, Munich 1888; idem, *Die klassische Kunst. Eine Einführung in die italienische Renaissance*, Munich 1899; English transl. *Classic Art*, London 1952.

101 Adolfo Venturi, 'Storia dell'Arte Italiana VII', *La pittura del Quattrocento*, III, Milan 1915.

102 Cf. Sylvia Ferino-Pagden, exh. cat. *'La prima donna del mondo' Isabella d'Este, Fürstin und Mäzenatin der Renaissance*, Vienna 1994.

103 Sandra Moschini Marconi, *Gallerie dell'Accademia di Venezia. Opere d'arte del secolo XVI*, Rome 1962.

104 Cf. note 58.

105 For more on Bernardino Pinturicchio cf. *The Dictionary of Art*, 1996 (as note 74), 829 ff.

106 Wolfgang Braunfels, 'Giovanni Bellinis "Paradiesgärtlein"', in: *Das Münster*, IX, 1956, 1 ff.

107 Cf. John Walker, *Bellini and Titian at Ferrara. A Study of Styles and Taste*, London 1956.

108 For more on the depiction of the sacrifice of the ass in the *Hypnerotomachia Poliphili* of 1499 (*Francesco Colonna, Hypnerotomachia Poliphili*, ed. by G. Pozzi, L. A. Ciapponi, Padua 1964) and on the *Ovidio Volgare*, cf. Marino Zorzi, 'Stampa, illustrazione libreria e le origini dell'incisione figurativa a Venezia', in: *La pittura*, vol. 2, 1990 (as note 35), 686 ff.

109 For more on the identification of individual figures with historic personae see Edgar Wind, *Bellini's Feast of the Gods: A Study in Venetian Humanism*, Cambridge (Mass.) 1948; cf. also D. Bull, J. Plester, *The Feast of the Gods: Conservation, Examination and Interpretation*, Washington 1990.

110 For more on the 'Libro Vendramin' cf. Günther Tschmelitsch, *Zorzo, genannt Giorgione*, Vienna 1975, 198 ff., figs 62, 63; Christian Hornig, *Giorgiones Spätwerk*, Munich 1987, 63, figs 75, 79, 80.

Selected Literature

on Jacopo Bellini, Andrea Mantegna, Gentile
and Giovanni Bellini, in chronological order

Jacopo Bellini

Lionello Venturi, *Le origini della pittura veneziana 1300–1500*, Venice 1907

Laudedeo Testi, 'Dei disegni di Jacopo Bellini', in: *Rassegna d'arte*, 1909

Victor Golubew, *Die Skizzenbuecher Jacopo Bellinis*, 2 vols, Brussels 1908–1912 (vol. 1, 1912, vol. 2, 1908)

Lionello Venturi, *La storia della pittura veneziana*, Bergamo 1915

Vittorio Moschini, *Disegni di Jacopo Bellini*, Bergamo 1943

Hans Tietze and Erika Tietze-Conrat, *The Drawings of the Venetian Painters in the Fifteenth and Sixteenth Centuries*, New York 1944

Luigi Coletti, *La pittura veneta nel Quattrocento*, Novara 1953

Rodolfo Palucchini, *La pittura veneta del Quattrocento*, Bologna 1955

Bernhard Degenhart and Annegrit Schmitt, 'Ein Musterblatt des Jacopo Bellini mit Zeichnungen nach der Antike', in: *Festschrift Luitpold Dussler*, 1972, 139 ff.

Bernhard Degenhart and Annegrit Schmitt, *Corpus der italienischen Zeichnungen 1300–1450*, part II: Venice 1300–1400, Addenda on Southern and Central Italy, Berlin 1980

Howard F. Collins, 'The Cyclopean Vision of Jacopo Bellini', in: *Pantheon*, XL, 1982

Bernhard Degenhart and Annegrit Schmitt, *Jacopo Bellini, The Louvre Album of Drawings*, New York 1984

Colin Eisler, *The Genius of Jacopo Bellini. The Complete Paintings and Drawings*, New York 1989

Andrea Mantegna

Paul Kristeller, *Andrea Mantegna*, Leipzig 1902

Giuseppe Fiocco, *L'Arte di Andrea Mantegna*, Bologna 1927

Erika Tietze-Conrat, *Andrea Mantegna: Paintings, Drawings, Engravings*, London 1955

Millard Meiss, *Andrea Mantegna as Illuminator: An Episode in Renaissance Art, Humanism and Diplomacy*, New York 1957

Ronald Lightbown, *Mantegna. With a Complete Catalogue of the Paintings, Drawings and Prints*, Oxford 1986

Sandriba Bandera Bistoletti (ed.), *Il Polittico di San Luca di Andrea Mantegna in occasione del suo restauro*, Florence 1989

Exh. cat. *Andrea Mantegna*, ed. by Jane Martineau, London/New York 1992

J. Greenstein, *Mantegna and Painting as Historical Narrative*, Chicago 1992

Nike Baetzner, *Andrea Mantegna*, Cologne 1998

Gentile Bellini

A. L. Meyer, 'Zu den Bildnissen des Gentile Bellini', in: *Pantheon*, V, 1930, 17 ff.

Bernhard Degenhart, 'Ein Beitrag zu den Zeichnungen Gentile and Giovanni Bellinis', in: *Jahrbuch der Preussischen Kunstsammlungen*, vol. LXI, 1940, 37 ff.

Howard F. Collins, *Gentile Bellini. A Monograph and Catalogue of Works*, Ph. D. Dissertation, University of Pittsburgh, 1970

Howard F. Collins, 'Time, space and Gentile Bellini's The miracle of the Cross at the Ponte San Lorenzo', in: *Gazette des Beaux-Arts*, 1982, 201 ff.

Jürg Meyer zur Capellen, *Gentile Bellini*, Stuttgart 1985

Giovanni Bellini

Georg Gronau (ed.), *Giovanni Bellini. Des Meisters Gemälde*, Stuttgart/Berlin 1930

Philip Hendy and Ludwig Goldscheider, *Giovanni Bellini*, Oxford/London 1945

Luitpold Dussler, *Giovanni Bellini*, Vienna 1949

Rodolfo Palucchini, *Giovanni Bellini*, Milan 1959

Giuseppe Fiocco, *Giovanni Bellini*, Milan 1960

Johannes Wilde, *Venetian Art from Bellini to Titian*, Oxford 1974

Jan Białostocki, 'Man and Mirror in Painting. Reality and Transcience', in: *Studies in Medieval and Renaissance Painting in Honour of Millard Meiss*, New York 1977, 61 ff.

Susan J. Delaney, 'The Iconography of Giovanni Bellini's Sacred Allegory', in: *The Art Bulletin*, LIX, 1977, 331 ff.

Rona Goffen, *Giovanni Bellini*, London 1989, Ital. edn Milan 1990

Anchise Tempestini, *Giovanni Bellini*, Milan 1997 (with bibliographic overview)

Exh. Cat. *Il colore ritrovato, Bellini a Venezia*, ed. by Rona Goffen and Giovanna Nepi Scirè, Venice 2000

List of Works

Works by Jacopo, Gentile, Giovanni Bellini and Andrea Mantegna arranged according to location.
The dimensions of colour plates are given here in centimetres, height before width.

BERGAMO
Accademia Carrara di Belle Arti

GIOVANNI BELLINI
Madonna and Child (Lochis Madonna)
47 x 34
Colour plate 20

BERLIN
Staatliche Museen zu Berlin
Preussischer Kulturbesitz, Gemäldegalerie

GENTILE BELLINI
Madonna and Child with Donors
73 x 45
Colour plate 9

GIOVANNI BELLINI
Pietà with Two Angels
83 x 67
Colour plate 25

ANDREA MANTEGNA
Presentation in the Temple
Fig. 137

Virgin and Child
Fig. 154

BRESCIA
Sant' Alessandro

JACOPO BELLINI
Annunciation
219 x 98
Colour plate 1

BUDAPEST
Szépmüvészeti Múzeum

GENTILE BELLINI
Caterina Cornaro
63 x 49
Colour plate 13

FLORENCE
Galleria degli Uffizi

GENTILE BELLINI
Miracle at the San Lio Bridge,
Pen and ink drawing, Inv. 1293 E
Fig. 119

GIOVANNI BELLINI
Sacred Allegory
73 x 119
Colour plate 35

Lamentation
Fig. 180

ANDREA MANTEGNA
Resurrection of Christ
Fig. 107

Virgin and Child (Madonna of the Quarries)
Fig. 142

Adoration of the Magi
Fig. 210

LONDON
British Museum

GENTILE BELLINI
Procession on St Mark's Square,
Preparatory drawing, Inv. 1933-8-3-12

JACOPO BELLINI
London Sketchbook
 Size: 99 paper sheets,
 Sheet size:
 41.5 x 33.6
 Leather binding, 19th-century
 Inv. 1855-8-11
Fig. 2, 3, 7, 28, 43, 45−48, 52, 54−56,
64, 71, 73, 77, 78, 147

ANDREA MANTEGNA
St James led to Execution,
Preparatory drawing, Inv. 1976-6-16-1
Fig. 101

Hampton Court Palace

ANDREA MANTEGNA
The Triumphs of Caesar
Fig. 209

National Gallery
GENTILE BELLINI
Sultan Mehmet II
Fig. 131

Virgin and Child Enthroned
Fig. 138

GIOVANNI BELLINI
The Agony in the Garden
81 x 127
Colour plate 18

Madonna of the Meadow
67 x 86
Colour plate 21

Pietà with Two Angels
94 x 71
Colour plate 26

The Blood of the Redeemer
Fig. 217

The Assassination of St Peter Martyr
Fig. 218

ANDREA MANTEGNA
The Agony in the Garden
63 x 80
Colour plate 17

LOVERE
Accademia Belle Arti Tadini

JACOPO BELLINI
Madonna and Child
98 x 58
Colour plate 3

MADRID
Museo Nacional del Prado

ANDREA MANTEGNA
Death of the Virgin
54 x 42
Colour plate 8

MILAN
Museo Poldi Pezzoli

JACOPO BELLINI
Madonna of Humility
Fig. 18

Pinacoteca di Brera

ANDREA MANTEGNA
St Luke Polyptych
 Overall dimensions: 178 x 227
 St Luke: 119 x 61
Colour plate 5

GIOVANNI BELLINI
Pietà with the Virgin Mary
and St John the Evangelist
86 x 107
Colour plate 23

Madonna and Child
Fig. 168

GENTILE BELLINI
St Mark preaching in Alexandria
347 x 770
Colour plate 11

JACOPO BELLINI
Madonna of 1448
Fig. 13

NAPLES
Galleria Nazionale di Capodimonte

GIOVANNI BELLINI
Transfiguration
116 x 154
Colour plates 15, 16

NEW YORK
The Frick Collection

GIOVANNI BELLINI
St Francis in Ecstasy
120 x 137
Colour plates 36, 37

Metropolitan Museum of Art

GIOVANNI BELLINI
Virgin and Child
Fig. 155

Madonna and Sleeping Child
(Davis Madonna)
Fig. 162

PADUA
Museo Civico

GENTILE BELLINI
Adoration of the Magi
Fig. 125

GIOVANNI BELLINI
Descent of Christ into Limbo
Fig. 26

Ovetari Chapel

ANDREA MANTEGNA
Legend of St James
Fig. 85

Legend of St Christopher
Fig. 86

The Assumption
Fig. 87

PARIS
Musée du Louvre

JACOPO BELLINI
Madonna of Humility with Donor
(Lionello d'Este)
60 x 40
Colour plate 2, fig. 14

Paris Sketchbook
 Size: 93 parchment sheets, 1 paper sheet
 Sheet size:
 Height 42.2 to 42.8;
 Width 28.3 to 29.3
 Sheets unevenly trimmed
 Leather binding, 15th-century
 Inv. R.F. 1475-1556

Saint Christopher (fol. 79)
*Colour plate 4; Figs. 5, 6, 14, 21, 27, 31, 32,
34–42, 44, 49–51, 53, 57, 59, 60, 65, 69, 70,
74–76, 78–81, 103*

*See also the concordance of the folio numbers
on p. 255*

ANDREA MANTEGNA
The Crucifixion (Predella panel
on the San Zeno Altarpiece)
Figs. 97, 116

PESARO
Museo Civico

GIOVANNI BELLINI
Pesaro Altarpiece
 Overall size: 262 x 240
 Pilaster panels each 61 x 25
 Pilaster plinth each 40 x 36
 Predella panels each 40 x 92
*Colour plate 29;
Figs. 188, 190–197*

PRIVATE COLLECTIONS

GENTILE BELLINI
Double Portrait of Sultan and Prince
Fig. 133

RENNES
Musée des Beaux-Arts

GIOVANNI BELLINI
Pietà, Pen and ink drawing
Fig. 179

RIMINI
Museo della Città

GIOVANNI BELLINI
Pietà with Four Angels
80 x 120
Colour plate 27

TOURS
Musée des Beaux-Arts

ANDREA MANTEGNA
The Agony in the Garden
(Predella panel on the San Zeno Altarpiece)
Fig. 114

Resurrection of Christ
(Predella panel on the San Zeno Altarpiece)
Fig. 115

VENICE
Gallerie dell'Accademia

GENTILE BELLINI
Procession in St Mark's Square
373 x 745
Colour plate 10

Miracle of the Cross on
San Lorenzo Bridge
320 x 435
Colour plate 12

Miraculous Healing of Piero de' Lodovico
Fig. 127

Beato Lorenzo Giustiniani
Fig. 128

GIOVANNI BELLINI
San Giobbe Altarpiece
471 x 258
Colour plate 30

Five Allegories ('Restelo')
Figs. 212–215

Fortuna or Melancholy
34 x 22
Colour plate 38

Vanitas
34 x 22
Colour plate 39

Pietà 'Donà dalle Rose'
65 x 87
Colour plate 28

Madonna degli alberetti
74 x 58
Colour plate 22

Madonna and Sleeping Child Enthroned
(Madonna della Milizia di Mare)
Fig. 159

Madonna and Blessing Child
(Contarini Madonna)
Fig. 165

Madonna 'dei cherubini rossi'
Fig. 166

Dead Christ,
Pen and ink drawing
Fig. 178

Triptychon 'della Carità'
Fig. 182, 183

JACOPO BELLINI
Legnaro Madonna
Fig. 8

Museo Civico Correr

GENTILE BELLINI
Doge Francesco Foscari
Fig. 129

Doge Giovanni Mocenigo
Fig. 130

GIOVANNI BELLINI
Transfiguration
134 x 68
Colour plate 14

Pietà supported by Two Putti
74 x 50
Colour plate 24

Crucifixion
Fig. 25

Palazzo Ducale

GIOVANNI BELLINI
Lamentation with Saints Mark and Nicholas
Figs. 169, 170

VENICE *(continued)*

Venetian Churches:

Madonna dell'Orto (formerly)

GIOVANNI BELLINI
Madonna dell'Orto
75 x 50
Colour plate 19

San Giovanni Crisostomo

GIOVANNI BELLINI
San Giovanni Crisostomo Altarpiece
300 x 185
Colour plate 34

San Zaccaria

GIOVANNI BELLINI
San Zaccaria Altarpiece
500 x 235
Colour plate 32

Santi Giovanni e Paolo

GIOVANNI BELLINI
Polyptych on the St Vincent Ferrer
Altarpiece
Fig. 184, 185

Santa Maria Gloriosa dei Frari

GIOVANNI BELLINI
Frari Triptych
Fig. 203

VERONA

San Zeno

ANDREA MANTEGNA
San Zeno Altarpiece
Overall size: 480 x 450
Colour plate 6
Central panel: 220 x 115
Colour plate 7

VICENZA

Santa Corona

GIOVANNI BELLINI
Baptism of Christ
440 x 263
Colour plate 33

VIENNA

Kunsthistorisches Museum

GIOVANNI BELLINI
Woman with a Mirror
62 x 79
Farbtafel 40

WASHINGTON

National Gallery of Art

GIOVANNI BELLINI
Feast of the Gods
Fig. 211

Concordance for the Paris Sketchbook

Drawings referred to in this volume are cited according to the old folio numbering (as in Golubew and Eisler). The following concordance relates these to the new folio numbering (as in the facsimile edition of the Louvre Album, published in 1984).

Old folio no.	New folio no.	Old folio no.	New folio no.
6	9	39	35
7v	10	40	36
12	11	41	37
13	13	42	39
16v	16	45	41
17	15v	49	45
18	17	53	48
19	18v	56	51v
20	20	62	56
21	21	63	57
23v	22v	69	63
24	23	73	67
25	24	74	68
28	27	77v	71v
30	28	82	76
32	29	85	79
35	32		

Acknowledgements

To mark what would have been my Father's hundredth birthday, I decided to publish another volume of his legendary lectures.

First and foremost, I should like to express my gratitude to the editor of this volume, Margareta Vyoral-Tschapka, who has supported me with painstaking care and patience throughout this demanding undertaking.

For the English edition I would like to thank the translator Fiona Elliott for her faithful rendering of my Father's style. At the same time I wish to express my deep gratitude to Elly Miller as a publishing friend for accompanying me over a period of so many years with her never tiring enthusiasm and her profound knowledge in making Otto Pächts scholarship known to the English speaking reader.

In my efforts to procure photographic materials for the illustrations and plates, I was assisted above all by the following, and I am greatly obliged to them for their spontaneous offers of support: Annegrit Schmitt-Degenhart (Staatliche Graphische Sammlung, Munich), who provided images from Jacopo Bellini's Paris Sketchbook; Martin Royalton-Kisch and his assistant James Hellings (British Museum, London, Department of Prints and Drawings) for their unbureaucratic willingness to allow me to use the best possible photographic materials for the London Sketchbook; Francesco Turio Böhm (Archivio Böhm, Venice) for his competent, uncomplicated help in my endeavour to find the correct photographic materials for the Venetian works and also the Museum of Fine Arts, Budapest, for their generosity in granting reproduction permission.

Michael Pächt

Index

Photo Credits